OLD MASTERS:

Signatures and Monograms, 1400-born 1800

by

JOHN CASTAGNO

THE SCARECROW PRESS, INC.
Lanham, Md., & London

SCARECROW PRESS, INC.

Published in the United States of America
by Scarecrow Press, Inc.
A wholly owned subsidiary of
The Rowman & Littlefield Publishing Group, Inc.
4501 Forbes Boulevard, Suite 200, Lanham, Maryland 20706
www.scarecrowpress.com

PO Box 317
Oxford
OX2 9RU, UK

British Cataloguing-in-Publication Information Available

Library of Congress Cataloging-in-Publication Data

Castagno, John, 1930–
Old Masters signatures and monograms : 1400–born 1800
/ by John Castagno.
p. cm.
Includes bibliographical references.
1. Artists' marks. 2. Initials. 3. Monograms. I. Title.
N45.C39 1996 702'.78—dc20 95–25561

ISBN 0–8108–3082–5 (cloth : alk. paper)

⊖™ The paper used in this publication meets the minimum requirements of
American National Standard for Information Sciences—Permanence of
Paper for Printed Library Materials, ANSI Z39.48–1984.
Manufactured in the United States of America.

To all who love art for its excitement, beauty and enlightenment; and to all the artists who have and will continue to enrich the lives of countless generations with their gifted creativity.

CONTENTS

ACKNOWLEDGMENTS

Many thanks for the love, friendship, and support of dear friends.

Special thanks to

The staff of the Art Department of The Free Library of Philadelphia.

to the following auction galleries and their painting departments:

BUTTERFIELD & BUTTERFIELD, San Francisco, CA
CHRISTIE'S, Amsterdam
CHRISTIE'S, London
CHRISTIE'S, Monaco
CHRISTIE'S East, New York City
CHRISTIE'S, New York City
CHRISTIE'S, Rome
CHRISTIE'S, South Kensington
CHRISTIE'S, Sussex
PHILLIPS, formerly of New York City
PHILLIPS, London
PHILLIPS, Marylebone
PHILLIPS, Toronto
FREEMAN/FINE ARTS, Philadelphia, PA
SOTHEBY'S, Amsterdam
SOTHEBY'S, London
SOTHEBY'S, Milan
SOTHEBY'S, Monaco
SOTHEBY'S, New York City
SOTHEBY'S Arcade, New York City
SOTHEBY'S, Sussex

INTRODUCTION

Art historians and collectors will find this current volume of artists' signatures of considerable value in researching the artworks of the Old Masters. Included are signature examples for these artists dating from the 14th Century and born no later than 1800. This volume is presently the only such book focusing exclusively on signature examples taken not only from oil paintings but also watercolors, pastels, drawings, prints, and other works.

This book is divided into several sections, the main body of which contains 2700 signature examples of 1700 artists. Nationality, birth, and death dates are given as well as bibliographical references including auction record catalogues which offer photographs and values of the paintings.

Signature examples of the Old Masters are difficult to obtain. Auctions of work from this period are relatively infrequent and often the art is not signed. Among those which are signed, many signatures are not sufficiently discernible to record accurately. I was able to glean an average of only four to six signatures per auction after concentrating on approximately 250 sales since 1980.

Following the main body of the volume are three sections: Monograms and Initials, Symbols, and Alternate Names. These sections provide easy cross-referencing with the main body of this volume. In the back of the book is supplemental signature information on additional artists whose actual signatures were not visually available to me but who could not be omitted because of their importance.

I have personally reproduced all the signatures from their many sources. Although they are accurate examples, they should only be used as guides.

John Castagno
Philadelphia
May 1995

LIST OF ABBREVIATIONS AND SOURCES

A	Artists as Illustrators, an international directory with signatures and monograms, 1800–present, John Castagno, Scarecrow Press, Metuchen, N. J., 1989.
ABS	AB Stockholm's Auktionsverk, Stockholm, Sweden.
ADE	Ader Tajan auction, Paris, France.
AGR	Agra auction, Warsaw, Poland.
AUD	Audap-Godeau-Solanet auction, Paris, France.
B	E. Bénézit, dictionnaire critique et documentaire des peintres, sculpteurs, dessinateurs et graveurs, E. Bénézit, Librairie Gründ, Paris, 1976.
BAR	Barridoff Galleries, Portland, Maine.
BAS	Galerie Gerda Bassenge, Berlin, Germany.
BB	Butterfield & Butterfield, San Francisco, California.
BEA	Bearnes' auction, Torquay (Devon), Great Britain.
BON	Bonham's, Montpelier, London, Great Britain.
BUK	Bukowskis of Malmö & Stockholm, Sweden.
CH	Christie's, (Christie, Mason & Woods, Ltd.), auction galleries, New York City.
CHE	Christie's, (Christie, Mason & Woods, Ltd.), auction galleries, New York City.
CH(AMS)	Christie's, (Christie, Mason & Woods, Ltd.), auction galleries, Amsterdam.
CH(AUS)	Christie's, (Christie, Mason & Woods, Ltd.), auction galleries, Australia.
CH(GEN)	Christie's, (Christie, Mason & Woods, Ltd.), auction galleries, Geneva.
CH(LON)	Christie's, (Christie, Mason & Woods, Ltd.), auction galleries, London.
CH(MON)	Christie's, (Christie, Mason & Woods, Ltd.), auction galleries, Monaco.
CH(R)	Christie's, (Christie, Mason & Woods, Ltd.), auction galleries, Rome.
CH(SK)	Christie's, (Christie, Mason & Woods, Ltd.), auction galleries, South Kensington, London.
D	Dictionary of Artists in America 1564–1860, The New York Historical Society's George C. Groce and David H. Wallace, Yale University Press, New Haven & London, 1969.
DAV	Davenport's Art Reference & Price Guide, Ray J. Davenport, Folsom, CA. Note: DAV93 may also be referred to DAV94.
DEL	Delorme auction, Paris, France.
DOB	Dobiaschofsky Auktionen AG, Bern, Switzerland.
DOL	Auktionsgalerie Dolezal, Zurich, Switzerland.
DOR	Doretheum Kunstabteilung, Vienna, Austria.
DRE	Dreweatt-Neate, Donnington, Great Britain.
DRO	Drouot-Estimations, Paris, France.
DU	DuMouchelle Art Galleries, Detroit, MI.

F	Mantle Fielding's Dictionary of American Painters, Sculptors & Engravers, Apollo Books, Poughkeepsie, NY, 1983 and/or revised edition 1988.
FA	Freeman/Fine Arts auction galleries, Philadelphia, PA.
FAL	Falkkloo's Auktioner, Malmö, Sweden.
FIN(M)	Finarte auction, Milan, Italy.
FIN(R)	Finarte auction, Rome, Italy.
FIS	Galerie Fischer, Luzern, Switzerland.
FR	Samuel T. Freeman auction galleries, merged in 1988, presently Freeman/Fine arts auction galleries, Philadelphia, PA.
GER	Galerie Gerda Bassenge, Berlin, Germany.
H	Index to Artistic Biography, volumes I & II, 1973, Supplement, 1981, Patricia Pate Havlice, Scarecrow Press, Metuchen, NJ.
I	Biographical Index of American Artists, Ralph Clifton Smith, Garnier & Co., Charleston, SC, 1967.
JUR	Galerie Jurg Stuker AG, Bern, Switzerland.
KAR	Karl & Faber auctions, Munich, Germany.
KLI	D. M. Klinger Auctions, Nürnberg, Germany.
KOL	Galerie Koller, Zurich, Switzerland.
LEM	Kunsthaus Lempertz, Cologne, Germany.
LH	Leslie Hindman Auctioneers, Chicago, IL.
LIB	Libert, Castor auctions, Paris, France.
M	Mallett's Index of Artists, international-biographical, Daniel Trowbridge Mallett, R. R. Bowker, Co., New York, with Supplement, both reprinted 1948.
MIL	Millon, Robert auctions, Paris, France.
NAG	Nagel Kunstauktionshaus, Stuttgart, Germany.
PH	Phillip's, auction galleries, New York City; closed as of late 1988, office retained.
PH(LON)	Phillip's, auction galleries, London, Great Britain.
PH(MAR)	Phillip's Marylebone, auction rooms, London, Great Britain.
PH(SCO)	Phillip's, auction galleries, Scotland, Great Britain.
PH(T)	Phillip's, auction galleries, Toronto, Canada.
R	The Renaissance Print 1470–1550. David Landau & Peter Parshall, Yale University Press, New Haven & London, 1994.
RAS	Rasmussen Stockholm, auction galleries, Stockholm, Sweden.
RB	Richard Bourne, auction galleries, Hyannis, MA. (recently closed)
SEM	Franco Semenzato Casa d'Aste, auction galleries, Venice, Italy.
SK	Robert W. Skinner, Inc., auction galleries, Boston, MA.
SOT	Sotheby's, auction galleries, New York City.
SOT(AMS)	Sotheby's, auction galleries, Amsterdam, The Netherlands.
SOT(ARC)	Sotheby's, auction galleries, New York City.

SOT(B)	Sotheby's, auction galleries, Billinghurst (Sussex), Great Britain.
SOT(F)	Sotheby's, auction galleries, Florence, Italy.
SOT(LON)	Sotheby's, auction galleries, London, Great Britain.
SOT(MAD)	Sotheby's, auction galleries, Madrid, Spain.
SOT(MIL)	Sotheby's, auction galleries, Milan, Italy.
SOT(MON)	Sotheby's, auction galleries, Monaco.
SOT(MUN)	Sotheby's, auction galleries, Munich, Germany.
SOT(SUS)	Sotheby's, auction galleries, Sussex, Great Britain.
SOT(T)	Sotheby's, auction galleries, Toronto, Canada.
SOT(Z)	Sotheby's, auction galleries, Zurich, Switzerland.
STU	Galerie Jurg Stuker AG, Bern, Switzerland.
TB	Thieme, U., and Becker, F., Allgemeines Lexikon der bildenden Kunstler von der Antike bis zur Gegenwart, volumes 1 to 37, 1907–1950.
WD	William Doyle, auction galleries, New York City.
WES	Weschler, auction galleries, Washington, D. C.
WIE	Wiener Kunst Auktionen, Vienna, Austria.
WIN	Arno Winterberg, auction galleries, Heidelberg, Germany.
ZEL	Auktionhaus Michael Zeller, Lindau, Germany.

ABBOTT, John White,
English 1763-1851,
B,H,M,TB,DAV93,
CH(LON)7/14/92,
SOT(LON)11/19/92

<(FROM PEN & INK DRAWING)

NOTE: CH(LON)7/14/92 SALE PICTURED 32 WORKS BY ABBOTT

ADAM, Albrecht,
German 1786-1882,
B,H,M,TB,DAV93,
CH2/25/88,CHE10/29/92,
SOT(MUN)6/22/93

ADAM, Heinrich,
German 1787-1862,
B,H,M,TB,DAV93,
CH(LON)11/27/87,
AUD11/19/92

ADAM, Lambert Sigisbert,
French 1700-1759,
B,H,M,TB,DAV93,SOT(MON)
12/5/92,SOT1/10/95

<(from chalk drawing)

FROM DRAWING OF RED CHALK,
HEIGHTENED WITH WHITE CHALK >
ON BLUE PAPER

ADRIAENSSEN, Alexander,
Flemish 1587-1661,
B,H,DAV93,SOT(LON)
7/3/91,SOT(MIL)5/18/93,
WIE4/20/94

(ADRIEANSSEN is correct in signature)

AELST, Evert van,
Dutch 1626/27-1683,
B,H,M,TB,DAV94,
SOT(AMS)5/10/94

AELST, Willem van,
Dutch 1626/27-1683
B,H,M,TB,DAV93,
CH(AMS)5/7/92

(1677)

1674

AGASSE, Jacques Laurent, Swiss 1767-1848/49, B,H,M,TB,DAV93,CH(LON) 7/15/88&7/9/93,SOT6/5/92	*J.L.A.* *Agasse*
AGLIO, Andrea Salvatore, Italian 1736-1786, B,H,CHE5/30/90	*S.Aglio* <(signature from drawing of pen & brown ink, brown wash, heightened with white on light brown paper)
AGRICOLA, Karl Josef, German 1779-1852, B,H,TB,DAV93, WIE4/20/94,CH(AMS)4/21/94	*AB* *Agricola.ft.* *1824*
ALBERTI, Carl, German 1800- , B,DAV93,BB10/8/80, LH?12/13/92	*C.Alberti* *C.Alberti*
ALDEGREVER, Heinrich, German 1502-c.1560, B,H,M,TB,DAV93, CH5/14/91,WIN10/9/92	*AG* <(monogram from engraving)
ALEXANDER, William, English 1767-1816, B,H,M,DAV93,SOT(LON) 3/10/88&11/19/92&4/1/93	*WA* <(initials from watercolor over pencil, heightened with body- color) *WA* *W.Alexander f.1799* < SIGNATURE FROM WATERCOLOR
ALFARO, Jose, Mexican 18th century, B,DAV93	*Jose Alfaro 1787.*

ALKEN, Henry Thomas, English 1785-1851, B,H,M,DAV93,SOT6/8/90& 6/5/92&6/4/93	H.ALKEN H.ALKEN H.Alken. H Alken <(SIGNATURE FROM WATERCOLOR OVER PENCIL)
ALKEN, Samuel, English 1750-1815/25, B,H,M,TB,DAV93, SOT(LON)2/28/90, SOT6/5/92	S·Alken Junr Sam Alken Junr 1812
ALLAN, (Sir) William, Scot 1782-1950, B,H,M,DAV94,CH10/29/92, CH(LON)7/13/93	William Allan
ALLSTON, Washington, American 1779-1843, B,D,F,H,I,M,TB,DAV93, CH4/12/85,SOT(LON)4/6/93	W.Allston
ALT, Jacob, German 1789-1872, B,H,DAV93,CH(LON)10/9/87& 5/20/93&11/17/94	Alt Jac. Alt $\frac{1818}{69}$ (SIGNATURE FROM WATERCOLOR) SIGNATURE FROM WATERCOLOR > J.Alt.
ALTDORFER, Albrecht, German c.1480-1538, B,H,DAV94,CH(LON)7/1/94	<MONOGRAMS FROM FROM ENGRAVINGS c. 1515 ALDORFER is correct > Aldorfer SIGNATURE FROM WOODCUT
ALZIBAR, Jose de, Mexican ac.1730-1806, SOT11/16/94	Joseph de Alzibar
AMMAN, Jost, German 1539-1591, B,H,M,R,DAV93, SOT1/13/88,CH(LON)12/1/92	IA 1556 < SIGNATURE FROM DRAWING OF PEN & BLACK INK, PARTIAL GREY WASH. .IA. < MONOGRAMS FROM WOODCUTS > JA

AMOROSI, Antonio Mercurio,
Italian 1660-1738,
B,H,DAV93,SOT10/8/93,
CH12/11/92&10/7/93

AMSLER, Samuel,
Swiss 1791-1849,
B,M

ANDERSON, William,
English 1757-1837,
B,H,M,TB,DAV93,
CH(LON)5/17/90,SOT6/7/91

W·A
1802

W·Anderson
1796

*(signature from watercolor
over pen & black ink)*

ANGERMEYER, Johann Adalbert,
Czechoslovakian 1674-1740,
B,H,DAV93,CH1/14/93

I.A.ANGERMEYER ⟨(oil on metal)
F: AO: 1733:

Note: Angermeyer is known to cover parts of his
signature with objects in his paintings.

ANGILLIS (or ANGELIS), Pieter,
or Pierre
French 1685-1734,
B,H,M,TB,DAV93,
SOT(AMS)5/22/90,SOT5/20/93,
CH(LON)7/9/93

P. Angellesi.

ANNA, Alessandro d',
Italian 18th century,
B,H,SOT(MIL)5/21/91,
SOT(ARC)1/20/93

Alessandro d'anna
1782

Alessandro d'Anna ‹ FROM GOUACHE

ANONYMOUS A J,
English?/French? c.1800,
SOT(LON)4/18/94

 ‹ FROM DRAWING OF PEN, BROWN
INK AND WATERCOLOR.

ANONYMOUS D M,
Continental ac. early 19th century,
SOT 10/12/94

D.M 1827

ANTHONISSEN, Arnoldus van,
Dutch 1630-1703,
B,SOT(LON)7/3/91

A.A.

ANTOLINEZ, Jose,
Spanish 1635/39-1675/76,
B,H,M,TB,DAV93,
SOT(LON)2/8/93

ANTOLN

APPIANI, Andrea,
Italian 1754-1817,
B,H,M,TB,DAV93,
CH(LON)12/6/88,FIN5/13/93,
SOT(LON)12/7/94

App.

ARAGO, Jacques Etienne Victor,
French 1790-1855,
B,H,DAV94,CH(LON)7/16/93&
7/15/94&7/17/94

J^s Arago fecit. < SIGNATURE FROM A PENCIL.
PEN & INK DRAWING

J.. Arago fecit 1820. < SIGNATURE
FROM GOUACHE

ARCIMBOLDO, Giuseppe,
Italian 1527-1593,
B,H,M,TB,DAV93,
CH(LON)12/10/93

Giuseppe Arcimbol __

Josephus Arcimboldus

Josephus Arcimboldus

ARDEMANS, Teodoro,
Spanish 1664-1726,
B,H,CH1/11/94

FROM ARCHITECTURAL DRAWING OF BLACK CHALK, PEN &
& BROWN INK, GREY & PINK WASH.

ARELLANO, (Family),
Mexican ac.1690-1720,
SOT5/18/93

(PROMINENT FAMILY STUDIO IN MEXICO FROM 1692-1721.
LARGE SCALE PAINTINGS WERE PRODUCED COLLECTIVELY
BY FAMILY MEMBERS AND SIGNED WITH THE FAMILY NAME)

ARELLANO, Juan de,
Spanish 1614-1676,
B,H,M,DAV93,
SOT1/11/90&1/15/83,
CH(LON)7/9/93

ARENDS, Jan,
Dutch 1738-1805,
B,DAV93,CH(AMS)11/14/88),
SOT(ARC)7/17/91

(from drawing: pencil, pen & black ink,
grey wash, brown ink framing lines)

ARENTSZ, Arent (called CABEL),
Dutch 1586-1635,
B,H,M,DAV93,SOT(AMS)11/11/92

ARLAUD-JURINE, Louis Ami,
Swiss 1751-1829,
B,H,DAV93,PH(LON)7/2/90,
SOT(LON)11/26/92

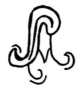

<(initials from drawing of
pen & ink & watercolor)

ARLES, Jean Henry d', French 1734-1784 , H,DAV94,SOT5/20/93, CH(MON)6/19/94	*J. henry D'arles f 1768*
ARMAND, A., French? early 19th century, CH1/13/93	*A A.* <(black lead, pen & brown ink & brown wash)
ARNOLD, George, English ac.1770-1780, B,DAV93,SOT6/5/86	*Geo. Arnold*
ARRIAGA, Juan Antonio, Spanish? 18th century, DAV94,CH1/10/91, CHE1/10/91	*Juan Ant.º Arriaga 1735*
ARRIETA, Pedro de, Mexican 17/18th century, CH5/15/91	*Arrieta. pinx*
ARTHOIS, Jacuqes s', Flemish 1613-1686, B,H,M,TB,DAV93, SOT(LON)4/21/93, CH(AMS)5/6/93	*Jaques Arthois* <(attributed) (no C in Jacques) *Jaeques d'Arthois* *Jacd Arthois*
ASCH, Pieter Jansz. van, Dutch 1603-1678, B,H,M,DAV93,CH5/21/92, CH(AMS)11/18/93	*PA*

ASCIONE, Aniello,
Italian ac. 17-18th century,
B,H,M,DAV93,SOT10/11/90,
SOT(MON)7/2/93

ASSELIJN (or ASSELYN), Jan,
Dutch 1610-1652,
B,H,M,DAV93,SOT(AMS)
11/21/89,SOT(MON)6/22/91,
SOT(LON)4/21/93

<(grey ink)

<(grey wash over black chalk)

A.1647

JA

ASSERETI, G. vo,
Italian 18th century,
DAV93,SOT4/11/91

G.vo
Assereti

ASSERETO, Gioacchino,
Italian 1600-1649,
B,H,M,DAV94,SOT(LON)10/28/92&
4/20/94

G·A·

ASSTEYN, Bartholomeus,
Dutch 1607-1667,
B?,H,DAV93,PH(LON)7/4/89,
SOT(AMS)5/12/92&11/16/93

B.Assteyn
1644

B.Assteyn
1655

<(from watercolor
heightened with white)

B.Assteyn. 1660.

AST, Balthasar Van Der,
Dutch 1590/93-1657,
B,H,DAV93,CH(MON)12/4/94,
CH(LON)12/10/93,SOT(LON)
12/7/94

·Balthasar·vander·ast·

·B·vander·Ast· B·V·A

B.V.Ast.

ATKINS, Samuel,
English ac.1787-1808,
B,H,M,TB,DAV93,
WES12/8/90,SOT(LON)11/19/92

Atkins <(signature from watercolor)

ATKINSON, (Rev.) Christopher,
English 1754-1795,
DAV94,CH(LON)3/22/89&
3/16/93

C A pinx^t
1756
< FROM DRAWING OF PENCIL &
WATERCOLOR, HEIGHTENED
WITH WHITE & GUM ARABIC.

AUDUBON, John James,
American 1785-1851,
A,B,D,F,H,I,M,TB,DAV93,
CH1/26/91,SOT5/27/93

J. J. Audubon

John J. Audubon

AUSTIN, Samuel,
English 1796-1834,
B,H,M,DAV94,CH(LON)7/14/92&
11/9/93

AUSTIN 1827
FROM PENCIL & WATERCOLOR WITH SCRATCHING OUT.

AVERCAMP, Barent,
Dutch 1612/13-1679,
B,H,DAV93,CH1/11/91,
CH(LON)7/9/93,
SOT(LON)12/7/94

BAvercamp *Avercamp*

AVERCAMP, Hendrik,
Dutch 1585-1634,
B,H,M,TB,DAV93,
CH1/15/88,SOT(ARC)1/20/93

BACCIGALUPPO, Giuseppe,
Italian 1744-1812/21,
B,DAV93,SOT(MON)6/22/91

VUE DU PORT GENES
PEINT PAR *JOSEPH BA*
CIGALUPO ANMDCCCVIII

<(one C in signature)
<(one P in signature)

BACHELIER, Jean Jacques,
French 1724-1806,
B,H,M,TB,DAV93,
SOT(MON)6/15/90,
SOT1/15/93

Bachelier.
1758.

BACK, (Admiral Sir) George,
British 1796-1875 ,
H,DAV93,CH(SK)11/15/90

Back. 1823 <(signature from varnished
watercolor)
(Sir Back accompanied Captain John Franklin on his
Canadian Artic expedition in the years 1819-1822)

BACKER, Adriaen,
Dutch 1635/36-1684,
B,H,CH(LON)12/10/93

Barker fecit 1671

BACLER d'ALBE, Louis Albert Guillain,
French 1761-1848,
B,H,M,TB,DAV93,SOT(MON)
6/22/91

Albe
1785

BADGER, Thomas,
American 1792-1868,
B,D,F,I,M,TB,DAV93

Thomas Badger

BAEDENS (or BADENS), Franciscus,
Flemish 1571-1618,
B,H

Baedens
Roma
1595

BAEN (or BAANE), Jan de,
Dutch 1633-1702,
B,H,M,TB,DAV93,
SOT(F)11/28/88,
CH(AMS)5/6/93

J de Baen. f
1664

Johan de Baane f.

BAGLIONE, Giovanni,
Italian 1571-1644,
B,H,DAV94,CH(LON)
7/2/91,SOT(LON)
10/26/94

IOANNES·BAGLIONVS

BAGUERO, Juan,
Spanish 18th century,
DAV93,SOT(MON)
6/22/91

Juan Baguero <(signature from pen
and watercolor)

BAILLIE, (Captain) William,
English/Irish? 1723-1792,
B,H,CH(LON)6/30/94

HBaillie

WILLIAM BAILLIE
(SIGNATURE FROM ENGRAVING)

BAILLIO, R.,
French ac. 1790-1810,
SOT(ARC)7/16/92&
1/19/95

R."BAILLIO <(SIGNATURE FROM
PENCIL DRAWING)

BAILLY, David,
Dutch 1584-1657,
B,H,M,TB,DAV93,
SOT(AMS)11/16/93

A°. 1624.

D.Bailly. fe.

BAKHUYZEN (or SANDE BAKHUYZEN),
Hendricus van de Sande,
Dutch 1795-1860
B,H,M,TB,DAV93, CH(AMS)
4/24/91,SOT(ARC)1/20/93

S·Bakhuyzen
48

HvdSandeBakhuyzen

BAKHUYZEN, Ludolf,
Dutch 1631-1708,
B,H,M,TB,DAV94,
CH10/7/93&10/6/94

L. BAKH. L·BAK

LUD BA LB

L.Back < FROM DRAWING OF BLACK
CHALK AND GREY WASH

BALDINI, (Fra) Tiburzio,
Italian ac.1611-1614,
B,H,DAV93,SOT(LON)
10/18/89

**PRATER
TIBVRTIVS
BALDINVS**

BALDUNG GRIEN, Hans,
German 1484-1545,
B,H,M,TB,DAV93,
CH(LON)7/5/91,
SOT5/13/93

IGB <(signature from drawing)

1520

BALEN, Matthys,
Flemish 1684-1766,
B,H,DAV94,PH(LON)
10/29/91,CH(AMS)
11/17/94

M.Balen

BALLY (or BAILLY), Alexandre,
French 1764-1835,
B,Parke Bernet-New York
1/13/78

Bally
1811

BANCHI, Giorgio,
Italian 1789-1853,
H,DAV93,SOT10/26/90

Banchi <(signature from gouache)

BANDINELLI, Bartolommeo
(called BACCIO),
Italian 1493-1560,
B,H,M,TB,DAV93,
CH(LON)7/2/91&7/7/92

*Baccio
Bandinelli* <(attributed)

BARAT, Pierre Martin,
French ac. 1st half 18th
century,
B,DAV93,SOT(AMS)
5/7/93

*Barat pinx
1776*

BARBIERE, Domenico del,
Italian 1506-1565/75,
H,M,TB,DAV93,SOT2/27/88

**DOMENICO-
DELBARBIERE.** (signature in engraving,
circa 1540-45)

BARBIERS, Pieter Pietersz.,
Dutch 1749-1842,
B,DAV93,SOT(LON)
7/5/93,SOT1/12/95

P. Barbiers < SIGNATURE FROM DRAWING OF PEN AND BROWN INK AND WATERCOLOR

BARDWELL, Thomas,
English 1704-1764/80,
B,H,M,TB,DAV93,
SOT(LON)5/27/87,
CH1/12/94

Bardwell f.1767

BARENGER, James, Jr.,
English 1780-1831,
B,H,M,DAV93,PH(LON)
11/13/90,SOT(LON)
11/18/92

J. Barenger *J. Barenger. 1811*

BARLOW, Francis,
English 1626-1702,
B,H,M,TB,DAV93,
CH6/5/93

Fra: Barlow <(SIGNATURE FROM ETCHING)

BARRABAN(D), Jacques,
French 1767/68-1809,
B,M,TB,DAV93,
CH(LON)7/7/92,
SOT1/12/94

Barraband. fecit.

(SIGNATURE FROM WATERCOLOR WITH PENCIL & BODYCOLOR)

BARRET, George, Jr.,
English 1767-1842,
B,H,M,DAV94,CH(LON)
11/9/93&7/12/94

G B 1833 < FROM PENCIL & WATERCOLOR, HEIGHTENED WITH GUM ARABIC.

FROM PENCIL & WATERCOLOR > WITH SCRATCHING OUT. *G. Barret 1831*

G. Barret < SIGNATURE FROM PENCIL & WATERCOLOR, HEIGHTENED WITH BODYCOLOR & GUM ARABIC

BARRIERE DE MARSEILLE, Dominique,
French 1610-1678,
B,H,DAV93,CH(MON)
6/20/92

BD feci <(SIGNATURE FROM DRAWING OF BLACK CHALK, PEN, BROWN & BLACK INK)

BARTHOLOMEW, Valentine, English 1799–1879, B,H,DAV93,CH(SK) 1/31/89	VBartholomew 1843. <(signature from a pencil & watercolor heightened with white)
BARTOLOZZI, Francesco, Italian 1725/27–1815, B,H,M,TB,DAV93, PH(LON)4/9/91, CH1/11/94	F. Bartolozzi <(SIGNATURE FROM ENGRAVING)
BARTSCH, Adam Von, Austrian 1757–1821, B,H,M,TB,DAV93, BASS6/4/93	AB
BAYRE, Antoine Louis, French 1796–1875, B,H,M,TB,DAV93, SOT10/24/89& 6/5/92&5/26/93	BARYE
BASEROY, Andries van, Flemish ac. early/mid 17th century, SOT(AMS)11/17/93	XB 1639
BASOLI, Antonio, Italian 1774–1848, B,H,DAV93,CH1/11/94	a: Basoli 1845 FROM ARCHITECTURAL DRAWING OF BLACK CHALK, PEN & BROWN INK, WITH PENCIL ON YELLOW PAPER.
BATONI, Pompeo, Italian 1708–1787, B,H,M,TB,DAV93, CH(MON)12/7/90, SOT(LON)7/3/91, SOT1/14/94	P.BATONI 1764 PB (ALSO SIGNS WORK Pompeo de Batoni)
BATTEM, Gerrit, Dutch c.1636–1684, B,H,M,TB,DAV93, CH(AMS)11/25/92, CH(LON)7/9/93, SOT1/12/95	Battem (from watercolor with bodycolor & black ink)

BATTISTA, di Giovanni, Italian ac.1432-1458, B,H,M,R	I · B < INITIALS FROM ENGRAVING
BAUER (or BAUR), Johann Wilhelm, French 1607-1640/41, B,H,M,TB,DAV93, SOT(LON)7/6/92, SOT1/12/94	Jo: WBaüer: Fecit <(FROM DRAWING OF PEN & 1637 GREY INK ON VELLUM) GOUACHE ON VELLUM > Wilh: Baür: Pinxitt. 1638
BAUGIN, Lubin, French c.1610-1663, B,H,M,TB,DAV93, PH(LON)4/18/89	Baugin
BAYNE, Walter McPherson, American 1795-1859, B,D,DAV93,SOT(ARC) 3/31/93	WM'Mayne
BAZZI, Giovanni Antonio (called SODOMA), Italian 1477-1549, B,H,M,DAV93, SOT(LON)4/20/88	**SODON**
BEACH, Thomas, English 1738-1806, B,H,M,DAV94, SOT7/22/93,CH10/6/94	TBeach pinxt 1783
BEALE, Mary, English 1632-1697, B,H,M,DAV93,PH(LON) 12/13/88,CH5/31/91, SOT(LON)6/10/93	Maria Beale
BEATRIZET, Nicolaus, French 1515-after 1565, B,H,M,R,TB,DAV94, CH(LON)7/2/92, KOL10/11/92	·NB· < MONOGRAM FROM ENGRAVING

BECCAMFUMI, Domenico,
Italian 1486-1551,
B,H,DAV93,CH5/21/92,
CH(MON)7/2/93

BECK, Jacob Samuel,
German 1715-1778,
B,DAV93,CH(AMS)
6/12/90,CH1/11/91,
SOT(LON)10/28/92

BEELD(E)MAKER, Adriaen Cornelisz.,
Dutch c.1618-1709,
B,H,DAV93,SOT(MON)
6/22/91,CH5/21/92,
CH(AMS)11/10/92

BEELT, Cornelis,
Dutch c.1600-before 1702,
B,H,M,DAV93,PH(LON)
4/16/91,CH10/7/93

BEERSTRAATEN, Jan Abrahamsz.,
Dutch 1622-1666,
B,H,M,TB,DAV93,
CH(AMS)5/7/92,SOT(LON)
7/6/92,SOT1/12/95

< FROM DRAWING OF BLACK
CHALK AND GREY WASH

BEERT, Osias I,
Flemish 1570-1624,
B,H,DAV93,SOT(MON)
6/17/88,CH12/11/92,
CH(AMS)5/11/94

(SIGNED?, STRENGTHENED?,CH(AMS)5/11/94)

BEGA, Cornelis Pietersz.,
Dutch 1620-1664,
B,H,M,TB,DAV93,
SOT(MON)6/15/90,
CH12/11/92,SOT(AMS)
11/17/93

BEGAS, Karl Joseph,
German 1794-1854,
B,H,M,TB,DAV94,
ADE11/27/92,
KAR12/1/92

BEGEYN (or BEGA), Abraham Jansz.,
Dutch 1637-1697,
B,H,M,TB,DAV93,
SOT(AMS)5/22/90,
CH(LON)3/23/93&7/9/93

BEHAM, Hans Sebald,
German 1500-1550,
B,H,M,R,TB,DAV93,
SOT2/27/88&1/13/93,
CH5/14/91

<(monograms from
engravings,
circa 1540)

BEIJER (or BEYER), Jan de,
Swiss 1703-1780,
B,H,DAV93,CH(AMS)
11/20/89,SOT(LON)
12/14/92

<(pencil, pen & grey & brown ink,
watercolor, black ink framing lines)

BEKE, L. van,
Dutch? 17th century,
SOT1/14/94

BELANGER, Francois Joseph,
French 1744-1818,
B,H,DAV93,CH1/11/94

FROM ARCHITECTURAL DRAWING OF BLACK CHALK,
PEN & BLACK INK, AND GREY WASH.

BELANGER, Louis,
French 1736-1816,
B,H,M,DAV93,
CH(MON12/7/90

<(signature from drawing of
black chalk, pen & brown ink,
brown wash with watercolor)

BELLANGE, Jacques,
French 1575-1616,
B,H,M,DAV93,
SOT1/16/86,
CH5/14/91,SOT(LON)
6/29/93

(signatures from etchings)

BELLEVOIS, Jacob Adriaensz.,
Dutch 1621-1675,
B,H,DAV94,SOT1/7/92,
SOT(LON)7/7/93

BELLINI, Giovanni
(Studio of),
Italian 1430-1516,
B,H,M,TB,DAV93,
CH1/11/91

IOANNES·BELLINVS·P.'

BELLOTTO, Bernardo,
Italian 1720/24-1780,
B,H,M,TB,DAV93,
CH(MON)6/22/91,
CH5/19/93,SOT1/13/94

BEMMEL (or BEMEL), Johann Christoph von, German -1778, B,DAV93,SOT5/22/92	*C.v. Bemel*
BEMMEL (or BEMEL), Pieter van, German 1685-1754, B,H,DAV93,SOT(LON) 6/27/88,SOT(AMS) 5/12/92	*P.V. Bemel fe.* (signature from etching)
BENEDETTI, Andrea, Flemish 1615/80-after 1649, B,H,DAV93,SOT6/1/90, CH(LON)3/23/93	*A. benedetti f.*
BENITES, ?, Latin American/Mexican? 18th century, SOT5/19/93	*Benites*
BERCHEM, Nicolaes Claesz., Dutch 1620-1683, B,H,M,TB,DAV93, CH4/6/89,SOT5/22/92& 5/20/93	*ABerch 112 1679* NB *Berchem Berghem* *Berghemf*
BERCKHEYDE, Gerrit Adriaensz., Dutch 1638-1698, B,H,M,TB,DAV93, PH(LON)7/2/90, SOT5/20/93	*G.B.* <(initials from drawing of red chalk & grey wash) *gerrit BerckHeyde*

BERENTS, J. (Jacob?),
Dutch c.1679-1723/48,
DAV94,SOT(AMS)
5/10/94

FROM GOUACHE ON VELLUM.

BERGH, Gillis Gillisz. de,
Dutch c.1600-1669,
H,DAV93?,CH10/15/92

BERGLER, Joseph, Jr.,
Austrian 1753-1829,
B,H,DAV93,
CH1/14/86

BERJON, Antoine,
French 1754-1843,
B,H,M,DAV93,
SOT1/13/93,SOT(MON)
7/2/93,SOT(ARC)
7/22/93

(black chalk & watercolor,
heightened with gouache)

BERNARD, Jean Joseph
(called Bernard De PARIS),
French 1740-1809,
H,DAV93,SOT(ARC)
1/17/90

(signature from drawing of pen,
black & brown ink, & watercolor)

BERTHELEMY, Jean Simon,
French 1743-1811,
B,H,DAV93,CH(LON)
7/2/91,CH(MON)7/2/93

SIGNATURE FROM DRAWING
OF RED CHALK >

BERTIN, Jean Victor, French 1775-1842, B,H,M,TB,DAV93, CH10/29/86,SOT(MON) 12/5/92,CH(MON) 7/3/93	*Bertin* *I.V. Bertin*
BESCHEY, Balthasar, Flemish 1708-1776, B,H,M,TB,DAV93, CH(MON)6/16/89,SOT(MON) 6/22/91,CH(AMS)11/18/93	*Beschey* *Balt Bescheyf.* *B. bescheij* *B. beschy* beschy *ÿ* is correct
BESCHEY, Jacob Andries, Flemish 1710-1786, B,H,M,DAV94,SOT(LON) 10/30/91&10/26/94	*J. Beschey*
BESSA, Pancrace, French 1772-1835, B,H,DAV93, SOT10/26/90, CH(LON)12/15/92	*P. Bessa.* (signature from watercolor on vellum)
BEST, John, English ac.1750-1792, B,H?,DAV93, CH6/5/93	*John Best*
BETTINI, Antonio Sebastiano, Italian 1707-after 1774, B,H,SOT(LON)10/26/94	ANT.BETTINI. (1745)
BEWICK, Thomas, English 1753-1828, A,B,H,M,DAV93	**B**

BEYEREN, Abraham van,
Dutch 1620-1675/90,
B,H,M,DAV93,SOT(LON)
6/4/90,CH1/11/91,
CH(LON)7/10/92

AB.f *&* < ATTRIBUTED SYMBOL/MONO

BIARD, Francois Auguste,
French 1799-1882,
B,H,DAV93,BB11/7/90,
SOT5/26/93

Biard *Biard*

BIDAULD, Jean Joseph Xavier,
French 1758-1846,
B,H,M,TB,DAV94,
SOT1/20/93,CH(MON)
6/19/94

J. Bidauld
1839

BILCOQ, Marie Marc Antoine,
French 1755-1838,
B,H,M,TB,DAV93,
CH(MON)6/15/90,
SOT10/14/92&5/20/93

A. Bilcoq. 1788

BILTIUS, Cornelis,
Dutch 1653- ,
B,H,DAV93,DOY
5/24/89

C Biltius fecit
1664

BILTIUS, Jacobus,
Dutch 1633-1676,
B,H,DAV93,CH5/31/90&
11/13/90,CH(AMS)
5/7/92

J: Biltius *J: Biltius fecit*
1678
J: Biltius fecit
1670

BIMBI, Bartolomeo,
Italian 1648-c.1725,
B,H,DAV93,
SOT1/14/94

B. Bimbi 1720

BINOIT, Peter,
German c.1590-1632,
B,H,DAV93,SOT(LON)
4/1/92

PB

BIRCH, Thomas,
American 1779-1851,
B,D,F,H,I,M,TB,DAV93,
CH5/25/89&5/26/93

T. Birch
(1846)

T. Birch

T. Birch
1848

BIRMANN, Peter,
Swiss 1758-1844,
B,DAV93,SOT(Z)
12/1/88,JUR5/20/93

P. Birmann 1805. <(signature from watercolor)

BISCAINO, Bartholomeo,
Italian 1632-1657,
B,H,M,TB,DAV93,
PH(LON)7/2/90,
CH(LON)4/20/93

B. Biscaino

inscription signature from red chalk drawing)

BISON, Giuseppe Berardino,
Italian 1762-1844,
B,H,DAV93,SOT(MIL)
5/17/90,CH1/13/93,
SOT1/10/95

Bison — <(signature from watercolor)

(signature from drawing of black
chalk, pen & brown ink,
and brown wash)> *Bison*

Bison <(signature from drawing of pen &
ink over black chalk)

(from red chalk drawing)> *Bison*

BISSCHOP (or BUSSCHOP),
Abraham,
Dutch 1670-1731,
B,DAV93,SOT(LON)
7/4/90

Busschop f. 1718

BIS(S)CHOP (or EPISCOPIUS),
Jan de,
Dutch 1628-1671,
B,H,M,TB,DAV93,
CH7/2/91,SOT(AMS)
11/16/93,SOT1/10/95

SIGNATURE IN BROWN INK, DRAWING OF RED CHALK AND
BROWN WASH

BISSOLO, Pier Francesco,
Italian c.1470-1554,
B,H,M,TB,DAV93,
SOT4/11/91&1/14/94

(BISOLUS IS CORRECT)

BLAKE, Benjamin,
English 1757-1830,
B,H,M,TB,DAV94,
PH(LON)4/27/93

BLANCHARD, Jacques,
French 1600-1638,
B,H,M,TB,DAV94,
CH(LON)4/15/92&6/10/94,
SOT1/12/95

BLANCHET, Louis Gabriel,
French 1705-1772,
B,H,DAV94,SOT(LON)
10/30/91,CH(LON)
6/10/94,SOT1/10/95

BLANKERHOFF, Jan Theunisz.,
Dutch 1628-1669,
B,H,DAV94,SOT(LON)
10/26/94

\mathcal{B} \mathcal{B}

BLARENBERGHE, Henri Joseph van,
French 1741-1826,
B,H,M,TB,DAV93,
SOT1/8/91,CH3/22/91,
CH(LON)7/9/93

Van Blarenberghe.1776.

(signature from gouache)

BLEKER, Gerrit Claesz.,
Dutch ac.1625-1664,
B,H,DAV93,SOT2/27/88,
CH5/14/91&1/16/92

CBleker f. 1638

(signature from etching)

BLES, Herri Met de
(called CIVETTA),
Flemish 1480-1550,
B,H,M,TB,DAV93,
CH(AMS)11/10/92,
SOT6/1/90&1/14/94

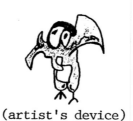 <<(OWL)>> 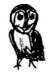

(artist's device) (artist's device)

BLIECK, Daniel de,
Dutch 1620-c.1673,
B,H,DAV93,
CH10/12/89,DOB5/5/93

D.D.BLIECK
1655 ·D·D·B·

D·D·BLIECK INv
A".1654

BLIN (or BELIN or BLAIN)
DE FONTENAY (or FONTENAY),
Jean Baptiste,
French 1653-1715,
B,H,M,TB,DAV93,
SOT1/14/94

Fontenay
1698

BLO, Henry Charles,
French ac. mid 18th century,
B,CH(MON)6/20/92

BLO 1759

BLOCKHAU(W)ER, Harmen,
Dutch? ac.1621,
B,DAV93,SOT(AMS)
11/21/89&5/10/94

Hermen Blockhauwer
1621

FROM DRAWING OF PEN & BROWN INK.

HB <(monogram in brown ink)
(pen & brown ink drawing)

BLOEM, Matthys,
Dutch ac.17th century,
B,H?,DAV93,SOT(MON)
6/15/90&6/22/91

MB:1663

BLOEMAERT, Abraham,
Dutch 1564-1651,
B,H,M,TB,DAV94,
CH1/16/92,SOT(AMS)
5/10/94,SOT1/10/95

A Bloemaert. fe.

FROM DRAWING OF PEN, BROWN INK, WASH OVER BLACK CHALK.

BLOEMAERT (or BLOMMAERT),
Adriaen,
Dutch 1609-1666,
B,H,DAV93,PH(LON)
12/6/88&12/5/89,
CH(AMS)5/7/92

A. Blommaert

A Bloemaert fe.

BLOEMAERT, Cornelis, Jr.,
Dutch 1603-after 1684,
B,H,M,TB,DAV94,
SOT(AMS)5/10/94

C: Bloemaert. fecit.

BLOEMAERT, Hendrick, Dutch 1601-1672, B,H,M,TB,DAV94, SOT1/15/93,SOT(LON) 10/26/94&12/7/94	*Hs. Bloemaert* *HB*
BLOEMEN, Norbert van, Flemish 1670-1746, B,H,DAV93,PH(LON) 7/2/91&3/5/91	**NO.V.B**
BLOEMEN, Pieter van, Flemish 1657-1720, B,H,M,TB,DAV93, CH(MON)6/15/90, CH10/20/88&1/13/93	**P.V.B** *1799*
BLOEMERS, Arnoldus, Dutch 1786-1844, B,H,DAV93,CH5/27/93, SOT(LON)7/5/93, CH(LON)7/9/93	*(monogram)* *(monogram)*
BLOME, Richard, English 17th century, CH6/5/93	*Ric.Blome.* <(SIGNATURE FROM ENGRAVING)
BLOMMAERDT, Maximilian, Flemish 1696/97- , B,H,DAV93,SOT(AMS) 11/14/90,CH12/11/92	*M.B.* *M.Blommaerdt.*
BLONDEL, Merry Joseph, French 1781-1853, B,H,DAV94,CH(MON) 6/19/94	*Blondel 1813*
BLOOT, Pieter de, Dutch c.1601-1658, B,H,M,TB,DAV93, CH5/21/92,CH(AMS) 11/10/92,SOT(AMS) 11/17/93	*P.De.Bloot.* (1639) *PDB*

BLYHOOFT, Zacharias, Dutch ac.1635-1681, B,H,DAV93,CH(AMS) 11/25/92	*Z. Blyhooft f. 1679* (from drawing of pen & brown ink, brown & grey wash)
BLYTH(E), Benjamin, American 1740-after 1788, B,D,F,H,I,M,TB,DAV93	*Beny. Blyth*
BOCK, Hans I, Swiss 1550-1624, B,H?,M,TB,DAV93, CH(AMS)11/12/90, SOT1/14/94	*HB* *HBock* <(attributed signature from drawing of pen & grey ink & grey wash)
BOGAERT (or BOGERT), Hendrik, Dutch 1635-1719, B,DAV93,CH5/31/90, CH(AMS)5/2/91&5/7/92	*HBogert 1649* *HBogert 1649* *HB*
BOGDANI (or BOGDANY), Jacob, Hungarian/English 1660-1724, B,H,M,DAV93,SOT(LON) 4/20/88,PH(LON)12/5/89, CH12/11/92	*J. Bogdani* *J. Bogdani*
BOILLY, Julien or Jules Leopold, French 1796-1874, SOT(MON)7/2/93, CH12/11/92&1/12/94	*Jul. Boilly* *1822* *Jul. BY.*
BOILLY, Louis Leopold, French 1761-1845, B,H,M,TB,DAV93, SOT(MON)7/2/93, CH12/11/92&1/12/94 CONTINUED	*L. Boilly pinx. L. Boilly 1607* *L Boil'ly* *L B.*

BOILLY, Louis Leopold
CONTINUED

L. Boilly L. Boilly

BOISSELIER, Felix,
French 1776-1811,
B,H,DAV94,
SOT10/23/90,CH1/11/95

BOISSELIER F.^t ROMA
1808

BOISSIEU, Jean Jacques,
French 1736-1810,
B,H,M,TB,DAV93,
CH(LON)12/10/93,
CH1/11/94

B. 1782.
FROM DRAWING OF BLACK CHALK

A.1807
J:J:B:

B·1799· < FROM RED CHALK DRAWING

BOL, Ferdinand,
Dutch 1616-1680,
B,H,M,TB,DAV93,
CH1/10/90,CH(AMS)
11/25/92

Bol fecit
1659 FB FB

BOL, Hans,
Dutch 1534-1593,
B,H,M,TB,DAV93,
SOT(AMS)11/21/89,
SOT(LON)6/2/90&
7/6/92,CH1/11/95

Hans bol <(signature in brown ink)
1579 (pen, brown ink & wash drawing)

HB HBol 1589 <(signature from
drawing: pen &
brown ink, grey wash)

Hans Bol < FROM DRAWING OF PEN,
1568 BROWN INK, GREY AND
PURPLE WASH.

BOLLONGIER (or BOULENGIER), Hans, Dutch c.1600–after 1642, B,H,DAV93,PH(LON) 4/10/90,CH(AMS)5/6/93	*Bollongier*
BONASONE, Giulio di Antonio, Italian c.1498–c.1580, B,H,M,DAV93, SOT12/27/88,CH(LON) 12/1/92	**BONASONIS** (signature from engraving, circa 1538–43)
BONE, Henry Pierce, English 1779–1855, B,H,M,DAV94, SOT(LON)7/11/91, SOT5/26/94	*Bone* 1822
BONNET, Louis Martin, French 1736–1793, B,H,M,TB,DAV93, SOT2/27/88,CH(LON) 12/1/92	*Bonnet* 1769 (signature from pastel manner etching and engraving printed in colors)
BORCHT, Pieter van der, Flemish 1614–c.1690, CH5/14/91	VANDER BORCHT 1560 <(signature from engraving)
BORDONE, Paris, Italian 1500–1571, B,H,M,TB,DAV93, CH5/21/91,CH(LON) 7/9/93	·O·PARIS·B·
BOSSCHAERT, Ambrosius, Sr., Flemish 1573–1621, B,H,DAV93,SOT(LON) 4/11/90&7/4/90, ADE12/14/92,CH1/11/95	

BOSSCHAERT, Ambrosius II,
Dutch 1609-1645,
B,H,DAV93,CH(AMS)
11/29/88,SOT(LON)
12/9/92

BOSSCHAERT, Jan Baptiste,
Flemish 1667-1746,
B,H,DAV93,SOT(LON)
7/3/91&7/8/92,CH(MON)
7/3/93

BOSSUET, Francois Antoine,
Belgian 1789/1800-1889,
B,H,M,TB,DAV94,
SOT(LON)3/18/92,
CH5/25/94

BOTH, Andries,
Dutch 1608-1650,
B,H,M,TB,DAV93,
CH(AMS)11/12/90&
11/24/92,SOT(AMS)
11/16/93

(signature from drawing
of pen & brown ink)

BOTTSCHILD, Samuel,
German 1640-1707,
B,H,DAV93,CH1/13/93

(from drawing of black,
red & yellow chalk on
blue paper)

BOUCHARDON, Edme,
French 1698-1762,
B,H,M,TB,DAV93,
CH1/9/91,CH(MON)
7/2/93,SOT1/10/95
CONTINUED

(inscription signature from
a red chalk drawing)

**BOUCHARDON
CONTINUED**

Bouchardon <(signature from sanguine drawing)

Bouchardon

**BOUCHER, Francois,
French 1703-1770,
B,H,M,TB,DAV93,
SOT1/13/93,CH(MON)
7/2/93,CH1/12/94**

f. Boucher. *f. Boucher*

(black, red & white chalk)

Boucher. *F. Boucher*

F. Boucher

f. Boucher
1738

**BOUCHER, Jean,
French 1568/75-1633,
B,DAV93,CH(MON)
12/7/90**

Boucher 1625 *B*

(signature in brown ink) (monogram in red chalk)

(both signature & monogram from red chalk drawing)

**BOUCHOT, Francois,
French 1800-1842,
B,H,M,TB,DAV94,
SOT10/26/90&10/12/94**

F. Bouchot

BOUCKHORST, Jan Philisz. van,
Dutch 1588-1631,
B,DAV93,CH1/9/91,
CH(LON)7/2/91

Iv.Bouchorst 1629.

<(signature from drawing of
pen & brown ink, brown
wash heightened with white)

Blorst 1619

<(B HORST signature from
drawing of pen & brown ink,
brown & grey wash, & white)

BOUCLE (or BOUCK), Pierre
or Peter,
Flemish 1610-1673,
B,DAV93,SOT(MON)
6/15/90&12/5/92

P.V.B. f. an. 1630.

p. Van Boucle
(1667)

BOUL(L)O(N)GNE, Louis
de, Jr.,
French 1654-1733,
B,H,M,TB,DAV93,
CH(MON)6/20/92,
SOT1/12/94&1/10/95

2B *Louis De Boullongne*
(signature from a drawing of black chalk
& stumping, heightened with white chalk,
on blue paper)

LB <(signature from drawing of black &
white chalk on blue paper)

Louis De Boullongne
(signature from drawing of black
chalk with white on blue paper) *1690*

BOULTBEE, John,
English 1753-1812,
B,H,DAV93,SOT6/4/87,
CH6/5/87,PH(LON)
4/27/93

J Boultbee *-Boultbee John*

BOURGEOIS, Charles
Guillaume Alexandre,
French 1759-1832,
B,H,DAV93

Bourgeois-

BOUT, Pieter, Flemish 1658-1702/19, B,H,M,TB,DAV93, SOT(MON)7/2/93, SOT(AMS)11/17/93, SOT1/12/95	*P. Bout*
BOUTTATS, Johann Baptiste, Flemish ac.1706-1735, B,H?,DAV93,SOT(LON) 5/27/87,SOT5/20/93	*JBBouttats*
BOZE, (Count) Joseph, French 1744/45-1825, B,H,M,TB,DAV93, SOT(LON)12/12/90, SOT(MON)6/22/91	*Boze Boze*
BRACKENBURGH (or BRAKENBURG), Richard, Dutch 1650-1702/03, H,M,TB,DAV93, SOT(LON)4/20/88& 4/21/93,CH1/11/95	*R. Brakenburg. 1700*
BRAEKELEER, Ferdinand de, Belgian 1792-1883, B,H,M,TB,DAV93, PH(LON)12/4/89, CH10/30/92	*F De Braekeleer* <(signature from a drawing of sepia wash over black chalk) *Ferdinand De Braekeleer* *Ferdinand De Braekeleer*
BRAMBIL(L)A, Fernando, Italian 18th century, B,SOT(MON)7/2/93	*F. Brambilla*
BRANDI, Gaetano, Italian -1696, B,SOT(LON)12/8/93& 12/7/94	CAETANVS BRANDI *Fecit* (CAETANVS IS CORRECT)

BRANDMULLER, Michael,
Austrian 1793-1852,
B,TB

BM

BRANTZ, A. de,
German? early 19th
century,
DAV93,CH3/22/91

A de Brantz

BRAY, Jan de,
Dutch 1626/27-1697,
B,H,M,TB,DAV93,
CH(AMS)5/6/93,
SOT(AMS)11/17/93

Bray 1662 ‹ SIGNATURE FROM DRAWING OF
PEN, BROWN INK & GREY WASH

BREA, (The Elder),
Italian/French
18th century,
B,M,TB,DAV93

Bréa
major
Pinxit 1750

BREDAEL, Jan Peter Van,
Flemish 1654-1745,
B,H,DAV93,CH(MON)
6/20/92

P. Vanbredael-f

BREDAEL (or BREDA),
Joseph van,
Flemish 1688-1739,
B,H,DAV93,CH(AMS)
11/28/89,PH(LON)
7/2/91,CH5/19/93

JvB J BREDA I B

BREE, Philippe Jacques Van,
Flemish 1786-1871,
B,H,M,TB,DAV93,
SOT10/29/87,CH(LON)
11/18/94

F. VAN BREE P. VAN BREE
(Rome) 1832

BREENBERGH (or BREENBORCH), Bartholomeus, Dutch 1598-1657, B,H,M,TB,DAV93, SOT1/15/93,CH1/12/94, SOT(LON)12/7/94

Breenberg *B Breenborch*

BB < MONOGRAM FROM DRAWING OF PEN, BROWN & BLACK INK, AND BROWN WASH, ALSO FOUND ON OIL PAINTINGS.

FROM DRAWING OF PEN, BROWN INK AND WASH > *BB.f.*

BREKELE(N)KAM, Quiryn Gerritsz. van, Dutch after 1620-1668, B,H,M,TB,DAV93, CH1/12/94,SOT(LON) 10/28/92&5/20/93

Q·B· *Q·Brekelenkam.*

Q·Brekelekam 1665

QvB 1652

Quierijn. 1664

(QUIERYN IS CORRECT)

BRENET, Nicolas Guy, French 1728-1792, B,H,DAV94,SOT(LON) 7/7/93

·B· f⠌ ·1764· *Breneh·N·*

BRENTEL, Friedrich, French 1580-1651, B,H,DAV93,CH(AMS) 11/12/90,SOT(LON) 12/14/92,SOT1/12/94

F. Brentel. <(signature from drawing of bodycolor & gold on vellum)

BREVIERE, Louis Henri, French 1797-1869, A,B,H,TB

Br

BREYDEL, Carel or Karel,
Flemish 1678–1733,
B,H,M,TB,DAV93,
SOT10/15/87,CH10/15/92

C.Breydel *C.Breydel*

BRIL(L), Paul,
Flemish 1554–1626,
B,H,M,TB,DAV93,
SOT1/15/93,CH(LON)
7/9/93,SOT(AMS)
11/17/93

 <(artist's device signature, a pair of spectacles on a shop sign)

P.Bril *·P. BRIL·*

BRISTOW, Edmund,
English 1787–1876,
B,H,M,TB,DAV93,
PH(LON)12/12/89&
4/27/93,SOT6/4/93

E·Bristow

BRIULLOV, Karl Pavlovich,
Russian 1799–1852,
H,DAV93,CH(LON)
10/5/89

CBriulloff. <(signature from drawing of pen & brown ink & wash)

IVI DCCCXXXII

P. Grsserolz

(Cyrillic signature in pencil from drawing of pencil, pen & ink, & black wash)

BROECK, Crispyn van der,
Flemish 1524–1588/91,
B,H,M,TB,DAV93,
CH(AMS)11/25/92,
CH(MON)6/20/94

CVB
1576 <(from drawing of black chalk, pen & brown ink, brown wash heightened with white)

Crispinov 1576 <(CRISPINOV)

FROM DRAWING OF BLACK CHALK, PEN & BROWN INK AND GREY WASH.

BROECK, Elias van den,
Dutch c.1650-1708,
B,H,M,TB,DAV93,
PH(LON)4/16/91,CH(LON)
7/10/92,SOT(LON)12/7/94

BROMLEY, William,
English 1769-1842,
B,H,M,DAV93,
SOT6/5/86

BRONC(K)HORST, Gerrit
or Gerard van,
Dutch c.1603-1673,
B,M,TB,DAV93,
SOT4/7/88

BRONCKHORST, Jan Jansz. van,
Dutch 1627-1656,
B?,DAV93,CH(AMS)
5/2/91

BRON(C)KHORST, Johannes,
Dutch 1648-1726/27,
B,H,DAV93,SOT(LON)
7/5/93,SOT1/12/94

FROM WATERCOLOR AND GOUACHE >

< INITIALS FROM WATERCOLOR &
BODYCOLOR OVER BLACK CHALK

FROM WATERCOLOR AND GOUACHE >

BROSAMER, Hans (called
The Meister HB),
German c.1500-c.1554,
B,H,M,TB,DAV93,
SOT1/11/90,GER12/4/92

BRU(E)GHEL (or BREUGHEL),
Abraham,
Dutch 1631-1690/97,
B,H,M,TB,DAV93,
CH12/11/92,CH(LON)
7/9/93,SOT1/12/95

Brughel

BRUEGHEL, Jan, Sr.,
Flemish 1568-1625,
B,H,M,TB,DAV93,
SOT5/20/93,CH1/12/94

BRVEGHEL
1600

Brueghel
fecit 1616

FROM DRAWING OF PEN & BROWN
INK, BROWN WASH WITH GREY.

BRUEGHEL, Jan, Jr.,
Dutch 1601-1678,
B,H,M,TB,DAV93,
SOT1/15/93,SOT(MON)
7/2/93

I B

Johan. breugel.
1620

FROM DRAWING OF PEN, AND BROWN AND
BLACK INK.

BRUEGHEL, Jan Pieter,
Flemish 1628-1662,
B,H,DAV93,CH(AMS)
11/28/89

I.P.Brueghel

BRUEGHEL, Pieter
(the younger),
Flemish c.1564-1637/38,
B,H,M,TB,DAV93,
CH5/14/93,CH(LON)
12/10/93,SOT1/12/95

P.BREVGHEL·1621

P.BREVGHEL

BRUGMAN, N. L.,
Dutch ac.1778-1785,
B,CH(AMS)5/11/94

N. L. Brugman

(fecit.) 1780

BRUNIAS (or BRUNAIS),
Augustin,
English c.1730-1810,
B,DAV94,CH(LON)
7/15/94

A. Brunias < FROM STIPPLE ENGRAVING

BRUSSEL, Paul Theodor van,
Dutch 1754-1795,
B,H,DAV93,PH(LON)
12/11/90,KOL9/11/92

BRUYERE, (Mme) Elise,
French 1776-1842,
B,H,DAV93,SOT10/13/89

BRUYN, Jacob de,
Dutch 18th century,
DAV93,SOT(AMS)
11/22/89

(Pen, inks & watercolor)

BRUYN, Johannes Cornelis de,
Dutch ac. 1763-1844,
B,H,DAV93,CH10/15/92

BUCK, Adam,
Irish 1759-1833,
B,H,M,TB,DAV93,
SOT(LON)2/29/84,
SOT(B)6/2/93

<(signature from drawing of black
chalk & watercolor over pencil)

BUESEM, Jan Jansz.,
Dutch 1600-1649,
B,H,DAV93,SOT(AMS)
5/22/90

BURCKHARDT, Daniel,
Swiss 1752-1819,
B,SOT(Z)11/28/85

BURGDORFER, David Daniel,
Swiss 1800-1861,
B,DAV93,JUR5/20/93

BURGH, Hendrik van der,
Dutch 1769-1858,
B,M,TB,DAV94,CH(LON)
4/14/92,CH(AMS)4/21/94

H.V.D.Burgh.

BURGKMAIR, Hans, Sr.,
German c.1473-c.1553/59,
B,H,M,R,TB

·H·BVRGKMAIR < SIGNATURE FROM WOODCUT

MONOGRAM FROM ETCHING > H B

BURLER, Gaspar,
Austrian? 18th century,
Parke Bernet - New York
5/30/79

Burler
1735

BUTTERSWORTH, Thomas,
English 1768-1842,
B,H,DAV93,CH(LON)
10/18/90,SOT6/5/92&
6/4/93

J.Buttersworth
(signature from a pencil & watercolor drawing)

TB pint

BYLERT (or BIJLERT),
Jan Harmensz. van,
Dutch 1598-1671,
B,H,M,TB,DAV93,
CH(AMS)5/7/92,
CH(LON)12/10/93,CH1/11/95

HbijLert·fe J.bylert fe

Hbijlert fe

BYS(S), Johann Rudolf,
Swiss 1662-1738,
B,H,M,TB,DAV94,
PH(LON)7/2/91,
CH(AMS)11/17/94

JRBijs

CABEL (or KABEL), Adriaen van der, Dutch 1630/31-1705, B,H,DAV93,SOT(LON) 4/11/90,SOT(MON)7/2/93, SOT(AMS)11/17/93	*AK* (1648) *AC*
CABRAL Y BEJARANO, Antonio, Spanish 1798-1861, B,DAV93,CH(LON) 2/17/89	*Mant C. Bejarano Sev.ʳ 1855.*
CABRERA, Miguel, Mexican 1695-1768, B,H,M,DAV93,CH1/22/89, SOT11/24/92&5/19/93	*Michel Cabrera Anno Domini 1768* (MICHEL IN SIGNATURE IS CORRECT) *Cabrera*
CADES, Giuseppe, Italian 1750-1799, B,H,M,TB,DAV94, SOT(LON)7/3/91,CH(MON) 6/20/94	*G. Cades* (1781) From drawing of black chalk, pen & brown ink & brown watercolor.
CALLANDE DE (and/or CHAMPARTMARTIN), Charles Emile, French 1797-1883, B,M,TB	*E. champmartin*
CALLOT, Jacques, French 1592-1635, B,H,M,TB,DAV93, CH(LON)7/2/91&4/20/93, SOT1/10/95	*Callot f. 1629*
CALVERT, Henry, English 1798- , B,DAV93,PH10/30/87, SOT(LON)11/18/92, CH(LON)11/4/94	*H. Calvert 1854* *H. Calvert 1827*

CAMARON Y BARONAT, Jose,
Spanish 1730–1803,
B,H,SOT(MAD)5/18/93

J. Camaron. ft.

(SIGNATURE FROM DRAWING)

CAMMILLIE, Nicolas,
French ac. 1811–1817,
DAV93,CH(MON)12/7/90

Nicolas Cammillie pinxit 1811

CAMPBELL, (Sir) Archibald,
English 1739–1791,
M,TB,CH(LON)4/12/94

Arch^d Campbell 1763.

SIGNATURE FROM DRAWING OF PEN, BLACK
INK & WATERCOLOR WITH SCRATCHING OUT

CAMPBELL, Tom,
English 1790–1858,
B,M,TB,DAV93,
SOT(GH)8/26/86,
PH(SCO)10/2/92

Tom Campbell *Tom Campbell*

CAMRADT, Johannes Ludvig,
Danish 1779–1849,
B,H,DAV93,SOT5/21/87&
5/26/93

J. L. Camradt 1819

*J. L. Camradt
1840*

CANALETTO (or CANAL),
Antonio,
Italian 1697–1768,
B,H,M,TB,DAV93,
CH(LON)7/9/93,
SOT1/13/94&1/10/95

A. Canal *A. Canal F.*

(FROM ETCHING c.1740)

CANDIDO, Francesco
Saverio,
Italian 18th century,
DAV94,CH(LON)7/9/93

Francesco Candido

CANDIDO, Salvatore,
Italian ac. early 19th
century
DAV94,WD1/24/90,
CH(MON)12/7/91&
6/19/94

*Sal^v. Candido
1827*

CANELLA, Giuseppe,
Italian 1788-1847,
B,H,DAV93,SOT(MIL)
5/17/90,CH(LON)
6/18/93

Canella <(signature from pencil drawing)

Canella 1827 *Canella 1828*

CANINI, Giovanni Angelo,
Italian 1617-1666,
B,H,M,TB,DAV93,
SOT1/13/88,CH5/30/90,
CH(LON)4/16/91

Jo Angto Caninus
Di Gio: Angelo Canini

(both signatures from red chalk drawings, former
drawing heightened with white chalk on beige paper)

CANTARINI, Simone
(called Simone da Pesaro or
IL PESARESE),
Italian 1612-1648,
B,H,M,TB,DAV93,PH(LON)
12/3/90,SOT1/13/93&1/12/95

S.C. da Pesaro fe

(signature from etching printed in sepia)

Sim.r Cantarini da Pesaro

(inscription signature from drawing of pen &
brown ink & brown wash)

CANUTI, Dominico Maria,
Italian 1620-1684,
B,H,DAV93,SOT(LON)
12/14/92,CH(LON)
12/15/92

X. Caruti <(bears signature, pen and brown
ink & red-brown wash)

CAPAGNOLA, Giulio,
Italian 15/16th century,
R

CAPAGNOLA

SIGNATURE FROM ENGRAVING

CAP(P)ELLE, Jan van de,
Dutch 1624/25-1679,
B,H,M,TB,DAV93,SOT(LON)
12/6/89,CH(AMS)11/24/92,
CH(LON)12/10/93

I.V.C.

CARDI, Lorenzo, Italian 17th century, B,DAV93,CHE1/8/90	LORENZO CARDI
CARESME, Jacques Philippe, French 1734-1796, B,H,M,TB,DAV93, CH(MON)7/2/93,CH1/11/94 (Antoine sic)	*ph. Caresme* *1765* FROM DRAWING OF BLACK CHALK & BODYCOLOR.
CARLEVARI(J)S, Luca, Italian 1663-1730, B,H,M,TB,DAV93, SOT(LON)7/3/91,CH(MON) 6/20/92,SOT1/10/95	L·C
CARMICHAEL, James, English 1702-1752, B,H	*JS 1752*
CARMICHAEL, John or James Wilson, English 1800-1868, B,H,M,TB,DAV93, SOT6/8/90&6/5/92, SOT(ARC)1/19/95	*JWCarmichael* *1865* *JWC. 1848*
CARO, Baldassare de, Italian c.1689-1750, B,H,DAV93,FIN5/13/93, CH10/7/93,CH(LON) 12/10/93	*BC* *BCara*
CARON, Jules Achille Le, French ac.1833-1865, B,CH1/11/95	A.LECARON.
CARPI, Ugo da, Italian c.1450-1525, B,H,M,R,TB,DAV94, SOT(LON)6/29/93	 (UGO) SIGNATURE FROM WOODCUT

CARR, John,
American -1837,
D,DAV93,PH10/21/82

John Carr.

CARRACCI, Annibale,
Italian 1560-1609,
B,H,M,TB,DAV93,
SOT(LON)7/2/90,
CH1/13/93,SOT1/13/94

Hanibal Caracio
(old signature attribution from drawing of pen
& brown ink & wash over red chalk)

CARRE(E), Hendrick,
Dutch 1656-1721,
B,H,M,TB,DAV93,
CH(AMS)5/6/93

H Carree.f

CARRE(E), Michiel,
Dutch 1657-1747,
B,H,M,TB,DAV93,
CH(AMS)11/12/90,
SOT(LON)10/28/92

M.Carree *M'Carre'f.*
(signature from drawing of pen
& brown ink & grey wash)

CARTY,
French, early 19th century,
DAV93,SOT(MON)6/18/88

Carty. 1828.

CARUELLE d'ALIGNY,
Claude Felix Theodore,
French 1798-1871,
B,H,M,TB,SOT10/24/89,
SOT(MON)12/5/92

 NOTE: Also research ALIGNY

CASA (or DELLA CASA),
Niccolo Della,
French/Italian? 16th century,
B,H,DAV93

·N·D·LA·
CASA·F·

CASISSA (or CASSISSA
OR CAFISSA), Nicolo,
Italian c.1680-1730/31,
B,DAV93,CH12/11/92&
5/14/93&1/12/94
CONTINUED

CASISSA (or CASSISSA
OR CAFISSA), Nicolo
CONTINUED

CASTEELS, Peter III,
Flemish 1684-1749,
B,H,M,DAV93,SOT(MON)
6/16/90,SOT1/15/93,
CH(MON)7/3/93

<(signature from drawing
black chalk, pen & brown
& black ink, grey wash
on blue paper)

CASTIGLIONE, Giovanni Benedetto,
Italian 1610/16-1663/70,
B,H,M,TB,DAV93,
CH(LON)7/2/91,SOT(LON)
7/8/92,SOT1/10/95

<(from black ink monotype)

CASTILLO, Jose del,
Spanish 1737-1793,
B,H,DAV93,SOT(MAD)
5/18/93

(SIGNATURE FROM WATERCOLOR)

CASTILLO SAAVEDRA,
Antonio del,
Spanish 1616-1668,
B,H,M,DAV93,SOT(LON)
12/14/92,SOT(MAD)
5/18/93,SOT1/12/95

<(bears signature, from drawing
of pen & brown ink)

CATEL, Franz Ludwig,
German 1778-1856,
A,B,H,M,TB,DAV93,
CH(LON)5/20/93

CATESBY, Mark,
English 1679-1749,
B,H,CH6/9/93

JC <(FROM FOLIO OF ETCHED PLATES OF WILD LIFE)

CATLIN, George,
American 1796-1872,
B,D,F,H,I,M,DAV93,
SOT12/1/88&5/27/93

Catlin'54 *G.Catlin 1857*

CATS, Jacob,
Dutch 1741-1799,
B,H,M,TB,DAV93,
CH(AMS)11/25/92,SOT
1/13/93&1/12/94

J. Cats. 1185. <(from drawing: drawn with the brush in grey & blue wash over traces of black chalk)

**CERROTI, Violante Beatrice
(nee SIRIES),**
Italian 1709-1783,
B,H,CH12/11/92

VIOLANTES.SIRIES.CERROTI.

NOTE:(Research SIRIES also)

CEULEN (or JONSON VAN CEULEN),
Cornelis Janssens van,
Dutch 1593-1661,
B,H,M,TB,DAV93,
SOT(AMS)5/12/92,
CH1/10/90&10/7/93

C.J. fecit 1627 *Cor Jonson*

CHALON, Alfred Edward,
English 1780-1860,
A,B,H,M,DAV93,
CH5/22/86,CH(LON)
4/14/93 (dates sic)

A·E·Chalon

CHALON, Henry Bernard,
English 1770-1849,
B,H,M,TB,DAV94,
SOT6/5/92&6/4/93

H.B.Chalon 1832.
H.B Chalon 1816

HB Chalon, pinx 1797

CHALON, Louis, Dutch 1687-1741, B,H,M,TB,DAV94, SOT1/17/90&1/13/93	*L. Chalon* <<(from gouache on vellum)
CHAMPAIGNE, Philippe de, Flemish 1602-1674, B,H,M,TB,DAV93, CH(MON)12/7/90,SOT(MON) 7/6/92,CH1/11/95	*Ph. Champaigne. Fecit.* *Anno. 1650.*
CHARDIN, Jean Baptiste Simeom, French 1699-1779, B,H,M,TB,DAV93, SOT5/11/87,CH5/31/90& 1/14/93	*chardin* *1769* *chardin* *J chardin.* *cd.* <<(initial signature)
CHARLEMAGNE, Josip Adol'fovich, Russian 1782-1861, A,B,DAV93,CH(LON) 10/5/89,SOT(LON) 11/24/92	*J Charlemagne '04* (signature in pencil from drawing of pencil & watercolor with scratch out)
CHARLES, William, American 1776-1820, B,D,F,H,I,M,TB, DAV93	*Charles*
CHARLET, Nicholas Toussaint, French 1792-1845, B,H,M,TB,DAV93, SOT(ARC)7/16/92	*Charlet.* <<(SIGNATURE FROM WATERCOLOR)
CHIANTARELLI, Giuseppe, Italian ac. late 18th century, DAV94,SOT1/10/95	*Chiantarelli del. 1793 .* < FROM GOUACHE AND WATERCOLOR ALSO SIGNS WORK GIUS. CHIANTARELLI
CHODOWIECKI, Daniel Nicolas, German 1726-1801, A,B,H,M,TB,DAV93, SOT1/13/93	*D. Chodowiecki* *DC* (from gouache)

CHOFFARD, Pierre Phillipe, French 1730-1809, B,H,M,TB,SOT(ARC) 1/17/91&7/16/92	*PP Choffard.* 1764 <(signature from drawing of black & colored chalks)
CIECA, Miguel Geronimo de, Mexican 17th century, CH5/18/93	*Miguel. & de cieca* 1667
CIGNAROLI, Gianbettino, Italian 1706-1770/72, B,H,DAV93,CH10/10/90& 12/11/92,SOT(LON)12/7/94	ΚΥΚΝΑΡΩΛΟΣ SIGNATURE IN GREEK LETTERS
CIOCI (or CIOCCHI), Antonio, Italian ac.1722-1792, B,DAV93,SOT(LON) 12/6/89,DEL12/16/92	*Studio Dipint d'Antº Cioci Firenze- 1787*
CLAESZ, Pieter, Dutch 1597-1661, B,H,M,TB,DAV93, CH(MON)7/3/93,SOT(LON) 12/7/94,CH1/11/95	*P' & Aº1630 P*
CLEMENT, M., French ac.1815, CH(MON)12/7/90	*Mⁱⁱ Clement 1815*
CLERISSEAU, Charles Louis, French 1721/22-1820, B,H,M,TB,DAV93, SOT(LON)7/5/93, SOT1/12/94&1/10/95	*Clerisseau* < SIGNATURE FROM GOUACHE
CLERMONT, Jean Francois, French 1717-1807, B,H,M,DAV93,CH(MON) 7/2/93	*clermont inv.* SIGNATURE FROM DRAWING OF BLACK CHALK AND GREY WASH

CLOWES, Daniel,
British 1774-1829,
H,DAV93?,CH6/5/87,
SOT6/9/89&6/4/93

D CLOWES

COCCORANTE, Leonardo,
Italian 1680-1750,
B,H,DAV93,CH1/14/93&
10/7/93,CH(MON)7/3/93,
CH1/11/95

Lℭ

COCK, Maerten de,
Dutch 1600-1646,
B,H,DAV93,SOT(LON)
12/14/92

M. Cock. fc.1625

(signature from drawing of pen & brown ink over
traces of black chalk on vellum)

COCLERS, Christian,
Belgian -1737,
B,DAV93,SOT4/5/90

C.Coclersf.

COCLERS, Jean George
Christian,
Flemish 1715-1751,
B,H,CH(LON)7/8/94

C coclers f
1743

CODDE, Pieter,
Dutch 1599-1678,
B,H,M,TB,DAV93,
SOT7/17/91,CH(AMS)
11/18/93,CH1/11/95

ℭℙ ℭodde

CODMAN, Charles,
American 1800-1842,
H,DAV93,CHE1/29/82,
BAR8/18/92

Codman
1831

COEME, Comstamtomis Fidelio,
Flemish 1780-1841,
B,H,DAV93,CH(LON)
10/5/90,CH(AMS)4/24/91&
4/21/93

C.Coene
1827

C. Coene
1839

COENE, Jean Henri de, Flemish 1798-1866, B,H,M,TB,DAV93, SOT 10/29/87 & 10/29/92	*J. Coene 1840* *J. Coene* *Henri De coene*
COINDET, Jean Jacques Francois, Swiss 1800-1857, B,DAV93,SOT(Z) 12/1/88	*John. Coindet. 1839*
COLIN, Alexandre Marie, French 1798-1873, B,H,M,TB,DAV93, SOT 10/19/84,CH(LON) 6/18/93	*A. Colin 1827*
COLLET, Jean Baptiste, French 18th-19th century, B,CH(MON) 7/2/93	*J. B. Collet* SIGNATURE FROM DRAWING OF BLACK CHALK AND BROWN-GREY WASH <u>NOTE</u>: COLLET EXHIBITED IN SALONS 1793-1822
COLLIER (or COLYER), Evert or Edwaert, Dutch c. 1640-c. 1706, B,H,DAV93,CH 12/11/92, CH(LON) 12/10/93 & 7/9/93	*E·COLLIER* *An: 1673* *E. collier* *E. Collier. fecit.* *1699*

COLLIGNON,
French ac. 1762,
B?,CH5/31/91

COLLIGNON (1762)

COLLINS, Charles,
English ac. 1720-1760,
B?,H?,CH(LON)
7/14/92

Cha. Collins. Oxt 1739

(FROM DRAWING OF PENCIL, WATERCOLOR & BODYCOLOR)

COLLINS, William,
English 1788-1847,
B,H,M,TB,DAV93,
CH(SK)4/13/89,
CH(LON)7/14/92

Wm Collins *Collins*

COLONIA, Adam,
Dutch 1634-1685,
B,M,DAV94,CH(LON)
11/21/91,CH(AMS)
11/17/94

A. Colonia

COLSON, Guillaume Francois,
French 1785-1850,
B,H,DAV94,SOT(MON)
6/19/94

Colson
(1814)

COLSON, Jean Francois
Gilles,
French 1733-1803,
B,H,M,TB,DAV93,
SOT(MON)12/5/92

J. Colson
1797

COMOLERA, Melanie de,
French ac.1808-1854,
B,H,CH(AMS)11/17/94

Mélanie.
Janvier 1808

CONCA, Tommaso,
Italian c.1735-1815/22,
B,H,DAV93,CH1/13/93

T. Conca <(from drawing of black lead,
pen & brown ink & brown wash)

CONCHILLOS Y FALCO, Juan,
Spanish 1641-1711,
B,H,SOT(MAD)5/18/93

Conchillos. fect <(SIGNATURE FROM DRAWING)

CONSTABLE, William,
American 1783-1861,
DAV93,WES12/9/88&
5/13/89

W.C.1807

Wm C. 1806. <(initials from drawing of pen
& ink, grey wash & watercolor)

CONTI, Vincenzo,
Italian ac.1763-1787,
B,SOT(LON)4/13/92

Vincenzo Conti <(SIGNATURE FROM DRAWING OF
PEN, BROWN INK & GREY WASH OVER BLACK CHALK)

COOKE, George,
American 1793-1849,
D,F,H,I,DAV93,
WES5/13/89&12/2/89

*G Cooke.
1845*

COOPER, Abraham,
English 1787-1868,
B,H,M,TB,DAV93,
SOT(LON)2/28/90,
PH(LON)4/27/93

A. C.1817.

COOPER, Edwin,
English 1785-1833,
H,DAV93,PH(LON)
10/3/89,SOT6/5/92&
6/4/93

E Cooper. Pinx
1808 *Edwin Cooper*
 1818

Ed Cooper fecit
1816

COOPSE, Pieter,
Dutch ac. 1668-1680,
B,H,M,TB,DAV93,
SOT4/5/90,SOT(AMS)
11/16/93

P. Coopsi: fec PC

SIGNATURE FROM DRAWING OF PEN AND
DARK GREY INK AND WATERCOLOR

COORTE, Adriaen,
Dutch ac. 1683-1723,
B,H,DAV93,CH(AMS)
11/29/88,SOT(LON)
12/12/90,CH(LON)
4/23/93

A Coorte 1705

A: Coorte 1685 *A. Coorte 1690*

A: Coorte 1685

COOSEMANS, Alexander,
Flemish 1627-1689,
B,H,DAV93,PH(LON)
4/10/90,SOT1/10/91

A. Coosem ??? A.C.
1660

COPLEY, John Singleton,
American 1738-1815,
B,D,F,H,I,M,TB,DAV93,
CH3/14/91&12/3/92

John Singleton Copley

COPPEYN, Francois,
Flemish -1692,
B(Coppein),H?,DAV94,
SOT(LON)7/7/93

(F) *Coppeyn 1681*

(F INITIAL NOT LEGIBLE)

CORDREY, John,
English c.1765-1825,
DAV93,SOT(LON)
10/31/90,SOT6/5/92&
6/3/94

Cordrey 1814

CORIOLANO, Bartolommeo,
Italian 1599-1676,
B,H,M,TB,DAV93,
CH5/14/91

Barthol. Coriolanus
(signature from woodcut)

CORNEILLE, Michel,
French 1602-1664,
B,H,M,TB,DAV93,
SOT(LON)12/8/93

MI·CORNEILLE·INV·Pinxit·

CORNELISZ, B. (Barent?),
Dutch 1610-after 1661,
B,M,TB,SOT1/12/95

B. Corneliß:1655

COROT, Jean Baptiste
Camille,
French 1796-1875,
B,H,M,TB,DAV93,
BB3/27/91,SOT5/28/92,
CH5/27/93

COROT ‹(signature from drawing of charcoal &
pencil heightened with white)

Corot COROT C.C.

CORREA, Jose,
Mexican ac.17th century,
B?,SOT5/19/93

Joseph Correa

CORREA, Juan de,
Mexican ac.1674-1739,
B,H,M,TB,SOT11/23/92

Juan Correa

CORT, Henrik Frans de,
Dutch 1742-1810,
B,H,M,TB,DAV93,
CHE1/10/91,CH(LON)
4/19/91,KLI12/2/92

Henri De Cort H. De Cort.–
(signature from a drawing
of pencil & grey wash)

COSTER, Hendrick, Dutch ac.c.1638-c.1659, B,H,DAV94,PH(LON) 12/10/91,SOT(AMS) 11/16/94	*H.C. fͨ 1654* *HCoster*
COSWAY, Maria Cecelia Louisa Catherine, English 1759-1838, B,H,M,DAV93, CH1/12/94	*Maria C. del.*
COSYN(S) (or COUSYN), Aert, Dutch 17th century, B,DAV93,PH(LON) 12/5/88	*Cosyn. fe. A 1670* <(signature from drawing: black chalk on vellum)
COTAN (or SANCHEZ Y COTAN), Fray Juan Sanchez (circle of), Spanish 1560/61-1627, B,H,DAV93,SOT(LON) 4/20/88	*Josa.Cotanfac!??*
COTES, Francis, English 1725/26-c.1770(1806?), B,H,M,TB,DAV93, SOT4/5/90&5/20/93& 1/14/94	*Cotes 1752* *Cotes.px.ᵗ 1767*
COTMAN, John Sell, English 1782-1842, B,H,M,TB,LH10/14/89, SOT(LON)7/14/88& 1/14/94	*J.S.Cotman 1831* <(signature from watercolor) *J.Cotman 1802.* <(signature from watercolor over pencil with scratching out) *J S Cotman* <(signature from a watercolor)

COURT, Joseph Desire,
French 1797-1865,
B,H,M,TB,DAV93,
CH(MON)6/19/88

Court

COUWENBERGH, Christiaen van,
Dutch 1604-1667,
B,H,DAV94,SOT(LON)
7/6/94

C B F - 1647

COWEN, William,
English 1797-1861,
B,H,M,TB,DAV94,
PH(LON)4/28/92,
CH(LON)4/12/94

W. Cowen 1819 < FROM PENCIL & WATERCOLOR.

COX, David,
English 1783-1859,
B,H,M,TB,DAV93,
SOT(LON)10/18/89,
BB11/7/90,CH(LON)
7/14/92

David Cox 1846 *David Cox.*

D.C. < PENCIL & WATERCOLOR *D. Cox*

COXIE, Jan Anthonie,
Flemish after 1650-1720,
B,H,SOT(AMS)5/12/92

(JA) *De Coxie. f.*
1693

COYPEL, Charles Antoine,
French 1694-1752,
B,H,M,TB,DAV93,
CH1/13/93,CH(MON)
7/3/93,SOT(MON)7/2/93

CHarles Coypel 1732 **COYPEL**

Coypel

COYPEL, Noel Nicolas,
French 1690-1734,
B,H,M,TB,DAV93,
CH(MON)12/4/92,
SOT1/14/94

n. Coypel. 1725

COZENS, John Robert,
English 1752-1797,
B,H,M,TB,CH(LON)
7/9/91&11/9/93

(J.) *Cozens*

FROM PENCIL & WATRCOLOR, TOUCHES OF WHITE

CRABETH, Wouter Pietersz.,
Dutch 1593-1644,
B,H,DAV94,SOT1/17/92,
SOT(LON)7/6/94

WCrabeth. F
(1631)

CRANACH, Lucas (the
elder),
German 1472-1553,
B,H,M,TB,DAV93,
CH(LON)5/20/93&12/10/93,
SOT1/12/95

(from woodcut)

CREGAN, Martin,
Irish 1788-1870,
B,H,M,TB,DAV93,
SOT(LON)2/29/84

MCregan
1531

CRISTALL, Joshua,
English 1767-1847,
B,H,M,TB,DAV93,
SOT(LON)4/1/93

Joshua Cristall *Joshua Cristall*

CROOS, Anthony Jansz.
van der,
Dutch 1606/07-c.1662,
B,H,M,TB,DAV93,
CH(AMS)11/10/92&
5/6/93,SOT1/12/95

AJ.CROOS f 1662 *N CROOS 1652*

N. CROOS f 1653

CROOS, Jacob van der,
Dutch ac.c.1654-c.1700,
B,H,DAV93,PH(LON)
4/10/90,CH(LON)
7/5/91,CH(AMS)
11/10/92

JvC

(165?)

CROOS, Pieter van der,
Dutch 1610-1701,
B,H,DAV93,CH4/4/90,
CH(AMS)5/7/92,
CH1/11/95

PC *PC*

CRUIKSHANK, George,
Scots/English 1792-1878,
A,B,H,M,TB,DAV93,
CH5/24/89,CH(LON)
4/9/91,WES5/22/93

George Cruikshank.

George Cruikshank

May 13th 1833.

(signature from watercolor)

CRUSSENS (or KRUSSENS),
Ant(h)on(ie),
Flemish ac.1650-1660s,
B,H,DAV93,SOT(AMS)
11/16/93

Crussens. < PEN AND BROWN INK
 ON VELLUM

CRUYL, Lieven,
Flemish c.1640-1720,
B,H,DAV93,CH(AMS)
11/12/90,SOT(LON)
7/1/91

£ *L.Cruyl.* **L.C.**

(signature & initials from drawings
of black chalk, pen & black ink, &
grey wash on vellum)

CUESTA, Francesco de la,
Spanish? ac.17th century,
CH(MON)12/4/92

(Fr.?) *de la Cuesta*

(1669)

CUYLENBORCH, Abraham van,
Dutch c. 1610–1658,
B,H,M,TB,DAV93,
CH(LON) 7/9/93,SOT(AMS)
11/16/93,SOT(LON)
12/7/94

ACuylenborchf *AB*

AC f 1641

CUYP, Aelbert,
Dutch 1620–1691,
B,H,M,TB,DAV94,
BB5/18/93,CH1/11/95

A. cuyp

CUYP, Benjamin Gerritsz.,
Dutch 1612–1652,
B,H,M,TB,DAV94,
CH10/9/91,CH(LON)
7/9/93,SOT1/12/95

CUYP

CUYP, Jacob Gerritsz.,
Dutch 1594–after 1651,
B,H,M,TB,DAV94,
CH10/9/91,SOT(LON)
10/26/94

CUYP

AN° 1640

DAEL, Jan Frans van,
Flemish 1764-1840,
B,H,M,TB,DAV93,
SOT12/2/89,CH1/13/93

JVandael
1794.

Vandael <(from drawing of black
chalk, pen & brown ink
& brown wash on light brown paper)

DAGOMER, Charles,
French -c.1768,
B,DAV93,SOT(MON)
7/2/93

Dagommer.1765

TWO Ms IN SIGNATURE IS CORRECT

DAHL, Johan Christian
Clausen,
Norwegian 1788-1857,
B,H,M,TB,DAV93,
CH(LON)3/25/88,SOT(LON),
6/19/91,ZEL10/7/92

Dahl *D1823*

DALBY, David (of York),
English 1790-1853,
B,H,M,DAV93,SOT(LON)
10/31/90,CH(LON)7/12/91,
SOT6/5/92

Dalby York
1828

Dalby York 1829

DANCE, George, Jr.,
English 1741-1825,
B,H,DAV94,CH(LON)
11/9/93&7/12/94
CONTINUED

George Dance

SIGNATURE FROM PENCIL DRAWING

DANCE, George, Jr.,
CONTINUED

Geo: Dance April 20" 1795

SIGNATURE FROM PENCIL DRAWING WITH TOUCHES
OF RED CHALK

DANDRE BARDON,
Michel Francois,
French 1700-1778,
B,H,DAV93,SOT(MON)
12/5/92,CH(MON)
7/2/93

Dandré Bardon

(from ink & chalk drawing)

DANLOUX, Henri Pierre,
French 1753-1809,
B,H,M,TB,DAV93,
SOT(MON)6/17/88,
SOT7/19/90,CH1/11/91

H.P. Danloux
1798

Danloux. fecit
1795

Hry pre Danloux

Signed Hry Pre Danloux. Black chalk & grey wash.

DASVELDT, Jan H.,
Dutch 1770-1850,
B,H,SOT(LON)4/30/90,
SOT(AMS)11/17/93

ID <(initials from black chalk drawing)

DAVID, Jacques Louis,
French/Belgian 1748-1825,
B,H,M,TB,DAV93,
CH(MON)6/22/91&6/20/92,
SOT1/12/94

L. David

L. David f 1793

DAVID, Louis,
French -1718,
H,M?,TB?,DAV93,
PH(LON)12/4/89,
SOT(MON)7/2/93

Louis David
Oct: 1793

<(signature from drawing of
pen & ink with watercolor)

DAVIS, Richard Barrett,
English 1782-1854,
B,H,M,TB,DAV93,
WES12/8/90,SOT6/5/92,
CHE4/28/93

R·B·DAVIS 1838

R B DAVIS *R·B·DAVIS*
 1841·

DAVIS, Samuel,
English 1757-1819,
H,CH(LON)7/14/92

Davis

DAVIS, William Henry,
English c.1795-1865,
B,DAV94,SOT6/4/93,
SOT(LON)7/14/93

WH Davis *WH Davis*
1839 *1842·*

DAYES, Edward,
English 1763-1804,
B,H,M,TB,DAV93,
PH(LON)4/23/90,
SOT(LON)7/11/91,
CH(LON)7/14/92

Dayes 1791

<(signature from watercolor
over pencil, with touches
of bodycolor)

DEANE, Charles,
English ac.1815-1851,
B,H,M,DAV93,SOT(LON)
10/18/89,CH(LON)
7/13/93

C.Deane 1832

**DELACROIX, Ferdinand
Victor Eugene,
French 1798-1863,
B,H,M,TB,DAV93,
CH(MON)6/15/90,
CH1/13/93,SOT(ARC)
7/23/93**

Eugene Delacroix E.D L.D.

E.D EUG. DELACROIX:

*Eug. Delacroix
1838*

**DELAFOSSE, Jean Charles,
French 1734-1789,
B,H,DAV93,CH(MON)
7/2/93,CH1/11/94**

J. C. delafosse

FROM DRAWING OF BLACK CHALK, PEN & BLACK INK,
AND GREY WASH.
Note: Also, known to sign work J. Ch. Delafosse)

J. Ch. delafosse

FROM DRAWING OF BLACK CHALK & BROWN & GREY WASH

**DELAROCHE, Hippolyte
(called Paul),
French 1797-1856,
B,H,M,TB,DAV93,
CH(MON)12/2/89,
CH10/24/90,SOT(ARC)
7/16/92**

PAUL DELAROCHE
MDCCCXXXII

*Paul Delaroche
1838*

**DELEN (or DEELEN or
DALENS), Dirk van,
Dutch 1605-1671/76,
B,H,M,TB,DAV93,
PH(LON)7/2/91,
CONTINUED**

D v delen 1643 D.D.

D.V. DELEN.

DELEN (or DEELEN or DALENS), Dirk van, CONTINUED SOT(LON)4/21/93& 12/7/94	*Dvan Delen 1628*
DELFF, Cornelis Jacobsz., Dutch 1571-1643, B,H,M,TB,DAV93, SOT(LON)4/17/91& 10/28/92,CH(MON) 7/3/93	*C.Delff*
DEMAY, Jean Francois, French 1798-1850, B,M,TB,DAV93, CH(MON)12/4/93, CH(LON)6/18/93	*Demay 1839*
DEMIN (or MIN), Giovanni De, Italian 1786-1859, B,H,DAV93,PH(LON) 12/5/88,SOT(MIL) 5/17/90	*G. De-Min* <(signature from drawing) *Gio-De-Min* <(signature from drawing: pen & brown ink heightened with white)
DENIS, Simon Joseph Alexander, Flemish 1755-1813, B,H,DAV93,SOT(MON) 6/19/92	*Denis 1793* *D. f. 1790*
DENON, Vivant, French 1747-1826, B,H,M,TB,DAV93, BB3/17/82,CH(LON) 7/3/90	*DN.*
DESPAUX, Emmanuel, French? ac. early 19th century, SOT(LON)4/13/92	*Emmanuel Despaux an 14e* (FROM BLACK CHALK DRAWING)

DESPORTES, Alexandre Francois,
French 1661-1743,
B,H,M,TB,DAV93,
BB11/13/91,SOT(LON)
7/8/92&12/7/94

Desportes
1706

Desportes
1724

DEVERIA, Achille Jacques Jean Marie,
French 1800/05-1857,
B,H,M,TB,DAV93,
BB3/15/84,CH10/26/88

Deveria
1826

Deveria.

DEVRIENT, Wilhelm,
German 1799-
B,TB,DAV93,
CHE2/16/93

WD

DIEPENBEECK, Abraham Jansz. van,
Flemish 1596-1675,
B,H,M,TB,DAV93,
CH3/6/89,BB5/20/92,
CH(AMS)11/24/92

Abraham van Diepenbeeck. F.
AD.

DIETRICH, Christian Wilhelm Ernst,
German 1712-1774,
B,H,M,TB,DAV93,
CH(LON)5/20/93,
SOT(AMS)11/17/93,
CH1/11/95

Dietricÿ:
1757

(DIETRICY IS CORRECT, ALSO
IS KNOWN TO SIGN DIETRICHJ)

D.1762

CW:Dietricy

D

DIETTERLIN, Bartholomeus,
French c.1590- ,
B,H,DAV93,SOT1/13/88,
CH(LON)4/16/91

B.Dietterlin.1638.

(signature from: pen, brown ink & gouache
over black chalk on vellum)

DIETZSCH, Barbara Regina,
German 1706-1783,
B,H,DAV94,CH(LON)
7/3/90,SOT(AMS)
11/15/94

Barbara Regina Diezsch
GOUACHE ON VELLUM

< DIEZSCH IS
CORRECT

DIGHTON, Denis,
English 1792-1827,
B,H,M,TB,DAV93,
CH(SK)5/25/89,
CH(LON)7/14/92

Denis Dighton Military Painter to The King
(signature & inscription from a pencil & watercolor)

DIGHTON, Josua,
English ac.1820-1860,
DAV94,CH(LON)
4/12/94

Joshua Dighton. 1853
FROM PENCIL & WATERCOLOR, TOUCHES OF WHITE.

DIONISY, Jan Michiel,
Belgian 1794-
B,TB

JMD

DITTENBERGER, Johann Gustav,
German 1794/99-1879,
B,H

DIZIANI, Gasparo,
Italian 1689-1767,
B,H,M,TB,DAV93,
CH(LON)7/9/93,
SOT1/14/94&1/10/95

Gasparo Diziani· <(signature from
drawing: pen &
brown ink & grey wash)

Gasparo Diziani Belluese.
(inscription signature from drawing of pen & black
ink & grey wash over black chalk)

DODD, Daniel,
English ac.1761-1780/90,
B,H,M,TB,DAV93,
SOT(LON)3/14/90,
SOT5/20/93

D.Dodd
(pinxt)
1782

DOESJEAN (or DOESJAN),
Adriaen,
Dutch 1740-1817,
B,DAV93,CH1/11/89

ADRIANUS, DOESJAN. *1767*
(from a 'Trompe l'Oeil' ... pen & brown ink,
grey wash)

DONCK, Gerrit,
Flemish before 1610-c.1640,
B,H,DAV94,PH(LON)
10/20/92,SOT1/12/95

Donck.

DORNE, Martin van,
Flemish 1736-1808,
B,H,DAV93,CH10/15/92

M.
Van Dorne
F.
1784

DORNER, Johann Jacob, Jr.,
German 1775-1852,
B,H,M,TB,DAV94,
CH(LON)6/18/93&
10/1/93

JDorner Junior
1810

JDorner Inspen 1812.

FROM CHARCOAL & WATERCOLOR HEIGHTENED WITH WHITE

DOUGHTY, Thomas,
American 1793-1856,
B,D,F,H,I,M,TB,DAV93,
CH10/30/90&12/6/91&
5/26/93

T.DOUGHTY DOUGHTY
 1847

DOUW, Simon Johannes van,
Flemish 1630-after 1677,
B,H,M,TB,DAV93,
CH10/7/93,SOT1/12/95

S V Douw

DOWNMAN, John,
English 1750-1824,
B,H,M,TB,DAV93,
SOT(SUS)5/20/91,
SOT(LON)7/11/91

J·D <(signature from drawing of
1780. pencil & black chalk)

J.Downman <(from watercolor
 1795 over pencil)

DROLLING, Martin,
French 1752-1817,
B,H,M,TB,DAV93,
SOT(ARC)7/17/91,
SOT10/26/90&
1/14/94

Drölling <(stamp signature)

*Drolling f
1794*

DROLLING, Michel Martin,
French 1786-1851,
B,H,M,TB,DAV93,
SOT(LON)6/19/90

Drolling 1819

DROOGSLOOT (or
DROOCHSLOOT), Cornelis,
Dutch 1630-after 1673,
B,H,M,TB,DAV,CH(AMS)
6/12/90,LIB12/18/92,
SOT(AMS)11/17/93

C. droogsloot.

DROOGSLOOT (or
DROOCHSLOOT), Joost
Cornelisz.,
Dutch 1586-1666,
B,H,M,TB,DAV93,
SOT(MON)12/3/89,
PH(LON)12/11/90,
CH1/14/93

J Drooch Sloot 1638

J. D. 1646

DUBBELS, Hendrik Jacobsz.,
Dutch 1621-1707,
B,H,M,TB,DAV94,
CH5/19/93&5/18/94

DVBBELS

DUBOIS DRAHONET,
Alexandre Jean,
French 1791-1834,
B,H,M,TB,DAV93,
Christie's International
Magazine-January 1991,
PH(LON)11/16/93

ADubois 1833

ADuBois Drahonet

DUBOURG, Louis Fabricius,
Dutch 1693-1775,
B,H,M,TB,DAV93,
CH1/11/89,SOT(LON)
10/28/92

1740
F.D.B. <(from red chalk drawing)

LFDB L.F.DuBourg.1730

DUBUFE, Claude Marie,
French 1790-1864,
B,H,M,TB,DAV93,
SOT(MON)6/17/88,
SOT(LON)6/7/89,CH(MON)
6/20/92

DUBUFE *Dubufe*

**DUBUISSON, Claude Nicolas
Le Pas,**
French 1663-1733,
CH1/11/94

FROM ARCHITECTURAL DRAWING OF BLACK CHALK, PEN
AND BROWN INK, AND PENCIL.

NOTE: EXTRA LOOP AFTER THE B IS CORRECT.

DUCK, Jacob,
Dutch 1600-1660,
B,H,M,TB,DAV93,
CH1/12/94,
SOT1/14/94

Dvck JDuck JD
J·Duck·1655

DUCLAUX, Jean Antoine,
French 1783-1868,
B,M,TB,DAV94,
SOT10/12/94

Duclaux
1831

DUJARDIN (or DU JARDIN), Karel,
Dutch 1622-1678,
B,H,M,TB,DAV93,
SOT1/10/91,
CH1/12/94&12/7/94

K D I . f. <(red chalk)
(drawing in red chalk)

K·DU·IARDIN·fe

·K·D·I· te H·DV·JARDIN

DUMESNIL, Pierre Louis,
French 1698-1781,
B,H,DAV94,
CH5/18/94

Dumesnil Le jeune 1741

DUNOUY, Alexandre Hyacinthe,
French 1757-1841,
B,H,DAV93,SOT1/12/89,
SOT(MON)7/2/93

DUPLESSIS, C. Michel Harmon,
French ac.1791-1799,
B,DAV93,CH(MON)
7/2/93,SOT1/12/95

(ALSO, KNOWN TO SIGN WORK MICH. DUPLESSIS)

M h Duplessis

FROM DRAWING OF BLACK
CHALK, GREY WASH, AND
TOUCHES OF WHITE ON
BEIGE PAPER >

M.h Duplessis.

DUPRE, Louis,
French 1789-1837,
B,DAV93,SOT10/26/90,
SOT(LON)6/20/90&
10/21/92

L Dupré

(signature from drawing of pen & watercolor)

DUPUIS, Pierre,
French 1610-1682,
B,H,DAV93,CH(MON)
5/31/90&12/4/92

DVPVIS P 1666

DURAND, Asher Brown,
American 1796-1886,
B,D,F,H,I,M,TB,
DAV93,SOT12/1/88&
9/24/92,CH9/23/92

DURER, Albrecht,
German 1471-1528,
B,H,M,TB,DAV93,
PH(LON)12/3/90,
BB2/25/92,SOT(LON)
12/9/92

∧ (monograms from woodcuts)

< THIS IA A SIMPLIFIED VERSION
OF A SCALLOP-SHELL SYMBOL USED
BY DÜRER; FROM PAINTING OF ST.
JAMES IN THE UFFIZI GALLERY.

DURU, Jean Baptiste,
French 18th century,
B,DAV93,SOT1/11/90

I B Duru

DUSART (or DUSAERT),
Cornelis,
Dutch 1660-1704,
B,H,M,TB,DAV93,
SOT4/11/91,CH1/14/93,
CH(LON)12/10/93,
CH1/11/95

Com.dvSart
1685.

<(signature from etching)
(also, same on drawings)

Cor. Dusart Cd

DUTCH SCHOOL,
18th century (possibly
OS, Jan van, Dutch
1744-1808),
H,PH(LON)12/5/88

<(monogram from gouache)

DUVAL-LECAMUS, Pierre,
French 1790-1854,
B,H,DAV94,SOT(MON)
6/19/94

Duval LC

DUYSTER, Willem Cornelisz,
Dutch 1598-1635,
B,H,M,TB,DAV93,
SOT1/12/89,PH(LON)
12/11/90,SOT(AMS)
11/11/93

WD WD

DUYVEN, Steven van,
Dutch ac. 2nd half 17th
century,
B,H,DAV94,CH(AMS)
5/11/94

S Van Duyven (1682)

DYCK, Philip van,
Flemish 1680-1753,
B,H,DAV93,
SOT1/10/91&1/15/93

P VanDyk.

EARLE, Augustus,
English 1793-1838,
B,H,DAV94,CH(LON)
7/16/93

A. Earle < SIGNATURE FROM WATERCOLOR

EARL(E), Ralph,
American 1751-1801,
B,D,F,H,I,M,TB,
DAV93,CH5/25/89,
SOT10/19/89&1/28/93

Ralph Earl 1784

R. Earl. Pinxt 1795

EARLOM, Richard,
English 1743-1822,
B,H,M,TB,DAV93

RE *Rich.ᵈ Earlom*
(SIGNATURE FROM ETCHING)

ECKERSBERG, Christoffer
Wilhelm,
Danish 1783-1853,
B,H,M,TB,DAV93,
CH(LON)5/17/91,
RAS2/23/93&5/11/93

1812. E. *E* *E. 72.*

E_1838

EDOUART, Augustin Amanat
Constance Fidele,
French 1789-1861,
B,D,H,M,TB,DAV93,
SOT1/28/93

*Aug Edouart
1841* (SOMETIMES CLASSIFIED
AS AMERICAN)

EDRIDGE, Henry,
English 1769-1821,
B,H,M,TB,DAV94,
CH(LON)3/20/91&
7/13/93

Edridge 1795

SIGNATURE FROM PENCIL & GREY WASH

EDWARDS, Sydenham Teak,
English 1768-1819,
B,H,M,TB,DAV94,
CH(LON)7/12/94

Sydⁿ Edwards

Sydenham Edwards. delᵗ

BOTH SIGNATURES FROM PENCIL, PEN, BLACK INK AND
WATERCOLOR, WITH TOUCHES OF WHITE HEIGHTENING &
GUM ARABIC.

EECKHOUT, Gerbrand
van der,
Dutch 1621-1674,
B,H,M,TB,DAV93,
SOT(LON)7/2/90&4/1/92,
SOT1/12/95

EECKHOUT, Jakob Josef,
Flemish 1793-1861,
B,H,M,TB,DAV93,
CH(AMS)10/31/89,
SOT6/5/92

EERTVELT (or ARTVELT),
Andries van,
Flemish 1590-1652,
B,H,M,CH(AMS)
5/7/92,SOT1/12/95

EGERTON, Daniel Thomas,
English 1800-1842,
B,H,DAV93,CH11/21/88,
WES5/13/89,SOT5/18/93

DJEgerton 1840 <(signature from hand colored lithograph)

EGOROV (or IEGOROF
or JEGOROFF), Alexie,
Russian 1776-1851,
B,H,TB,DAV93

EHRET, Georg Dionsius,
German 1710-1770,
B,H,DAV93,
SOT(LON)7/5/93

G. D. Ehret. pinxt 1747

(black lead, watercolor & bodycolor)

G. D. Ehret. Pinx.

PENCIL, WATERCOLOR, TOUCHES OF WHITE

Georg Picnyf. Ehret pinx 1745

PENCIL, WATERCOLOR, HEIGHTENED WITH WHITE ON VELLUM

ELIAERTS, Jean Francois,
Belgian 1761-1848,
B,H,DAV93,SOT(LON)
4/19/89,CH(AMS)
11/10/92

Eliaerts

ELLENREIDER, Anna Marie,
Swiss 1791-1863,
B,H,M,TB,DAV93,
KAR12/1/92

MÆ *ME.*

ENDER, Thomas,
Austrian 1793-1875,
B,H,TB,DAV93,
CH(SK)11/15/90,
SOT(ARC)1/20/93,
WIE4/20/94

Tho. Ender. *TE* *Tho. Ender*

Thomas Ender <(signature in brown ink from a watercolor with bodycolor)

ENRIQUEZ, Nicolas,
Mexican ac.1730-1780,
B,SOT5/16/94&5/17/94

N. Enriquez (1777)

EPINAT, Fleury, French 1764-1830, B,H,DAV93,SOT(MON) 12/2/89	*Epinat* <(signature from watercolor)
ES, Jacob van, Flemish 1596-1666, B,H,M,TB,DAV93, SOT1/14/94,CH(LON) 7/9/93,CH1/11/95	**IVE** *J. v. Es. f.*
ESCHARD, Charles, French 1748-1810, B,H,DAV93,SOT7/12/89, SOT(MON)12/5/92	*C. Eschard. f.* <(from ink drawing)
ESCOBAR, Vicente, Cuban 1757-1834, CH5/1/90	*Vicente Escobar Jecit en Agosto de 1828*
ESPINOS, Benito, Spanish 1748-1818, B,H,DAV93,SOT(LON) 4/20/88	*Benito Espinos ft.*
ESPINOSA, Juan Bautista de, Spanish 1590-1626/41, B,H,DAV93,SOT10/11/90	*Joannes Bap.ta Despinusa* *1624*
ESSEN, Cornelis van, Dutch ac.c.1700, B,DAV93,CH(AMS) 11/10/92&5/6/93, SOT(AMS)11/16/94	*C.V.E.*
EULER, Henry, Jr., Swiss 18th century, DAV93,PH(LON)12/4/89, SOT(LON)7/5/93	*Henry Euler Jng* <(signature from pen & ink drawing with watercolor & bodycolor)

EVERDINGEN, Allaert van,
Dutch 1621-1675,
B,H,M,TB,DAV93,
SOT(AMS)11/21/89,
CH5/31/90,SOT5/22/92

A v E <(grey ink signature)

(grey wash & watercolor, black chalk)

A v Everdingen

AVEVERDINGEN

AVE <(from drawing of black chalk,
pen, grey & brown ink, water-
color, brown ink framing lines)

EYRE, Edward,
English ac.1771-1776,
B,H,DAV93,SOT(LON)
7/14/88

E. Eyre.1788 <(signature from watercolor
with pen, black ink & pencil,
heightened with bodycolor)

FABER, Karl Gottfried
Traugott,
German 1785–1863,
B,DAV93,CH(LON)
5/20/93

J. Faber

FABRE, Francois Xavier,
French 1766–1837,
B,H,M,TB,DAV93,
CH(MON)6/16/89&
6/20/91&12/4/93

Fx Fabre Flor. <(Florence) *X. F.*

(Fabre lived in Florence 1793–1826)

F.X.F. J. 1804

FABRIS, Jacopo,
Italian 1689–1761,
DAV93,SOT(LON)
7/3/91

Ja. Fabris pin.

FABRIS, Pietro,
Italian ac.1754–1792,
B,DAV93,CH5/21/92,
SOT6/19/92&1/14/94

Fabris.p. *Fabris.p.* <(both signatures from
1773 watercolors with
 bodycolor)

P. Fabris *P. Fabris*

FABRITIUS, Barent,
Dutch 1624–1673,
B,H,M,TB,DAV93,
SOT11/5/86,PH(LON)
2/27/90,WIN10/9/92

*B. Fabritius
1660*

FABRITIUS DE TENGNAGEL,
Frederick Michael Ernest,
Danish 1781-1849,
B,DAV93,SOT2/22/89,
RAS10/20/92

F.E.F.d.T
1827

FAES, Pieter,
Flemish 1750-1814,
B,H,DAV93,PH(LON)
10/24/89,SOT(MON)
7/2/93

P. Faes 1789

P: Faes

P. Faes 1780

FARINGTON, Joseph,
English 1747-1821,
B,H,M,TB,DAV94,
SOT(LON)7/11/91,
CH(LON)7/12/94

(Jos:) Farington
Signature from drawing of pen, brown ink,
and grey and blue wash.

FAROLFI, Giuseppe,
Italian ac. late 18th century,
CH(MON)12/4/92

Giuseppe Farolfi 1791.

Giuseppe Farolfi 1790~~

FASSIN, Nicolas Henri
Joseph de,
Flemish 1728-1811,
B,H,DAV94,CH(AMS)
5/11/94

 CALLED CHEVALIER DE FASSIN

FELAERT (or VELLERT),
Dirk Jacobsz,
Flemish 1511-1554,
B,H,M,R,DAV93,
CH(LON)6/29/88

1544
D☆V <(signature from etching
with engraving)

FELLNER, Ferdinand,
German 1799-1859,
B,H,TB,DAV93,
SOT(MUN)10/10/92

FENDI, Peter,
Austrian 1796-1842,
B,H,M,TB,DAV93,
CH(LON)11/24/89&
7/18/91,DOR11/11/92

P. FENDI

FERG, Frans de Paula,
Austrian 1689-1740,
B,H,M,TB,DAV93,
SOT1/15/93,CH(LON)
12/10/93,SOT(LON)
12/7/94

P Ferg Fr Ferg fec.

FERGUSON, William Gowe,
Scots 1633-after 1695,
B,H,M,TB,DAV93,
SOT(LON)4/17/91,
CH12/11/92,CH(AMS)
5/6/93

W G Ferguson f
1684 f

W. G. Ferguson fec.

W. G. Ferguson

FERNANDEZ, Francisco,
Spanish 1604/05-1651/57,
B,H,M,TB,DAV93,
CH(LON)5/29/92

F qvs F dez F 1650

FERNELEY, John E., Sr.,
English 1782-1860,
B,H,M,TB,DAV93,
PH(LON)2/9/90,
SOT6/5/92&6/4/93

MANY PICTURE EXAMPLES IN CATALOGUE SOT6/3/94

J Ferneley 1841 John Ferneley 1842

J. Ferneley 1833 J Ferneley 1840

FERRARI, Francesco, Italian 1634–1708, B,H,CH1/11/94	*Francesco Ferrari* SIGNATURE FROM ARCHITECTURAL DRAWING OF BLACK CHALK, PEN AND BROWN INK, AND WATERCOLOR.
FERRI,, Italian ac. 18th century, SOT(LON)10/26/94	*Ferri.f.*
FERRI, Domenico, Italian 1797–1869, B,H?,CH(MON) 12/4/93,SOT5/26/94	*D. Ferri f. 1832*
FIELDING, Anthony Van Dyke Copley, English 1787–1855, B,H,M,TB,DAV93, BB5/20/92,CH(LON) 2/9/90&7/14/92	*Copley Fielding 1838* *Copley. Fielding 1846.* *CVFielding NS 1809* (signature from watercolor over pencil)
FIELDING, Thales, English 1793–1837, B,H,M,TB,DAV94, PH(LON)6/21/94	(T.?) *Fielding*
FIORONI, Teresa, Italian 18th–19th century, BEA2/22/89,DOR11/11/92	*Teresa Fioroni*
FISHER, Alvin T., American 1792–1863, B,D,F,H,I,M,TB,DAV93, CH9/26/91&12/6/91, SK3/12/93	*AF* 1842

FISHER, Jonathan,
American 1768-1847,
C,H,DAV93?

Jon. Fisher Sept.1824.

FLAMEN (or FLAM(M)AND),
Albert,
Flemish 1620-1692,
B,H,M,TB,DAV93,
SOT2/27/88,ADE11/27/92

B. Flamen fe <(signature from etching,
circa 1672)

B.F.

FLAXMAN, John II,
English 1755-1826,
A,B,H,M,DAV93,
CH(LON)7/9/91&7/7/92

J. Flaxman. July 1792.
(FROM DRAWING OF BLACK CHALK, PEN AND
BLACK INK WITH GREY WASH)

FLEGEL, Georg,
German 1563/66-1638,
B,H,M,TB,DAV93,
CH1/10/90,SOT(LON)
7/3/91

Gf. *Œ.*

FLINCK, Govaert,
Dutch 1615-1660,
B,H,M,TB,DAV93,
SOT(AMS)11/17/93,
SOT1/11/90&1/15/93

*G.Flinck.fl
1637* *Flinck f*

*G.flinck f.
A°1645*

FLOENTINE SCHOOL,
c.1570,
CH12/11/92

·F·S·F·F· <(TEMPERA ON LINEN)

FLORIS, Frans,
Flemish 1516–1570,
B,H,M,TB,DAV93,
CH(LON)2/7/91,
SOT(LON)10/28/92,
CH1/11/95

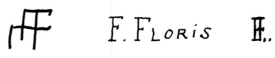

FOKKE, Simon,
Dutch 1712–1784,
B,H,DAV93(dates
sic),CH(AMS)11/24/92,
SOT(AMS)11/17/93

S Fokke

SIGNATURE FROM DRAWING OF BLACK
LEAD AND BLACK CHALK

FOLWELL, Samuel,
American 1765–1813,
B,D,F,H,I,M,TB,
DAV93,RB10/22/76

FOLWELL·NEW YORK.
1791.

FONTENAY, Louis Henri de,
Dutch 1800–
B,TB

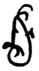

FORNENBURGH, Jan Baptist van,
Flemish 1608–1656,
H,DAV93

Ü V

**FORNENBURGH, Jean or Jan
or Johannes Baptiste,**
Dutch c.1585–1649,
H,DAV93,SOT(LON)
11/30/93

.B.F. ⟨(From gouache on vellum)

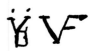

FOSCHI, Francesco,
Italian c.1745–1805,
B,DAV93,PH(LON)
7/2/91,SOT(MON)
7/2/93,SOT(LON)
12/8/93

Ch.F.Foschi 1776

**FRAGONARD, Alexandre
Evariste,**
French 1780–1850,
B,H,M,TB,DAV93,
WES6/6/86,CH5/24/89,
SOT10/12/94

A fragonard fragonard

FROM DRAWING OF PEN AND INK,
GUM ARABIC AND GOUACHE, AND
HEIGHTENED WITH WHITE.

FRAGONARD, Jean Honore, French 1732-1806, B,H,M,TB,DAV93, CH1/12/94,SOT1/12/94& 1/10/95	*Frago*　　*Frago* *Fragonard.*
FRANCHI, R. D., Italian 18th century, SOT(LON)7/5/93	*R.D.Franchi* SIGNATURE FROM DRAWING OF PEN & BROWN INK & WASH, AND PINK AND YELLOW WASH
FRANCIA, Francois Louis Thomas, French 1772-1839, B,H,M,TB,DAV94, SOT(LON)4/9/92, CH(LON)4/12/94	*Francia* *1824*　< FROM DRAWING OF PEN, PENCIL AND BROWN INK, WITH WATERCOLOR AND SCRATCHING OUT.
FRANCKEN, Ambrosius I, Flemish c.1544-1618, B,H,M,TB,DAV94, CH(LON)7/8/94	Æ. INV.ET FEC. A·1600
FRANCKEN, Frans II, Dutch 1581-1642 and MOMPER, Joos de, Dutch 1564-1635, B,H,M,TB,DAV94, CH(LON)4/20/94	JDM FFranck
FRANCKEN, Frans II, Flemish 1581-1642, B,H,M,TB,DAV93, SOT(MON)7/2/93, WIE4/20/94,SOT1/12/95	·De. FFranck·IN.　　1608 FF ·F·Frank· IN. f.
FRANCKEN, Frans III, Dutch 1607-1667, B,H,M,TB,DAV93, PH(LON)12/5/89& 3/5/91,ZEL10/7/92	⊃² ffranck inf 1636
FRANCKEN, Hieronymus, Sr., Flemish 1540-1610, B,H,M,TB,DAV93, SOT(AMS)11/21/89, CH(LON)7/4/91	HF　<(initials in brown ink on gouache) HF:

FRANCOIS, Ange, Flemish 1800-1869, B,DAV93,CH5/25/88, CH(MON)12/7/90, PH(LON)11/15/94	*Ange Francois*
FRANQUELIN, Jean Augustin, French 1798-1839, B,H,M,TB,DAV93, PH(T)11/15/89,BUK5/17/93, CH1/11/95	*Franquelin*
FRASER, Charles A., American 1782-1860, B,D,F,H,I,M,TB,DAV93, WES8/26/86,CH10/24/92, SOT1/28/93	**C. Fraser.**
FREDRIKS, Jan Hendrik, Dutch 1751-1822, B,DAV93,CH5/21/92, SOT(LON)12/8/93& 10/27/93	*H: Fredriks.* *1774*
FRENCH SCHOOL, 18th century, PH(LON)4/16/91	**GM** **G͞M**
FREUDENBERGER, Sigmund, Swiss 1745-1801, B,H,M,TB,DAV93, SOT(Z)12/1/88,SOT(LON) 3/28/90,KOL3/10/93	*S. Freudenberger*
FRISCH, Johann Christoph, German 1738-1815, B,H,DAV93,BB3/22/89, CH5/23/89,SOT(ARC) 7/17/91	*J.C. Frisch* *JCF*

FRYE, Thomas,
Irish 1710-1762,
B,H,M,TB,DAV93,
CH(LON)2/20/91&
6/13/91

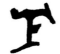

FUCHS, Georg Matthias,
Austrian/Danish? c.1719-
1797,
B,DAV93,SOT(LON)
12/9/92

Fuchs
1766

FUGER (or FUEGER),
Friedrich Heinrich,
German 1751-1818,
SOT(MON)12/7/90,
SOT(LON)7/3/91,
CH1/11/95

Fuger. 1809. F

FUSSLI, Johann Heinrich
(Henry FUSELI),
Swiss 1741-1825,
B,H,M,TB,DAV94,
CH(LON)7/2/91&7/13/93,
CH1/11/95

H: Fuseli Roma 1777
FROM DRAWING OF PEN & BROWN INK, BROWN & GREY WASH

FYT, Jan,
Flemish 1611-1661,
B,H,M,TB,DAV93,
CH1/16/92,CH(AMS)
5/6/93,SOT1/10/95

Joannes Fyt

GADBOIS, Louis,
French -1826,
B,CH1/13/93

Gadbois <(from watercolor heightened with white)

GAEL (or GAAL),Barendt,
Dutch 1620-1687 or 1703,
B,H,DAV93,BB11/13/91,
CH(LON)4/23/93,
CH1/12/94

B GAAL ß GAAL

Also: Listed in SOT(LON)10/26/94, lot 59, as signing work B. Ga<u>e</u>l

GAINSBOROUGH, Thomas,
English 1727-1788,
B,H,M,TB,DAV93,
BB11/7/90&5/20/92,
SOT1/15/93

TG. <(initials from pencil drawing)

GALET, Franz,
Austrian 1762/65-1847,
B,H

FG.

GAMELIN, Jacques,
French 1738-1803,
B,H,M,TB,DAV93,
SOT(MON)6/15/90&
12/5/92,CH(MON)
7/2/93

Gamelin inv <(signature in brown ink from brush & brown wash drawing)

GANDOLFI, Gaetano,
Italian 1734-1802,
B,H,M,TB,DAV93,
SOT(MON)12/5/92,
SOT5/20/93&1/12/94

Gandolfi

GARCIA EL HIDALGO,
Josef,
Spanish 1650-1717,
B,H,DAV93,CH(MON)
6/20/92

Josef Garcia. f 1682

GARGIULO, Domenico (called
Micco SPADARO),
Italian 1609/12-1675/79,
B,H,M,TB,DAV93,
SOT(LON)4/11/90,PH(LON)
7/2/91,CH1/14/93

GARNERAY, Ambroise Louis,
French 1783-1857,
B,H,M,TB,DAV93,
CH(MON)12/4/92

L. Garneray

GARNIER, Etienne Barthelmy,
French 1759-1849,
B,H,M,TB,DAV93

Garnier.

GASTINEAU, Henry G.,
English 1791-1876,
B,H,DAV93,PH(LON)
11/21/88,CH(LON)
4/26/90,CH(SK)10/29/92

Gastineau <(signature from a watercolor over pencil)

GATTA, Saverio Xavier
Della,
Italian ac.1777-1811
(died 1829?),
B,DAV93,SOT(LON)
7/5/93,SOT1/13/93&
1/12/94

Gatta 1824 <(signature from a drawing of pencil, pen & watercolor)

S. xavier della Gatta

SIGNATURE FROM GOUACHE > *Gatta f. 1795*

Xav. della Gatta. 1809
SIGNATURE IN BLACK INK FROM WATERCOLOR

GAUFFIER, Louis,
French 1761-1801,
B,H,M,TB,DAV93,
SOT(MON)6/17/88,
SOT(LON)10/28/92,
CH(LON)7/9/93

LG. 1796 *L Gauffier*

L. Gauffier

GEDDES, Andrew, Scots/English 1783-1844, B,H,M,TB,DAV93, CH(LON)6/3/88, CH2/23/89, SOT(Scotland)4/23/93	*AGeddes*
GELDER, Aert de, Dutch 1645-1727, B,H,M,TB,DAV93, PH(LON)12/6/88, CH(LON)5/18/90, SOT1/10/91	*DeGelder*
GELDORP, Goltzius, Flemish 1553-c.1616/18, B,H,DAV93,SOT(LON) 3/16/93&12/7/94, CH1/12/94	*AN° 1599* *GG* *·GG·F·*
GELLEE, Claude (called Claude LORRAIN), French 1600-1682, B,H,M,TB,DAV93, CH5/30/91,CH(LON) 7/7/92,SOT1/13/94	*Claudio fecit.* <(signature in pen & brown ink) (pen, brown ink & grey wash)
GENOELS, Abraham (called ARCHMEDES), Flemish 1640-1723, B,H,M,TB,DAV93, CH1/10/90,CH(AMS) 11/24/92	*A.Genoels* *AG* (pencil & grey wash) FROM DRAWING OF PEN & > *A. Genoels* BLACK INK & GREY WASH
GERARD, (Baron) Francois Pascal Simon, French 1770-1837, B,H,M,TB,DAV94, SOT1/20/93,SOT(MON) 12/2/94	*F. Gérard*
GERARD, Marguerite, French 1761-1837, B,H,M,TB,DAV93, SOT(MON)6/22/91, ADE1/20/93,SOT1/12/95	(Mte) *gerard*

GERICAULT, Jean Louis
Andre Theodore,
French 1791-1824,
B,H,M,TB,DAV93,
BB2/25/92,CH(MON)
6/22/91&6/20/92

Gericault

Gericault *Gericault*

TWO ABOVE SIGNATURES ARE FROM DRAWINGS OF
pencil, brown and grey washes.

GERMAN SCHOOL,
c.1800,
CH5/18/94

A M

GERMAN SCHOOL,
Early 19th century,
WES11/18/89

TMC. *fecit*
. Roma
1807

GERMAN SCHOOL,
18th century,
PH(LON)10/24/89

NCM 1733

GERMAN SCHOOL,
17th century,
SOT(LON)4/21/93

1639

GHEYN, Jacob or
Jacques de,
Dutch 1565-1629,
B,H,M,TB,DAV93,
CH(LON)7/2/91,
SOT1/13/93,
SOT(LON)7/5/93
CONTINUED

DG. <(monogram in brown ink)

(pen & brown ink over red chalk)

DG

I. de gheyn < SIGNATURE FROM ENGRAVING

GHEYN, Jacob or Jacques de
CONTINUED

SIGNATURE FROM PEN, BROWN INK & GREY WASH. LAST NAME G E Y N IS CORRECT. 7

J.D.Geyn.

GHEZZI, Pier Leon,
Italian 1674-1755,
B,H,M,TB,DAV93,
CH1/13/93,SOT1/12/94&
1/10/95

<(sitter's thumb over signature)

GIANLISI, Antonio
(the younger),
Italian 1652/77-1727,
SOT1/15/93

Il Sig. Antonio Gianlisi

GIAQUINTO, Corrado,
Italian 1690-1765,
B,H,M,TB,CH(LON)
7/5/91&12/10/93,
SOT(LON)12/7/94

Corrado Giaquinto

GILLEMANS, Jan Pauwel, Sr.,
Flemish 1618-1675,
B,H,DAV93,CH1/10/90,
SOT(MIL)5/21/91,
SOT(LON)12/7/94

Jan Paulo.Gillemans

GILLEMANS, Jan Pauwel, Jr.,
Flemish 1651-1704,
B,H,DAV93,SOT(LON)
7/8/92,SOT10/14/92

J.P.Gillemans.

GILPIN, Sawrey,
English 1733-1807,
B,H,M,TB,DAV93,
SOT6/5/92,CH3/21/91&
5/27/93

S Gilpin *S Gilpin 1776*

S. Gilpin 1790 < FROM PEN, BROWN INK AND WATERCOLOR.

GILPIN, William,
English 1762-1843,
B,H,M,TB,DAV93,
FA2/17/86,SOT(LON)
11/19/92

W. GiLPiN 1841

GIORDANO (or JORDANUS),
Luca,
Italian 1632-1705,
B,H,M,TB,DAV93,
CH(LON)7/9/93,
SOT1/14/94&1/12/95

Jordanus f.

L. Giordano.

NOTE: Also known to
sign work JORDANO

GIRODET-TRIOSON,
Anne Louis,
French 1767-1824,
B,H,M,TB,DAV93,
SOT(MON)6/22/91,
SOT(LON)6/16/93,
CH(MON)7/2/93

GHL.
1800

GIRODET.
1820

giroder

FROM DRAWING OF CONTE CRAYON

GLOVER, John,
English 1767-1849,
B,H,M,TB,DAV94,
SOT(LON)11/19/92,
PH(LON)12/13/94

J. Glover

GOBELL (or GOEBELL),
Gerrit Hendrik,
Dutch 1786-1833,
B,H,M,TB,DAV94,
CH(AMS)4/21/94&
10/20/94

G.H. Göbell. fecit 1829

GOEREE, Jan,
Dutch 1670-1731,
B,H,M,TB,CH(AMS)
11/14/88&11/24/92,
CH(LON)4/16/91
CONTINUED

J. Goeree fec.

GOEREE, Jan
CONTINUED

J Goeree fec: < FROM DRAWING OF RED
CHALK, PEN & BROWN INK, BROWN WASH HEIGHTENED WITH
WHITE, INCISED OUTLINES, BROWN INK FRAMING LINES.

GOLTZIUS (or GOLTZ or
GOLTIUS), Hendrick,
Dutch 1558-1616,
B,H,M,TB,SOT(LON)
6/27/88,CH(LON)
4/19/91,SOT1/13/93

∧(from engraving)

HG

1593

(from engraving)

HGoltzius fecit <(signature from
(1592) an engraving)

GONZALEZ VELAZQUEZ,
Isid(o)ro,
Spanish 1765-1829,
B,DAV93,SOT(MAD)
5/18/93

Ysidro Velazquez

SIGNATURE FROM PEN AND WATERCOLOR

GOOL, Jan van,
Dutch 1685-1763,
B,H,M,TB,DAV94,
CH(LON)7/8/94

J.VGool

GOTZLOFF (or GOETZLOF),
Karl Wilhelm,
German 1799-1866,
B,H,DAV94,CH5/26/92,
CH(LON)10/1/93

Götzloff d.d.

FROM PENCIL AND WATERCOLOR,
HEIGHTENED WITH BODYCOLOR.

GOYEN, Jan or Jean
Josefsz van,
Dutch 1596-1656/65,
B,H,M,TB,DAV93,
SOT1/15/93,CH(LON)
CONTINUED

I. V. GOLEN . 1625 *VG*

VGOYEN *IVG*

**GOYEN, Jan or Jean
Josefsz van,
CONTINUED**
12/10/93,SOT(LON)
12/7/94

I V GOJEN 1627 <(grey ink)
(drawing: black chalk, light & dark grey wash)

VG VG

z VGoieN

**GRAAF (or GRAVE),
Josua de,**
Dutch 1643-1712,
B,H,M,TB,DAV93,
SOT(AMS)11/17/93&
11/15/94

Joshia De Graire. < BOTH SIGNATURES FROM
DRAWINGS OF PEN, BROWN
INK AND GREY WASH

Joshia De Grave

Joshia De Grave: 1687:

FROM DRAWING OF PEN, BROWN INK & GREY WASH

GRAFF, Anton,
German 1726-1813,
B,H,M,TB,DAV93,CHE
3/30/90,SOT(LON)
7/3/91,CH(LON)5/20/93

A. Graff <(signature from a black &
white chalk drawing)

GRAHL, August,
German 1791-1868,
B,H,TB

Gr.

GRASDORP, Willem,
Dutch 1678-1723,
B,H,DAV93,
CH1/11/89

W. Grasdorp F.

GRASSI, Joseph or Giuseppe, Austrian 1755-1838, B,H,M,TB,DAV93, SOT(MON)12/7/90	*JsGrassy* (179?)
GRAVE, Charles de, German 17th century, B,SOT1/12/90	*charles de grave le 3 doust* (brown ink)
GRAVELOT called, D'ANVILLE, Hubert Francois Bourgignon, French 1699-1773, B,H,M,TB,DAV94,CH 1/9/91,SOT(LON)10/21/92	*Gravelot* <(inscription signature from drawing of red chalk)
GREBBER, Pieter Fransz de, Dutch c.1600-1692, B,H,M,TB,DAV93, PH(LON)7/3/90, CH12/11/92	*P. DG*
GREGOIRE, Paul, French ac.1781-1823, B,PH(LON)7/2/90	*Paul Gregoire 1795* (signature from watercolor over black chalk)
GREUZE, Jean Baptiste, French 1725-1805, B,H,M,TB,DAV93, CH1/9/91&1/12/94, SOT1/15/93	*Greuze* <(from drawing: black, red & white chalk on buff paper) *J. B. Greuze*
GREVEDON, Henri Pierre Louis, French 1776-1860, B,H,M,TB,DAV93, CH(LON)11/8/94 CONTINUED	*Gr Grevedon 1834*

GREVEDON, Henri Pierre Louis
CONTINUED

Grevedon G =h=G

Henry Grevedon. 1816.

^ FROM PENCIL & GREY WASH

GRIFFIER, Jan,
Dutch 1652/56-1718,
B,H,M,TB,DAV93,
CH1/11/91,SOT(MON)
12/5/92&7/2/93

·J·GRIFFIER

JG

GRiFFiER J. GRiFFiER

**GRIMALDI, Giovanni Francesco
(called II BOLOGNESE),**
Italian 1606-1680,
B,H,M,TB,DAV93,
CH1/9/91,CH(LON)
7/2/91,SOT1/13/93

G F G

GRIMM, Samuel Hieronymous,
Swiss 1733-1794,
B,H,M,TB,DAV93,
SOT(LON)4/11/91&
11/19/92

S.H. Grimm fecit 1784 <(signature from drawing of pen, grey ink & watercolor)

GRIM(M)ER, Abel,
Flemish 1570-c.1619,
B,H,M,TB,DAV93,
CH5/31/91,SOT(LON)
7/3/91,DOR11/4/92

ARIMER.F.

GROOTH, Johann Friedrich Von,
German c.1717-c.1791,
B,DAV93,WES12/8/91

J.F.Grooth
Pinx 1746

J.f.v.Grooth

GROS, (Baron) Antoine Jean, French 1771-1835, B,H,M,TB,DAV93, CH10/26/88&5/31/91& 5/14/93	*Gros Gros*
GROSCLAUDE, Louis Amie, French 1784-1869, B,H,DAV93,SOT(Z) 12/1/88	*L. Grosclaude 1858.*
GRUBACS, Carlo, German ac.1840-1870, B,H,M,TB,DAV93, PH(LON)6/18/91, SOT1/13/93&1/12/94	*C. Grubas.* <(signature from gouache)
GRUNDMANN, Basilius, German 1726-1798, B,H,DAV93,CH12/11/92	*Grundman.* (one N at end of signature) (1788)
GRYEF(F), Adriaen De, Flemish 1670-1715, B,H,M,TB,DAV93, SOT(MON)7/2/93, CH(LON)12/10/93, SOT(LON)12/7/94	*AGryef f.* *AGryef.f* Note: Also, known to sign name with the A D G in ligature.
GUARDI, Francesco, Italian 1712-1799, B,H,M,TB,DAV93, CH1/13/93,CH(LON) 12/10/93,SOT1/10/95	*F.G.* *f.co Guardi .* (signature from drawing of pen & brown ink & brown wash)
GUERCINO (called), BARBIERI, Giovanni Francesco, Italian 1591-1666, B,H,M,TB,DAV93, SOT(LON)7/5/93, SOT1/13/93&1/10/95	*Guercino* <(inscription signature from drawing of pen, sepia ink & wash)
GUERIN, (Baron) Pierre Narcisse, French 1774-1833, B,H,M,TB,DAV93,CH(MON) 6/15/90,SOT5/28/92&10/12/94 CONTINUED	*Guerin fut* <(signature from a drawing of black chalk & brown ink)

GUERIN, (Baron) Pierre Narcisse
CONTINUED

SIGNATURE FROM PENCIL, > *Pierre Guerin 1812.*
BROWN INK & WASH.

GUEVARA, Juan Nino de,
Spanish 1632-1686,
B,H,M,CH(LON)
5/29/92

Juan Nino

(FROM DRAWING OF PEN, BROWN INK & BROWN WASH)

GUYOT, Julie,
French early 19th century,
SOT 1/12/95

Julie Guyot 1806 (APPARENTLY AN UNRECORDED ARTIST)

GYSBRECHTS, Franciscus,
Dutch ac.1674,
B,H,PH(LON)12/6/88&
12/11/90,SOT10/11/90

F. Gysbrechts

HAARLEM (or CORNELISZ),
Cornelis Cornelisz. van,
Dutch 1562-1638,
B,H,M,TB,DAV93,
CH(AMS)11/10/92&
5/6/93,CH(LON)7/9/93

ᴅH
1672

ᴅH 1636

GH.
(1600)

A° 1697
GH-

HAASBROEK (or HASBROCK),
Gerard,
Dutch late 18th century,
B,DAV93,PH(LON)
12/5/88

G. Haasbroek f. <(signature from drawing
with grey washes)

HABERT, F.,
French ac. 17th century,
DAV93,SOT(MON)
6/17/88,CH(LON)
4/23/93

F·HABERT·
1651

HACKAERT (or HACKAART), Jan,
Dutch 1629-1699,
B,H,M,TB,DAV93,SOT(MIL)
10/5/93,CH(LON)7/9/93,
SOT(LON)12/7/94

HACKAART **J·H**

HACKERT, Jacob Phillip,
German 1737-1807,
B,H,M,TB,DAV93,
CH(LON)4/16/91,
SOT(LON)7/8/92&
12/7/94

Filippo Hackert 1797.

HAENSBERGEN, Jan or
Johann van,
Dutch 1642-1705,
H,DAV93,CH5/31/91,
CH(LON)12/10/93&
7/9/93

I V H

HAEVENAUX, W.,
Dutch 18th century,
PH(LON)12/5/88

YHaevenaux f. <(signature from drawing:
colored chalk)

HALLE, Noel,
French 1711/1781,
B,H,M,TB,DAV93,
SOT(LON)7/2/90,
CH(MON)6/20/92,
CH(LON)7/9/93

Hallé hallé <(signature from drawing of black & white chalk)

1763 Halle

HALS, Dirck,
Dutch 1591-1656,
B,H,M,TB,DAV93,
SOT(LON)12/9/92,
SOT5/20/93&1/12/95

DHALS 1624 DH

DH DHALS·1623

HALS, Frans (the elder),
Dutch 1580-1666,
B,H,M,TB,DAV93,
SOT10/11/90,
CH5/31/90&1/11/91

FH Hals FH

HAMBACH, Johann Michael,
German 17th century,
B,DAV93,PH(LON)
12/11/90&4/16/91,
CH2/11/92

M: Hambach fee: 167? AM

HAMEN Y LEON (or
VANDERHAMEN Y LEON),
Juan van der,
Spanish 1596-1631,
B,M,TB,DAV93,
CH1/10/90&5/14/93,
SOT1/14/94

Ju Vander Haman de Leon a. 1622.

Ju Vander Samen fat. ·1622·

HAMILTON, Carl Wilhelm de,
Austrian 1668-1774,
B,H?,M,TB,DAV93,
SOT(LON)7/4/90,
CH(AMS)5/2/91

C.W.D.H. 1735

HAMILTON, Johann Georg de,
Flemish 1672-1737,
B,H,M,TB,DAV93,
CH10/12/89,SOT(LON)
7/4/90,NAG12/4/92

*Jean Geo. d'Hamilton. Peintre
1724*

HAMILTON, Philip
Ferdinand von or de,
Flemish 1664-1750,
B,H,M,TB,DAV93,
SOT(LON)12/8/93,
CH(LON)7/9/93

PVH

HANCOCK, Charles,
English 1793-1855,
B,H,DAV93,CH6/5/93

*C.HANCOCK
1827*

HANNEMAN, Adriaen,
Dutch 1604-1671,
B,H,M,TB,DAV93,
PH(LON)2/27/90,
SOT10/11/90,CH(LON)
4/18/91

*Aº. 1656
Adn Hanneman F.*

HANTZSCH, Johann Gottlieb,
German 1794-1848,
B,H,DAV93,SOT(MON)
12/5/92

I.H

HARDIME, Pieter,
Flemish 1677-1758/59,
B,H,M,TB,DAV93,
CH1/13/90,PH(LON)
7/2/91,SOT5/20/93

*P.Kard. P.hardime
P.hardimé,*

HARDING, James Duffield, English 1798-1863, B,H,M,TB,DAV93, CH10/26/88,SOT(LON) 11/15/90&11/19/92	·H·	*JDH*
HARVEY, George, Anglo/American 1800?-1878, B,D,F,H,I,M,TB,DAV93, BB3/21/90,CH5/31/90, SK3/8/91	G.Harvey 1846	
HAS, H. (may be HAAS, Hans), German ac.1517-1548, TB,DAV93,CH1/16/92	·H·HAS· ·MALER·	
HASSELT, W., Dutch ac.1670, PH(LON)12/6/88	*W Hasselt. Fec*	
HATHAWAY, Rufus, American 1770-1822, B,D,H,DAV93, RB11/29/86	RH	
HAUDEBOURT, Antoinette Hortense, nee LESCOT, French 1784-1845, B,H,M,TB,DAV94, SOT(MON)12/2/94	*Hort.H* ALSO, KNOWN TO SIGN WORK H. LESCOT	
HAVELL, Robert, Jr., Anglo/American 1793-1878, B,H,M,TB,DAV93, SOT(ARC)9/23/88	R.H.	
HAVELL, William, English 1782-1857, B,H,M,TB,DAV93, SOT(LON)5/27/87& 5/12/93	*W.HAVELL 1852*	

HAYES, Edward, Irish 1797–1864, B,H,M,TB,DAV93, SOT(LON)4/24/86	*Edwd Hayes* *1844*
HAYES, John, English 1786–1866, B,H,M,TB,DAV94, CH(LON)7/16/91,CH 5/25/94	*John Hayes*
HAYEZ, Francesco, Italian 1781–1881, B,H,M,TB,DAV93, BB5/20/92,SOT(MIL) 10/14/93	*F.Hayez*
HAYTER, (Sir) George, English 1792–1871, B,H,M,TB,DAV93, CH(LON)3/20/91, SOT(LON)5/16/90&6/10/93	*GeorgeHayter* *GH 1820* *GH* *1851*
HECK, Claes Dircksz van der, Dutch 1571-after 1648, B,H,M,TB,DAV94, SOT(MON)6/19/94	*Heck fecit 1655*
HEDA, Gerrit Willemsz, Dutch c.1620-c.1702, B,H,M,TB,DAV93, SOT(MON)6/16/90, CH(LON)3/1/91, SOT1/14/94	*Gerret HeDA ,646* *·HEDA·* *1642*
HEDA, Willem Claesz., Dutch 1594-1680, B,H,M,TB,DAV93, SOT(LON)4/17/91& 7/3/91,CH(AMS) 11/10/92	*HEDA* *·HEDA·* *1633* *·1632·*

HEEM, Cornelis de,
Dutch 1631–1695,
B,H,M,TB,DAV93,
SOT(MON)12/5/92,
SOT1/14/94,CH1/11/95

C CDECHEEMf. C D.f

C.DECHEEM.f

HEEM, Jan Davidsz. de,
Dutch 1606–1684,
B,H,M,TB,DAV93,
CH(LON)7/5/91,
SOT(LON)12/9/92,
SOT5/20/93

J De Seem fecit
A° 1653

G. d De Heem

HEEMSKER(C)K, Egbert, Sr.,
Dutch 1610–1680,
B,H,M,TB,DAV93,
PH(LON)7/3/90,
CH(LON)4/18/91,
CH(AMS)5/7/92

HR EHK
(HK) (EHK)

E:HeemsKerck 1686

HEEMSKER(C)K, Egbert, Jr.,
Dutch/English c.1634–1704,
B,H,M,TB,DAV93,
CH(AMS)5/7/92,
CH10/7/93,SOT(AMS)
11/17/93

E:HKerck HR LOOKS LIKE H R,
 REALLY IS H K

E.HK

HEEMSKER(C)K, Maarten van,
Dutch 1498-1574,
B,H,M,TB,DAV93,
CH5/31/90,CH(AMS)
11/25/92,SOT(AMS)
11/17/93

M Heemskerch 1567
(signature from drawing of pen, brown ink & chalk)

Heemskerck <(signature from engraving)

Martinus van

Heemskerch 1549.
(SIGNATURE FROM DRAWING OF PEN, BROWN & BLACK INK)

HEER, Gerrit Adriaenisz. de,
Dutch 1606-after 1652,
B,H,DAV93,SOT(AMS)
11/16/93

G. de Heer < PEN AND BROWN INK
ON VELLUM, BLUE PAPER

NOTE: DATES SOMETIMES LISTED AS 1634-1681. SOME
WORKS BY GERRIT'S SON WILLEM (or GUILLAM)
ARE SIGNED THE SAME WAY THUS CREATING SOME
UNCERTAINTY AS TO IT'S AUTHOR

HEER, Margareta De,
German/Dutch before
1603-before 1665,
H,DAV94,PH(LON)
4/20/93,SOT(AMS)
5/10/94

Margareta D Heer
Fecit
FROM DRAWING OF BLACK INK AND GOUACHE
ON VELLUM.

HEEREMANS, Thomas,
Dutch 1640-1697,
B,H,DAV93,CH5/14/93,
CH(LON)7/9/93,
SOT(LON)12/7/94

FMANS-1691 *FMANS*

HMAN·f·1686 *Fm* (1680)

HEIDECK (or **HEIDEGGER** or **HEYDECK**), Carl Wilhelm, German 1788-1861, B,H,M,TB,DAV93, SOT(MUN)12/10/92	*C. v Bak.* *V Hak*
HEIDELOFF, Carl Alexander von, German 1789-1865, B,H,TB	H
HEIL, Daniel van, Flemish 1604-c.1662, B,H,M,TB,DAV93, CH(LON)4/23/93, SOT(LON)10/27/93& 12/7/94	*D.V.H.*
HEIM, Francois Joseph, French 1787-1865, B,H,M,TB,DAV93, PH7/26/86,CH10/26/88	*Heim* *Z* *Z* *Heim 1827*
HEIMBACH, Wolfgang, German 1613-1678, B,H,DAV93,CH(LON) 4/14/91,SOT(LON) 7/3/91,LEM12/2/92	H W 1642
HEIN, H. H., German ac. 19th century, DAV93,CH(MON) 12/2/89	*H.J.Hein.fect*
HEINS, John Theodore, German/English 1732-1771, B,H,M,TB,DAV94, SOT5/20/93,PH(LON) 12/13/94	*Heins. Fec.1748.*

HEINSIUS, Johann Ernst,
German 1740-1812,
B,H,M,TB,DAV94,
SOT(MON)6/19/94

heinsius
pinxit

HEIN(T)Z, Joseph, Sr.,
Swiss 1564-1609,
B,H,DAV93,SOT(LON)
7/2/90,CH(LON)
7/4/91,SOT(MON)
12/5/92

Ioseph Heintz <(signature from
a drawing of
red & black chalk)
1 5 9 4

HELMONT, Mattheus van,
Flemish 1623-1674/79,
B,H,M,TB,DAV93,
SOT(AMS)5/12/92,
SOT1/12/95

*MV
Helmont
f 1679*

HENNEQUIN, Philippe Auguste,
French 1762-1833,
B,H,M,TB,DAV93,
PH(LON)12/12/90

Hennequin <(signature from a drawing of
pen & grey ink with wash)

Hennequin.

P. A. Hennequin.

FROM DRAWING OF BLACK CHALK, PEN & BLACK INK,
GREY WASH, HEIGHTENED WITH WHITE, BLUE PAPER.

HENNIG, Gustav Adolf,
German 1797-1869,
B,H,M,TB,DAV93,
PH(MAR)1/27/89

AGH

HENSEL, Wilhelm,
German 1794-1861,
B,H,M,TB,DAV93,
CH(LON)6/21/91

HWH *W*

HENSTENBURG, Anton,
Dutch 1695-1781,
DAV93,CH1/13/93,
SOT(AMS)11/17/93

A: HB. fec =
(bodycolor on vellum)

HENSTENBURGH, Herman,
Dutch 1667-1726,
H,DAV93,SOT(LON)
7/5/93,SOT1/13/93&
1/12/94

C H: Henstenburgh. fec =

∧(watercolor, bodycolor & gold ink)

C+B. fe = *H:HB:fe =*

(above: both monograms in grey ink. Watercolors)

HERGENRO(E)DER, Georg Heinrich,
German 1736-c.1794,
B,H,DAV93,CH(AMS)
11/10/92&5/6/93

HergenRoeder

HERRERA (EL VIEJO), Francisco,
Spanish 1576/90-1656,
B,H,M,TB,DAV93,
SOT(MAD)5/18/93

Fran de Herrera
1642 (SIGNATURE FROM DRAWING)

HERRING, John Frederick, Sr.,
English 1795-1865,
B,H,M,TB,DAV93,
CH(LON)1/15/91,
SOT6/5/92,CH5/27/93

J.F.Herring. 1834

J.F.Herring. Sen" 1852.

J. F. H. 1851. *J.F.H*

MANY PICTURE EXAMPLES IN CATALOGUE SOT6/3/94

HERSENT, Louis,
French 1777-1860,
B,H,M,TB,DAV94,
SOT5/26/94

L Hersent 1830

HESS, HIERONYMOUS,
Swiss 1799-1850,
B,H,M,TB,DAV93,
SOT(Z)11/28/85

HHeSs 1828.

HESS, Peter Heinrich
Lambert van,
German 1792-1871,
B,H,M,TB,DAV93,
Parke Bernet-NY
4/2/75

Peter Hess.
1861.

P.H.

HESSE, Henri Joseph,
French 1781-1849,
B,H,M,TB,DAV93,
CH(MON)7/2/93,
SOT(ARC)7/23/93

FROM WATERCOLOR > Hesse.1829.

Hesse 1810

SIGNATURE FROM DRAWING OF BLACK CHALK
AND BROWN WASH

HEUSCH, Jacob de,
Dutch 1657-1701,
B,H,M,TB,DAV93,
PH(LON)2/27/90,
SOT(MIL)5/18/92,
CH(LON)7/9/93

Heusch Heusch.f

Heusch f.

HEYDEN, Jan van der,
Dutch 1637-1712,
B,H,M,TB,DAV93,
SOT6/2/89,CH1/14/93,
CH(LON)7/9/93

VHeyden <(signature from an oil painting
on glass, painted in reverse)

JHeyden

IVDHeijde ?
1668

HICKEL, (Karl) Anton,
Austrian 1745-1798,
B,H,M,TB,DAV94,
CH(LON)7/9/93

Hickel p.
1790

HICKEY, Thomas,
Irish 1741-1824,
B,H,M,TB,DAV93,
PH(LON)7/9/91,
SOT(LON)2/28/90&
4/6/93

T·HICKEY
1782

HILAIRE, Jean Baptiste,
French 1753-1822,
B,H,M,TB,DAV93,
SOT1/8/91&10/8/93,
CH1/13/93

B.Hilair. 1783

B. Hilair <(signature from
drawing of pencil
& watercolor)

SIGNATURE FROM WATERCOLOR
OVER BLACK CHALK. HILAER
IS CORRECT.

hilaer. 1790

HILLIAR (or HILLIYARDE),
Nicholas,
English 1547-1619,
B,H,M,TB,DAV93,
CH(LON)7/10/91,
SOT(LON)7/11/91

H.

HILLS, Robert,
English 1769-1844,
B,H,M,TB,DAV93,
SOT(SUS)5/20/91,
CH(LON)7/9/91,
CH(SK)10/8/92

R.Hills 1810 <(from watercolor over pencil)

FROM PENCIL & WATERCOLOR R.Hills
> 1838

HIMPEL (or TER HIMPEL),
Aernout Ter,
Dutch 1623/34-1686,
B,H,DAV93,CH(AMS)
11/12/90&11/25/92,
CONTINUED

AH ATH <(initials from drawing of
pen & brown ink & grey wash)

HIMPEL (or TER HIMPEL), Aernout Ter <u>CONTINUED</u> SOT(AMS)11/17/93	*1654. a. ter Simpel.* FROM DRAWING OF BRUSH, GREY INK & BLACK CHALK
HIRSCHVOGEL, Augustin, German c.1503-1553, B,H,M,R,TB,DAV94	 MONOGRAM FROM ETCHING F IN MONOGRAM IS FOR FECIT
HIRT, Wilhelm Friedrich, German 1721-1772, B,H,M,TB,DAV93, PH(LON)12/11/90& 7/2/91,STU5/20/93	*W. F. HiRT* *1755*
HOCH, Johann Jacob, German 1750-1829, B,H,DAV93, SOT1/13/93&1/12/94	*joh. jacob Hoch P:* *1774* <(from gouache)
HOECKE, Robert van den, Flemish 1622-1668, B,H,DAV93,Parke Bernet- NY 1/12/79,DOR3/10/90 (School of)	*RobeRT vanden Hoecke.*
HOEFEL (or HOFEL), Blasius, Austrian 1792-1863, B,H,TB	*HB*
HOEF(F), Abraham van der, Dutch ac.1613-1649, A,B,M,TB,DAV93, CH(MON)6/20/92	*AHoef* *1642*
HOET, H., Dutch ac. mid 17th century, SOT(AMS)11/16/93, Braunsschweig, Herzog Anton Ulrich Museum	*H. Hoet. fecit* *A° 1649* < GRAPHITE ON VELLUM

HOFFMANN, Hans or Johann,
German 1545-1600,
B,H,M,TB,DAV93,
CH(LON)7/3/90,
WD1/23/91&3/27/91

<(signature from watercolor on vellum)

1578

HOGARTH, William,
English 1697-1764,
B,H,M,TB,DAV93,
CH(LON)3/1/91,
SOT(LON)7/10/91,
SOT10/14/92

W Hogarth

H. W H

HOLDEN, Samuel,
English c.1800-1860,
B,DAV93,CH(LON)
7/14/92

S. Holden 1837 Noted botanical artist
(FROM PENCIL & WATERCOLOR HEIGHTENED WITH GUM ARABIC)

HOLLAND, James,
English 1799/1800-1870,
B,H,M,TB,DAV93,
CH(LON)6/15/90&
7/14/92,PH(LON)
5/10/93

Ja Holland
(1862)

H <(initials from watercolor)

JH JH 1846 JHH
 1863

Holland 1826 < FROM PENCIL & WATERCOLOR, HEIGHTENED WITH GUM ARABIC

HOLLAR, Wenceslaus von Prachna,
Czechoslovakian 1607-1677,
B,H,M,TB,DAV93,
PH(LON)4/9/91,SOT(LON)
7/11/91,BB2/25/92

W: Hollar 1644 W Hollar 1647.

W Hollar fecit 1645 <(SIGNATURE FROM ETCHING)

HOLMAN, Francis,
English ac.1760-1790,
B,H,M,TB,DAV93,
CH(LON)4/20/90,
SOT6/8/90,SOT(LON)
4/6/93

Holman
1789

F. Holman
(1782)

HONDECOETER, Gillis Claesz. de,
Dutch 1575-1638,
B,H,M,TB,DAV93,
SOT5/20/93,CH(AMS)
11/18/93,SOT(LON)
12/7/94

G · H
1623

G · H ·
A 1619

G · H :
A 1625

HONDECOETER, Melchior de,
Dutch 1636-1695,
B,H,M,TB,DAV93,
SOT(LON)7/8/92,
CH(LON)7/9/93,
SOT1/14/94

MD Hondecoeter

Melchior de hondecoeter

HONDIUS, Abraham,
Dutch 1625/30-1695,
B,H,M,TB,DAV93,
PH(MAR)12/8/89,
SOT(LON)12/12/90&
7/8/92

Abraham Hondius

HN

A Hondius

HONDIUS, Hendrick de, Sr.,
Dutch 1573-1650/60,
B,M,TB,DAV93,SOT(AMS)
11/21/89,CH(AMS)11/25/92

Hh. 1642 <(monogram & date in brown ink)
(pen & brown ink over black chalk on vellum)

HONE, Horace,
English 1756-1825,
B,H,M,TB,DAV93,
PH(LON)4/22/91,
CH(LON)7/10/91,
CH(GEN)5/25/93

*HH
1777* (INITIALS FROM MINIATURE PORTRAIT)

HOOCH, Charles Cornelisz. de,
Dutch ac.1627-1638,
B,H,M,TB,DAV94,
CH(LON)7/5/91,
CH(AMS)5/11/94

charles d hooch

Charles d hooh HOOH IS CORRECT

HOOCH (or HOOGH),
Pieter de,
Dutch 1629-1681/84,
B,H,M,TB,DAV93,
CH(LON)7/6/90,
SOT(LON)12/9/92,CH1/11/95

*P·DH·
1653*

*P·D·H·
1658*

HOOGSTRAATEN, Samuel van, Flemish 1627-1678, B,H,M,TB,DAV93, CH1/16/92,SOT(LON) 2/18/91&4/13/92	S.v.H. S.v.H. 1669.
HOOP, Piere de, Dutch ac.1800, DAV93,CH(AMS) 11/14/88	Piere de Hu (signature intermixed with 'Tromp l'Oeil' subjects, pen & brown ink & watercolor)
HOPFER, Daniel, Dutch c.1470-1536, B,H,M,R,TB,DAV93, PH(LON)6/29/92	D.H <(INITIALS TAKEN FROM ETCHING)
HOPPENBROUWERS, **Johannes Franciscus,** Dutch 1791-1866, B,DAV93,CH(AMS) 4/26/89&10/28/92	J.F. Hoppenbrowers 53
HOREMANS, Jan Joseph, Sr., Dutch 1682-1759, B,H,M,TB,DAV93, SOT(MON)7/2/93, CH10/7/93,SOT1/12/95	JHoremans.1720 JHormans. FROM DRAWING OF BLACK CHALK, PEN AND BROWN INK > JH
HOREMANS, Jan Joseph, Jr., Dutch 1714-1790, B,H,M,TB,DAV93, CH(LON)7/5/91, SOT7/17/91,SOT(LON) 12/9/92	JHoremans.
HORSTINK, Warnaar, Dutch 1756-1815, B,DAV93,CH(AMS) 11/25/92	Wr.Horstink jr. 1796

HORSTOK, Johannes
Petrus van,
Dutch 1745-1825,
B,H,DAV93,CH(LON)
10/5/90

J. P. Horstok

HOTHAM, George,
English 1796-1860,
DAV93,SOT(LON)
7/14/88&11/2/88,
Husband of Amelia

GH <(initials from drawing)

HOUBRAKEN, Arnold,
Dutch 1660-1719,
B,H,M,TB,DAV93,
PH(LON)4/16/91,
CH10/9/91,SOT(AMS)
5/12/92

ARN. HOUBRAKEN *1718.*
(Pen, brown & black inks)

A H A6

HOUTEN, Gerard van,
Dutch -1706,
B,DAV93,CH1/11/89

G. van Houtenf
(from drawing: red chalk, pen &
brown ink, grey wash)

HOUTEN, P. P. Van,
Dutch? ac.1816,
DAV94,CH(LON)7/16/93

P: P: van HOUTEN **1816**
SIGNATURE FROM WATERCOLOR

HOUTMAN, M.,
Dutch ac. early 19th
century,
DAV93,SOT4/5/90

M. Houtman fecit 1816

HOWELL, Henry,
English ac.1660-1720,
SOT5/20/93

*Henry Howell
Anno 1702*

HOWITT, William Samuel, English 1765-1822, B,H,M,TB,DAV93, CH(LON)7/9/91, SOT6/7/91&6/5/92	*Howitt* <(signature from a watercolor with traces of pencil)
HUBNER (or HUEBNER), Leonart, German? ac.1675, DAV93?,PH(LON) 7/4/89	*L.Hubner. Pinxit.*
HUCHTENBURGH, Jan van, Dutch 1647-1733, B,H,M,TB,DAV93, SOT(LON)12/8/93, SOT1/12/94,SOT(LON) 12/7/94	*.JHB.* *JHB*
HUDSON, Thomas, English 1701-1779, B,H,M,TB,DAV93, PH(LON)7/9/91,SOT 5/20/93,SOT(MON) 7/2/93	*Hudson Pinxit 1750*
HUE, Jean Francois, French 1751-1823, B,M,TB,DAV93,SOT(LON) 12/12/90,WD1/23/91, SOT1/15/93	*JF Hue* *hue*
HUET, Christophe, French 1694-1759, B,H,M,TB,DAV93, CH5/31/91,SOT(MON) 6/19/92	*C. Huet. 1734*
HUET, Jean Baptiste, Sr., French 1743/45-1811, B,H,M,TB,DAV93,SOT 5/20/93&1/12/94,SOT(LON) 12/7/94 CONTINUED	*J.B.Huet.1788..* *J.B.Huet* FROM PEN, BROWN INK AND > *huet 1777* WASH OVER BLACK CHALK. *JBH* (red chalk) *J.B.Huet*

HUET, Jean Baptiste, Sr.,
CONTINUED

J. B. Huet 1762 <(signature from drawing of red, black, white & blue chalk)

HULSDONCK, Jacob van,
Flemish 1582-1647,
B,H,DAV93,SOT(LON)
7/4/90,CH(LON)4/18/91,
SOT(AMS)11/11/93

VHVLSDONCK·Ft.

HULST, Frans De,
Dutch 1610-1661,
B,H,DAV93,CH(LON)
3/1/91,BB6/19/91,
SOT(LON)4/21/93

F. D. HULST

HUNT, William Henry,
English 1790-1864,
B,H,M,TB,DAV93,
BB5/31/90,CH2/26/91,
CH(LON)7/14/92

W. HUNT *W. HUNT 1833*

Wm. HUNT. 1827
FROM PENCIL & WATERCOLOR WITH SCRATCHING OUT

HUSSON, Jeanne Elisabeth
(veuve CHAUDET),
French 1767-1832,
B,M,TB,DAV93,
SOT(MON)6/17/88

Eh chaudet.

HUYS, Frans,
Belgian 1522-1562,
B,M,TB,DAV93,
SOT(LON)6/27/88

·F·H· (initials from etching with engraving)

HUYSUM (or HUIJSUM),
Jan van,
Dutch 1682-1749,
B,H,M,TB,DAV93,
SOT5/22/92&5/20/93,
CH1/12/94
CONTINUED

Jan Van Huijsum <(black ink)
(greasy black chalk drawing)

Jan Van Huijsum

HUYSUM (or HUIJSUM),
Jan van
CONTINUED

INGRES, Jean Auguste
Dominique,
French 1780-1867,
B,H,M,TB,DAV93,
CH10/16/91,CH(LON)
7/7/92,SOT(MON)
7/2/93

Yngres *INGRES*

J Ingres *Ingres 1836*

Ingres roume 1813

(signature from pencil drawing)

ISABEY, Jean Baptiste,
French 1767-1855,
B,H,M,TB,DAV93,
CH1/9/91,CH(LON)
4/16/91,SOT(MON)
6/19/92

J. Isabey *J J*

ISLAS, Andreas de,
Mexican 18th century,
SOT11/23/93

Andreas·ab·Iſlas (1770)

ITALIAN SCHOOL,
17th century,
SOT(LON)7/2/90

G. C <(initials from drawing of pen
& brown ink over black chalk)

JACOPO DE CAROLIS, ac. late 14th-early 15th century, CH1/16/92	**Jacobs de carolis** (FROM PAINTING OF TEMPERA ON GOLD GROUND) NOTE: From only known signed painting.
JANNECK, Franz Christoph, Austrian 1703-1761, B,H,M,TB,DAV93, SOT(LON)7/3/91, DOR3/9/93,SOT(LON) 12/7/94(lot 273)	*F.C.J.*
JANSON, Johannes, Dutch 1729-1784, B,H,DAV93,CH(AMS) 11/25/92&5/6/93, SOT(LON)10/27/93	*J°.Janson f. 1783* *J°Janson f 1783*
JANSSENS, Hieronymus, Flemish 1624-1693, B,H,M,TB,DAV94, SOT4/11/91,SOT(AMS) 5/10/94	*J. Janssens fecit*
JARVIS, John Wesley, American 1780-1840, B,D,F,H,I,M,DAV93, CHE1/24/90,CH(LON) 3/19/91,CH5/28/92	*JARVIS* *1807* <(signature from drawing of watercolor, gouache & pencil)
JEAURAT (or JORAS), Etienne, French 1699-1789, B,H,M,TB,DAV93, SOT(LON)4/17/91,SOT(MON) 6/19/92,SOT(LON)12/7/94	*E Jeaurat* *P 1766* *Jeaurat* *pinxit* *1734*
JEFFERSON, John, English ac.1811-1825, H,CH(SK)11/4/93	*John Jefferson* *1813*
JENSEN, Johan Laurentz, Danish 1800-1856, B,H,M,TB,DAV93, CH(LON)3/29/90, SOT(ARC)7/17/91, CHE4/28/93	*I.L.JENSEN* *J.L.JENSEN.* *1834*

JOLI, Antonio, Italian c.1700-1777, B,H,DAV93,CH1/16/92, CH(LON)12/10/93& 7/9/93	*AI*
JOLLIVET, Pierre Jules, French 1794-1871, B,H,M,TB,DAV93, SOT(MON)6/18/88	*J. Jollivet* 1834
JONES, George, English 1786-1869, B,H,M,TB,DAV93, PH(LON)5/1/90, SOT7/11/90,CH(LON) 7/14/92	*GJ* <(FROM DRAWING OF BLUE, BROWN & GREY WASH, SOME WHITE & SCRATCHING OUT)
JONES, Thomas, English 1743-1803, B,H,M,TB,DAV93, SOT3/14/90,PH(LON) 4/23/90&4/27/93	*JJ 1777* <(signature from watercolor over pencil) *Thos Jones* (1774)
JONES, William, English ac.1764-1777, B,H,DAV93,PH(LON) 12/13/88,SOT(LON) 2/28/90,CH10/15/92	*W. Jones. 1777*
JOHGH, Claude de, Dutch -1663, B,H,DAV93,SOT7/17/91& 1/15/93	*Song* (h?) *1634*
JORDAENS, Hans, Sr., Dutch c.1539-1630, B,H,M,TB,DAV94, CH(LON)4/20/94, SOT(LON)12/7/94	*h Joerdaens* < JOERDAENS IS CORRECT

JORDAENS, Hans III, Dutch 1584/95-1643, B,H,M,TB,DAV93, PH(LON)7/3/90, CH(LON)4/23/93, CH10/7/93	*H. Jordaens.*
JORDAENS, Jacob, Flemish 1593-1678, B,H,M,TB,DAV93, SOT(LON)7/3/91, CH(AMS)11/25/92, CH(LON)12/10/93	*J·Jor.* *Jordaens f* (1652) (signâture from drawing of black lead, black & red chalk, light brown wash)
JORDAENS, Simon, Flemish 1590-1640, B,DAV93,CH(AMS) 11/28/89,PH(LON) 3/5/91	*S. JORDAENS*
JOUETTE, C. W. or C. M., French ac. late 18th century, CH(MON)6/20/92, SOT(MON)7/2/93	*C. W. Jouette* <(FROM PASTEL) NOTE: Exhibited SALON du COLISEE 1797
JUAREZ, Luis, Mexican ac.1590-1635, B,H,SOT11/15/94	*Luis Juarez Fa. nJ615.*
JUEL, Jens, Danish 1745-1802, B,H,M,TB,DAV93, PH(LON)7/2/91, CH1/14/93,CH(LON) 12/10/93	*Juel pinxit 1778*
JULIEN, Jean Antoine, Italian 1736-1799, B,H,SOT(MON)6/18/88, CH(LON)4/19/91	*Julien fecit 1773*

JULIENNE, Eugene,
French c. 1800-1874,
B,DAV93,SOT1/13/88

E.JULIENNE. <(signature from gouache)
EX. A. SEVRES.
(painter of porcelain for Sèvres Factory)

JUNCKER, Justus,
German 1703-1767,
B,H,M,TB,DAV93,
CH(LON)2/7/91,
CH12/11/92,SOT
1/14/94

Juncker (1761)

KALF, Willem, Dutch 1619-1693, B,H,M,TB,DAV93, SOT1/10/91,SOT(LON) 12/9/92	KALF <(signature from oil on copper)
KALRAET (or CALRAET), Abraham, Dutch 1642/43-1721/22, B,H,M,TB,DAV93, CH(LON)7/5/91, CH5/31/91&5/14/93	A.C.
KAUFFMAN, Angelica C. M. A., Swiss 1740-1807, B,H,M,TB,DAV93, CH1/10/91,SOT1/17/91, CH(MON)12/4/93	Angelica Kauffman. (ALSO SIGNS WORK WITH INITIALS A K, AND A MONOGRAM A C)
KEISERMAN, Franz or Francois, Swiss 1765-1833, B,DAV93,SOT(ARC) 7/17/91,CH(LON) 4/10/93,SOT(LON)7/5/93	F. Keiserman. Roma 1803 (signature from drawing of pencil & watercolor)
KELDERMAN, Jan, Dutch 1741-1820, B,H,DAV93, SOT1/14/94	Jan Kelderman,
KERCKHOFF, Frans, Dutch ac.1661, B,CH5/18/94	F kerkhof F.K.
KER(C)KHOVE, Joseph van den, Flemish 1667-1724, B,H,M,TB,DAV93, CH(MON)7/3/93	I.VD.K. V.d.Kerckhove.

KERKHOFF, Daniel Johannes Torman, Dutch 1766-1821/31, B,H,M,TB,DAV93, CH(AMS)11/20/89& 10/24/92	*DL Kerkhoff* <(signature from drawing: pencil, pen & black & grey ink, grey wash, brown ink framing lines)
KESSEL, Jan or Johan van I, Flemish 1626-1679, B,H,M,TB,DAV93, SOT(MON)12/2/89, SOT(LON)12/9/92, SOT1/14/94	*J V Kessel* *J. GV. Kessel. 1652* *V KESSEL* *I.V. Kessel.f.*
KESSEL, Jan or Johan II, Dutch 1654-1708, B,H,M,TB,DAV93, SOT(LON)7/4/90, CH(LON)7/5/91, ADE12/15/92	*J.cv.Kessel. f.*
KESSEL, Jan van III, Dutch 1641-1680, B,H,M,TB,DAV93, CH12/11/92,SOT(LON) 12/7/94	*JVC* *Frkessel*
KEUN, Hendrik, Dutch 1738-1787/88, B,DAV93,CH(AMS) 11/20/89&11/18/93	*H Keun 1771* <(signature from drawing: black chalk, pen & grey & brown ink, watercolor, grey ink framing lines)
KEYSE, Thomas, English 1722-1800, B,H,M,TB,DAV93, SOT10/14/92, PH(LON)4/27/93	*Keyse 1762* *T. REYSE 1757*
KEYSER, Thomas de, Dutch 1596-1667, B,H,M,TB,DAV94, SOT7/17/91,SOT(LON) 12/7/94	*TĐ 1637*

KINSON (or KINSOEN),
Francois Joseph,
Flemish 1771-1839,
B,H,M,TB,DAV93,
CH(MON)12/2/89,
CH2/26/91,
SOT10/29/92

KINSON 1822

F. Kinsoen.

KIO(E)RBO(E), Carl
Friedrich,
Swedish 1799-1876,
B,H,M,TB,CH(LON)
2/16/89,ABS5/11/93

Kiorbo *Kiorboe*

KLEIN, Johann Adam,
German 1792-1875,
B,H,M,TB,DAV93,
DOB5/5/93

AK

KLYHER,
Dutch? 17th-18th century,
SOT(MON)6/19/92

KLYHER
INV & F

KNELLER (or KNILLER), (Sir)
Godfrey or Gottfried,
German/English 1646/49-1723,
B,H,M,TB,DAV93,
BB5/20/92,CHE4/27/93,
CH1/11/95

G. Kneller *GK*

KNIP, Josephus August,
Dutch 1777-1847,
B,H,DAV94,SOT1/13/93,
CH(AMS)11/17/94

JAKnip
1816

KNIP, Nicolaas Frederik,
Dutch 1742-c.1802/09,
B,H,DAV93,PH(LON)
7/3/90,SOT10/14/92

NFKnip 1789

KNOLLER, Martin,
Austrian 1725-1804,
B,H,M,TB,DAV94,
SOT(LON)12/7/94

M.Knoller.P
1782

KNYFF, Wouter,
Dutch 1607-1693,
B,H,M,TB,DAV93,
SOT(AMS)11/14/90,
SOT(LON)4/21/93

WK *WK 1641*

KOBELL, Jan II or Jean
Baptiste,
Dutch 1778-1814,
B,H,M,TB,DAV94,
WD1/20/93,
SOT1/12/95

J. Kobell

KOBELL, Wilhelm
Alexander Wolfgang von,
German 1766-1855,
B,H,M,TB,DAV93,
CH1/9/91,CH(LON)
3/17/89&5/20/93

WKobell *WKobell*
1823 *1838*

Wilhelm Kobell 1803
(SIGNATURE FROM PEN & INK & WATERCOLOR WITH WHITE)

Wilhelm v Kobell 1838.
FROM PENCIL & WATERCOLOR, HEIGHTENED
WITH WHITE.

KOEKKOEK, Jan Hermanus,
Dutch 1778-1851,
B,H,DAV93,CH(LON)
11/30/90,SOT(LON)
6/9/91,SOT(AMS)
11/2/92

H.Koekkoek

KOENIG (or KONIG),
Johann or Hans,
German c.1586-c.1642,
B,H,DAV93,PH(LON)
4/16/91,SOT(MON)
7/2/93

IK·F·i618·
THE F STANDS FOR Fecit

KOETS, Andries, Dutch 1622- , B,SOT(AMS)11/17/93	*Koets*	ANDRIES WAS THE ELDEST SON OF ROELOF KOETS THE ELDER

KOETS, Roelof, Sr., Dutch c.1592-1655, B,H,DAV93,PH(LON) 7/2/91,CH(AMS) 11/10/92,CH(LON) 7/9/93	*Koets·f·*

KOLLMAN(N), Karl Ivanovich, Russian 1788-1846, B,M,TB,DAV93,CH(LON) 10/5/89,SOT(LON) 11/24/92,SOT1/12/94	*Kollman 1842* <(signature from watercolor with pencil) *Kollmann 1839* (pencil signature from drawing of pencil & watercolor)

KONINCK, Salomon, Dutch 1609-1656/68, B,H,M,TB,DAV94, CH(LON7/9/93	*S Koninck·A° 1645*

KOOL, Willem, Dutch 1608-1666, B,H,DAV94,CH(LON) 4/23/93,CH(AMS) 11/17/94	*WK* *WKooL*

KRAFFT, Johann Peter, German/Austrian 1780-1856, B,H,M,TB,DAV93, SOT(LON)6/22/83	*PK*

KRUGER (or KRUEGER), Ferdinand Anton, German 1793/95-1857, B,H,M,TB	*AK*

KRUSEMAN, Cornelis,
Dutch 1797-1857,
B,H,M,TB,DAV93,
CH10/26/88,CH(AMS)
4/24/91

C. Kruseman 1835

KUIPERS, Cornelis,
Dutch ac.1756-1784,
B,DAV93,CH(LON)
12/16/88,CH1/16/92

C.ᔆ=KUIPERS, FJ779

LAAN, Adolf van der,
Dutch 1684-1755,
B,DAV93,CH1/11/89,
CH(AMS)11/24/92

Adolf van der Laan

FROM DRAWING OF BLACK CHALK, PEN & BROWN INK, &
GREY WASH

LABATIE, Pierre,
French -1777,
B,DAV94,SOT(LON)
7/7/93

Labatie pinxit 1773

LABILLE GUIARD, Adelaide,
French 1749-1803,
B,H,M,TB,DAV93,
CH(MON)12/4/92,
SOT(MON)7/2/93,CH1/11/95

L. Guiard Labille dtte Guiard

LA CAVE (LE CAVE),
Peter,
English 1769-1811,
B,H,M,TB,DAV94,
CH(LON)4/12/94

Lo-Cave < SIGNATURE FROM DRAWING
OF PENCIL, PEN BROWN
INK AND WATERCOLOR.

LACEPEDE, Amelie de
(nee Comtesse KAUTZ),
French 1796-1860,
B,H,SOT10/12/94

Amelie Kautz
1833 < SIGNATURE FROM WATERCOLOR
& GUM ARABIC OVER TRACES
OF PENCIL ON PARCHMENT.

LACROIX, Charles Francois de,
French 1720-1782,
B,M,TB,DAV93,
SOT(MON)7/2/93,
SOT1/14/94,
SOT(LON)12/7/94

De Lacroix *De Lacroi* <(no X in
1770 *1766* signature)

NOTE:(Also known to sign work De La)

LA FARGUE, Jacobus Elias,
Dutch 1732/42-1782,
B,DAV93,PH(LON)
12/6/88,CH(LON)
12/10/93

J. E. la Fargue advin Pinx. 1757.

LA FARGUE, Paulus
Constantin,
Dutch 1729-1782,
B,H,DAV93(dates sic),
CH(MON)7/2/93,
CONTINUED

P.C la Fargue f:
P.C. La Fargue
pinx 1443

LA FARGUE, Paulus Constantin CONTINUED SOT1/15/93&1/12/94	*Paulus Constant La Fargue 1775* FROM DRAWING OF PEN, GREY INK & WATERCOLOR
LAFOND, Charles Nicolas Rafael, French 1774-1835, B,H,CH1/14/93	*LAFOND*
LAFOSSE, Charles de, French 1636-1716, B,H,M,TB,DAV94, CH5/21/92,CH(LON) 6/20/94	*Lafosse* < FROM DRAWING OF RED & BLACK CHALK ON BEIGE PAPER.
LAGOOR, Jan de, Dutch ac. 1645-1659, B,H,DAV94,CH(LON) 4/20/94	*Lagoor*
LAGRENEE, Anthelme Francois Rafel, French 1774-1835, B,H,CH1/12/94	*Lagrenée*
LAGRENEE, Jean Jacques, French 1739-1821, B,H,M,TB,DAV93, CH(MON)7/2/93, SOT1/15/93&1/12/94	*J.J.Lagrenée* *JJLagrenée 1777* *Lagrenée 1781* *JLagrenée*
LAGRENEE, Louis Jean Francois, French 1725-1805, B,H,M,TB,DAV93, CH5/31/91,CH(MON) 6/22/91,SOT1/12/95	*L. Lagrenee 1772* *L. Lagrenee* (from mixed media drawing) *Lagrenée. Pinxit*

LA HYRE (or LA HIRE),
Laurent de,
French 1606-1656,
B,H,M,TB,DAV93,
SOT(MON)12/5/92,
SOT5/20/93,CH(LON)
7/9/93

LH. L.H.

L. De La Hyre
1653

L. De La Hyre'
In & F. 1635.

L'AINE, Louis Moreau,
French 1740-1806,
CH1/11/94

LM. *LM.* < BOTH INITIALS FROM DRAWING OF
BODYCOLOR ON VELLUM.

LAJOUE, Jacques De,
French 1680-1761,
B,H,M,TB,DAV93,
CH1/10/90&1/11/94,
CH(MON)7/2/93

Lajoüe < FROM DRAWING OF
BLACK CHALK, PEN
& BLACK INK, AND
GREY WASH.

Lajoue <(From a red crayon drawing)

Lajoue < FROM DRAWING OF RED CHALK

LALLEMAND, Jean Baptiste,
French 1716-1803,
B,H,M,TB,DAV93,
SOT1/15/93,CH(MON)
7/2/93,SOT(MON)
7/2/93,CH1/11/95

Lallemand <(signature from drawing of
grey ink & wash with touches
of brown ink over black chalk)

L B lallemand *lallemand*

LAMBERTS, Gerrit,
Dutch 1776-1850,
B,H,DAV93,CH(AMS)
11/20/89,SOT(AMS)
11/17/93

GL <(signature from drawing: pencil,
pen & brown ink, watercolor,
brown ink framing lines)
(1815)

LAMI, Eugene Louis,
French 1800-1890,
A,B,H,M,TB,DAV93,
CH(LON)3/17/89&
6/23/89,CH1/11/94

Eny.Lami <(signature from a pen & black
ink & watercolor)

E.L <(from watercolor heightened with white)
1881

E.LAMI *luy.Lami*
1883

Eugene LAMI 1855. <(signature from a pencil
& watercolor heightened
with white)

FROM DRAWING OF PENCIL & *Eugene Lami*
WATERCOLOR HEIGHTENED 1853.
WITH WHITE >

E.1836.
FROM PEN & BLACK *E.L*
INK & WATERCOLOR FROM BLACK CHALK & WATER-
COLOR HEIGHTENED WITH WHITE.

LANDSEER, Charles,
English 1799-1879,
B,H,M,TB,DAV94,
CH(LON)2/18/93&
6/11/93

CL
1854

LANGENDIJK, Dirk or
Theodore or Thierry,
Dutch 1748-1805,
B,H,M,TB,DAV93,CH(SK)
6/22/89,CH(AMS)11/25/92,
SOT(AMS)11/17/93

D. Langendijk 1786

(from drawing: black chalk, pen & black
ink, grey wash)

LANGENDIJK, Jan Anthonie,
Dutch 1780-1818,
B,H,DAV93,CH(AMS)
11/12/90,SOT1/13/93&
1/12/94

J. A. Langendijk 1804

(signature from drawing of pencil,
pen & grey ink & watercolor)

LANGLACE, Jean Baptiste
Gabriel,
French 1786-1864,
B,H,DAV93,CH(SK)
6/22/89

Langlacé 1818

LANZANI, Andrea,
Italian 1639-1712,
B,H,DAV93,PH(LON)
7/2/90

Lanzani

(signature from red chalk drawing)

LARGILLIERE, Nicolas de,
French 1656-1746,
B,H,M,TB,DAV93,
SOT(MON)7/2/93,
SOT1/14/94&1/12/95

N De Largilliere

LAROON, Marcellus, Jr.,
English 1679-1772/74,
B,H,M,TB,DAV93,
CH5/31/90&5/3/91,
SOT(LON)4/6/93

M. L. Fe. <(initials from drawing
of pen & brown ink)

LA RUE (or RUE), Louis
Felix,
FRENCH 1718/31-1765/80,
B,H,M,DAV93,CH(MON)
6/20/92

*L.F. Delarüe
1750* <(SIGNATURE FROM DRAWING OF
BLACK CHALK, PEN, BROWN INK,
BROWN WASH & TOUCHES OF WHITE)

LA RUE (or RUE),
Philibert Benoit de,
French 1718-1780,
B,M,TB,DAV93,
SOT1/8/91

Delarue <(signature from drawing of pen,
black ink & wash over black chalk)

LASTMAN, Pieter Pieteresz,
Dutch 1583-1633,
B,H,M,TB,DAV93,
CH(AMS)11/12/90,
SOT(LON)12/14/92,
CH(LON)7/9/93

P Lastman. f. <(signature from a
drawing of black lead
& pen & brown ink, &
grey & brown wash)

*Lastman
Fecit 1622*

LAURI, Filippo, Italian 1623-1694, B,H,M,TB,DAV94, PH(LON)7/2/91, SOT(MON)6/19/94	**FL.**
LAUTENSACK, Hans, German 1524-c.1560, B,H,M,R,TB,DAV94, BAS6/4/93	*HsL* 1553　　MONOGRAM FROM ETCHING
LAWRENCE, (Sir) Thomas, English 1769-1830, B,H,M,TB,DAV93, SOT1/15/93&5/20/93, CH10/7/93&1/11/95	*T Lawrence*　*TL.* *TL april 1819* <(FROM DRAWING OF PENCIL RED & BLACK CHALK)
LEAKEY, James, English 1775-1865, B,H,M,TB,SOT(LON) 7/10/90,SOT2/27/91, CH(LON)3/19/91	*JAMES LEAKEY* *1838*
LE BARBIER L'Aine, **Jean Francois,** French 1738-1826, B,H,M,TB,DAV93, SOT4/7/88,SOT(MON) 12/2/89	*Lebarbier* *lainé* *1772* <(signature from drawing of pen & black ink with watercolor) *Lebarbier*
LE BAS, Louis Hippolyte, French 1782-1867, DAV93,SOT(MON) 6/15/90	*h. LeBas f.* <(signature from black ink & wash drawing)

LECOMTE, Hippolyte, French 1781-1857, B,H,M,TB,DAV93, SOT10/28/86, SOT(LON)6/6/90, PH(LON)6/15/93	*H.t Lecomte.* *HL*
LEE, Frederick Richard, English 1798-1879, B,H,M,TB,DAV93, SOT(LON)3/21/90& 7/11/90,PH(LON) 4/27/93	*F. R. Lee. RA* *F.R. Lee RA*
LEEMANS, Antonius, Dutch 1631-1673, B,H,DAV94, SOT5/19/94	*Leemans. F. 1655*
LEEMANS, Johannes, Dutch c.1633-1688, B,H,DAV93,SOT(AMS) 11/22/89,SOT(LON) 7/3/91,CH(LON) 4/23/93	*J. A.o Leemans: F.* *1667.* *HL* *J. Leemans:* *1675.*
LEEN, Willem van, Dutch 1753-1825, B,H,DAV93,SOT(MON) 6/15/90,BB11/7/90, SOT(LON)3/16/93	*Van Leen. f t/o* *Leen. f t.* *W. van Leen F t.*
LEEUWEN, Gerrit Jan van, Dutch 1756-1825, B,H,M,TB,DAV93, SOT(LON)10/4/89, SOT(MON)6/15/90	*Leeuwen* (signature from watercolor & gouache)

LEEUWEN, Philip van,
Dutch before 1662–1723,
B,M,TB,CH(AMS)
5/6/93

P. van Leeuwen
1662

LEGILLON, Jean Francois,
Belgian 1739–1797,
B,H,DAV93,PH(LON)
12/5/89&4/10/90,
CH(MON)12/7/90

LEGILLON *Legillon*

(signature from drawing of black
chalk, pen & brown wash with white)

LEGRAND, Pierre Nicolas,
French 1758–1829,
B?,DAV93,CH1/10/90

P.N. Legrand (black chalk, pen & black
ink, watercolor & body-
color)
(1765)

Le Grand
A°III R.F.=1794-5

LEGROS, Sauvier,
French 1754–1834,
B,SOT(LON)4/18/94

LeGros. 1809

FROM DRAWING OF PEN, BROWN INK &
GREY WASH.

LE GUAY, Etienne Charles,
French 1762–1840/46,
B,H,M,TB,DAV93,
CH1/11/89,DRO11/20/92

E.C. LaGuay
1790

<(signature from
drawing: black &
red chalk, brown
wash heightened
with white)

LEJEUNE, A. A.,
French ac. 18th century,
DAV93,SOT1/12/90

Par A.A. LEJEUNE, ce 8 Juillet 1796.
(gouache, pen & brown ink with white)

LE MOINE, Elisabeth,
French ac.1783,
B,DAV93,SOT10/13/89

Eli. Lemoine
oc 1783

LEMOINE, Jacques Antoine Marie, French 1751-1824, B,H,M,TB,DAV93, SOT(MON)12/2/89,SOT 1/8/91,SOT(LON)4/13/92	*Lemoine* 1796
LEMOINE, Marie Victoire, French 1754-1820, B,H,DAV93,CH10/10/90, SOT7/17/91,SOT(MON) 7/2/93	*Lemoine 1818*
LENGERICH, Immanuel Heinrich, German 1790-1865, B,H,M,TB,DAV93	*JHL*
LEONI, Camillo, Italian ac. 1st half 19th century, PH(LON)4/30/90	*Camillo Leoni* <(signature from drawing of brown ink & watercolor)
LEPAGE, Francois, French 1796-1871, B,DAV94,CH(LON) 6/10/94	*Lepage* 1826
LEPICIE, Michel Nicolas Bernard, French 1735-1784, B,H,M,TB,DAV93, SOT10/26/90,CH1/9/91, SOT(LON)4/21/93	*Lepicie. 1772 Lepicie*
LEPRINCE, Auguste Xavier, French 1799-1826, B,H,M,TB,DAV94, CH(LON)7/8/94	*X.Leprince.*
LEPRINCE, Jean Baptiste, French 1734-1781, B,H,M,TB,DAV93, SOT(MON)6/21/91, CH1/14/93,SOT(LON) CONTINUED	*L.P. de Prince1775*

LEPRINCE, Jean Baptiste,
<u>CONTINUED</u>
12/7/94

Le Prince

<(signature in ink...from drawing: pen, black ink & grey wash)

Le Prince 1776

J.B. Le Prince 1763

LERDICH, Hans,
Dutch ac.1550-1570,
B,CH(AMS)5/6/93

Aº 1551 ÆTAT·35

Job Lerdich·pinget

LESLIE, Charles Robert,
English 1794-1859,
B,H,M,TB,SOT(LON)
1/8/93,SOT(ARC)
1/20/93

CRL

LESOURD BEAUREGARD,
Ange Louis Guillaume,
French 1800-1885,
B,DAV93,SOT(MON)
6/22/91,CH(LON)
10/10/90&11/18/94

Le Sourd-Beauregard

Lesourd de Beauregard.

LETHIERE, Guillaume
Guillon,
French 1760-1832,
B,H,M,TB,DAV93,
CH(MON)12/7/90&
12/4/93,SOT1/14/92

Gu Guillon
Lethiere
R-1812'

LEVIEUX, Reynaud,
French 1613-1690/99,
B,H,DAV94,PH(LON)
12/8/92,SOT(MON)
12/2/94

R.Levieux

LEYSTER, Judith Molenaer,
Dutch 1600-1660,
B,H,M,TB,DAV93,
CH1/11/89,PH(LON)
12/11/90,SOT4/11/91

LIEGEOIS, Simon Michel,
French c.1687-1775,
B,SOT(MON)12/2/94

LIEVENS, Jan or Johannes,
Dutch 1607-1674,
B,H,M,TB,DAV93,
CH5/31/90,SOT(LON)
7/3/91&7/5/93

< SIGNATURE FROM DRAWING OF
PEN AND BROWN INK

LIN, Herman van,
Dutch c.1630-after 1670,
B,H,DAV93,CH5/21/92,
SOT(LON)4/1/92&
12/7/94

LINARD, Jacques,
French c.1600-1645,
B,H,DAV93,SOT(MON)
6/17/88,SOT(LON)
4/11/90,SOT5/22/92

LINDSAY, Thomas,
English 1793-1861,
B,H,DAV93,PH(LON)
6/17/89

<(signature from watercolor
over pencil with scratching
out)

LINGELBACH, Johannes,
German/Dutch 1622-1674,
B,H,M,TB,DAV93,
SOT1/15/93,CH1/12/94,
SOT(LON)12/7/94
CONTINUED

**LINGELBACH, Johannes,
CONTINUED**

*Lingelbach
1659*

lingelbach

FROM DRAWING OF PEN, BROWN INK AND
GREY WASH.

I: LINGELBACH

**LINNEL, John,
English 1792-1882,
A,B,H,M,TB,DAV93,
PH(LON)11/13/90,
BB5/20/92,CH(LON)
4/12/94**

*J. LINNELL
1841* *J. Linnell*

Linnell 61 <(signature from a drawing of
watercolor & bodycolor)

J Linnell *John Linnell f 1840*
(FROM DRAWING OF PENCIL,
COLORED CHALKS & WATERCOLOR)

FROM DRAWING OF COLORED
CHALKS > *J. Linnell fec.
1838*

**LINT, Hendrik Franz van,
Dutch 1683/84-1763,
B,H,M,TB,DAV93,
SOT(MON)6/18/92,
CH1/12/94,SOT(LON)
12/7/94**

H. van Lint
(oil on copper)

*H. Van Lint. Fi
1726*

**LINT, Pieter van,
Flemish 1609-1690,
B,H,M,TB,DAV93,
SOT10/31/90,PH(LON)
7/2/91,CH12/11/92**

P. V. Lint F.

**LINTHORST, Johannes
or Jacobus,
Dutch 1745/55-1815,
B,H,M,TB,DAV93,
CH5/31/89,CH(LON)
CONTINUED**

J. Linthorst 1780 *Linthorst f 1804*

LINTHORST, Johannes
or Jacobus,
CONTINUED
9/13/90,SOT(AMS)
11/12/92

I.Linthorst

LIOTARD, Jean Etienne,
Swiss 1702-1789,
B,H,M,TB,DAV93,
BB5/20/92,SOT(LON)
7/5/93

Liotard < SIGNATURE FROM PASTEL

FROM DRAWING OF BLACK
CHALK, PASTEL, WITH
TOUCHES OF GESSO ON
VELLUM >

Liotard
1761

LISSE, Dirck van der,
Dutch c.1600-c.1669,
B,H,M,TB,DAV93,
CH10/9/91,SOT10/10/91,
SOT(AMS)11/16/93

·D·

LODER, James,
British 1784-1860,
M,DAV93,SOT6/9/89,
CH5/22/90,CH(SK)
11/12/92

Loder Pinxt
Bath 1838

LODER, Matthaus,
Austrian 1781-1828,
B,H,M,TB,DAV93,
SOT1/13/93

LODER. <(signature from drawing of
black chalk, grey wash, &
touches of white chalk)

LOIS, Jacob,
Dutch 1620-1676,
B,M,TB,SOT1/12/95

Jac Lois 1650

LOISEL, Alexandre
Francois,
French 1783-
B,SOT(MON)12/5/92

Loisel 1834

LONGASTRE, L. De, English 18th century, B,PH2/5/78	*De Longastre* *1799* <(signature from pastel)
LONGHI, Luca, Italian 1507-1580, B,H,M,TB,DAV93, SOT1/12/89, CH1/16/92&1/12/94	LVCHAS DE LONGHIS M. D. X L X
LOO (or VANLOO), Carle van or Charles Andre, French 1705-1765, B,H,M,TB,DAV93, CH5/14/93,CH(MON) 12/4/92&7/2/93	*C. Vanloo. Carle Vanloo* (red, black & white chalk) *Carle Vanloo*
LOO, Jules Cesar Denis van, French 1743-1821, B,H,M,TB,DAV93, CH5/21/92,SOT(LON) 7/8/92&12/7/94	*Van Loo Cesar L'an x* *Cesar Van Loo L'an x* *Van Loo 1803*
LOO, Louis Michel van, French 1707-1771, B,H,M,TB,DAV93, SOT6/1/89,CH(LON) 4/19/91,SOT1/15/93	*L. M. Van Loo* *1766*
LOO (or LOON), Pieter van, Dutch 1731-1784, B,H,DAV93,SOT1/8/91& 1/13/93&1/12/94 CONTINUED	P:V:Loo Ad:Viv Del. (signature from watercolor with gum arabic & touches of bodycolor over black chalk)

LOO (or LOON), Pieter van,
CONTINUED

P:V:L☾☽. <(from watercolor)

LOOS, Friedrich,
Austrian 1797-1890,
B,H,DAV93,CH(LON)
5/20/93

Fried. Loos 1841.
(SIGNATURE FROM WATERCOLOR)

LOPEZ, Carlos Clemente,
Mexican ac. 18th century,
SOT5/19/93

Cárlos Clemente Lopez

LORICHON, Constant
Louis Antoine,
French 1800- ,
B,TB

LORRAIN(E) (or GELLEE),
Claude,
French 1600-1682,
B,H,M,TB,DAV93,
CH10/9/91,CH(LON)
7/2/91&7/7/92

Claudius

Claudius Gellee 1657

LORY, Gabriel Ludwig,
Swiss 1763-1840,
B,H,M,TB,DAV93,
SOT(LON)11/28/90,
FIS11/10/92

G. Lory

LOUW, Pieter,
Dutch c.1720-after 1800,
B,H,CH(AMS)11/12/90

<(signature from drawing of
black chalk, brown wash
heightened with white)

LOYS, Etienne,
French 1724-1783/88,
B,DAV94,SOT(LON)
7/7/93

E. Loys pinit
1753

LUCAS VAN LEYDEN (or LEYDEN), Lucas van,
Dutch 1489/94-1533,
B,H,M,TB,DAV93,
SOT12/27/88,CH(LON)
10/26/90,SOT(LON)
6/29/93

L L 1523 <(both monograms taken from engravings)

LVL Ł

LUCHINI, Pietro,
Italian 1800-1883,
SOT2/16/94

P. Luchini

LUCIANI, Ascanio,
Italian -1706,
B,DAV93 dates sic?,
PH(LON)10/24/89

ASCANIVS
LVCIANVS

LUINI, Aurelio,
Italian 1530-1593,
B,H,M,TB,DAV94,
CH(LON)7/6/93,
CH(MON)6/20/94

A: f. < FROM DRAWING OF PEN & BROWN INK, BROWN & GREY WATERCOLOR, AND HEIGHTENED WITH WHITE.

LUNDENS, Gerrit,
Dutch 1622-1677,
B,H,M,TB,DAV93,
CH11/13/90,SOT(LON)
4/21/93,SOT1/12/95

GŁundens CŁundens 1653

GŁundef <(LUNDE SIGNATURE IS CORRECT)

LUNY, Thomas,
English 1759-1837,
B,H,M,TB,DAV93,
CH5/31/90,CH(LON)
7/12/90,CHE4/28/93

Luny 1826 LUNY 1835

LUTI, BENEDETTO, Italian 1666-1724, B,H,DAV94,SOT(LON) 7/4/94,CH1/11/95	*B· Luti* SIGNATURE IN BROWN INK, FROM BLACK CHALK DRAWING, HEIGHTENED WITH WHITE, BLUE PAPER.
LUTTICHUYS, Isaac, Dutch 1616-1673, B,H,M,TB,DAV93, CH(LON)7/6/90, CH10/9/91,SOT(LON) 10/28/92	*ILuttichuÿs 1653*
LUYCKX (or LUYKX), **Christiaen or Cerstiaen,** Dutch 1623-1653, B,H,M,TB,DAV93, SOT(MON)6/22/91,CH(LON) 7/5/91,SOT(LON)10/28/92	KL KL
LUYKEN, Jan, Dutch 1649-1712, B,H,M,TB,DAV93, CH5/31/90,CH(AMS) 11/25/92,SOT(AMS) 11/17/93	*J·Luyken* (signature from drawing of pen & brown ink)

MAAS (or MAES), Dirk or Theodorus, Dutch 1659-1717, B,H,M,TB,DAV93, SOT7/17/91&1/15/93& 5/20/93	*D.Maas*
MABER, Jan de, Dutch -died 1702, B,DAV94,CH(AMS) 11/17/94	*D. Maber*
MACKENZIE, Frederick, Scots/English 1787-1854, B,H,M,TB,DAV93, CH(LON)7/9/91	*FM 1847*
MADOU, Jean Baptiste, Belgian 1796-1877, A,B,H,M,TB,DAV93, CH2/25/88,CHE4/28/93	*Madou Madou*
MAELLA, Mariano Salvador de, Spanish 1739-1819, B,H,M,TB,DAV93, CH1/16/92,SOT(MAD) 5/18/93	*Maella* <(SIGNATURE FROM DRAWING) (SIGNATURE FROM DRAWING)> *Maella*
MAES, Nicolaes, Dutch 1634-1693, B,H,M,TB,DAV93, SOT1/15/93, CH1/11/91&1/12/94	N.MÆ Maes MAES.1667 N.MAES. MAES N.MAES. 1660 N.MÆS 1655

MAES, Pieter van, Dutch ac. mid 17th century, SOT(AMS)11/14/90	*Rvmaes* (1679)
MAHU, Cornelis, Flemish 1613-1689, B,H,M,TB,DAV93, SOT(AMS)5/22/90& 11/11/92	C M A HV·f 1649
MAIR (VON LANDSHUT), Nicolaus Alexander, German ac. 1492-1520, B,H,M,R,TB,DAV94, BAS12/4/92	+MAIR+ FROM ENGRAVING
MALAINE, Joseph Laurent, French 1745-1809, B,H,DAV93,SOT(MON) 6/15/90&6/22/91, BB5/20/92	*L.Malaine Pt*
MALLET (or MALET), Jean Baptiste, French 1759-1835, B,H,M,TB,DAV93, CH1/9/91&1/11/94, SOT1/14/94	*Malet.* <(signature from bodycolor drawing) *JB Mallet.* *mallet* < FROM WATERCOLOR AND BODYCOLOR DRAWING.
MALLEYN, Gerrit, Dutch 1753-1816, B,H,DAV94,SOT(LON) 4/1/92,CH10/6/94	*G:c Malleijn*
MALTON, James, English 1761-1803, B,H,M,TB,DAV94, CH(LON)11/8/94	*James Malron* *1799* SIGNATURE FROM PENCIL, PEN & BLACK INK & WATERCOLOR WITH SCRATCHING OUT

MANAIGO, Silvestro,
Italian 1670-1734,
B,H,DAV93,
CH1/11/94

S. manaigo

FROM DRAWING OF RED CHALK, PEN AND
BROWN INK, AND BROWN WASH.

MANCADAN, Jacob Sibrandi,
Dutch 1602-1680,
B,H,DAV93,SOT(LON)
4/21/93,SOT(AMS)
11/17/93

S.Man. *S.Mar.* *M.*

M

MANDER, Karl van,
Dutch 1548-1606,
B,H,M,TB,DAV93,
CH(LON)10/26/90,
SOT(LON)7/6/92

KM '596 <(MONOGRAM FROM DRAWING OF PEN,
BROWN INK & WASH & BLACK CHALK)

KM < FROM DRAWING OF PEN,
BROWN INK, GREY WASH,
HEIGHTENED WITH WHITE.

KM 1594

MANDEVARE, Alphonse
Nicolas Michel,
French -1829,
B,DAV93,SOT(LON)
7/6/92,SOT1/12/94

Michel Mandevare

(SIGNATURE FROM DRAWING OF PEN & BROWN INK)

MANGLARD, Adrien,
French 1695-1760,
B,H,M,TB,DAV94,
CH1/14/93,CH(MON)
7/2/93,SOT5/20/93

Manglar <(MANGLAR without the
D is correct)
Signature from crayon drawing.

Manglar <Signature from drawing

MANZONI, Ridolfo,
Italian 1675-1743,
B,H,SOT(LON)
10/27/93

Rodulfus Manzoni

MARATTI, Carlo, Italian 1625-1713, B,H,M,TB,DAV93, SOT(LON)7/5/93, SOT1/13/93&1/12/94	**C.M.** <(initials from drawing of pen & brown ink with wash heightened with white)
MARCHE, Nathalie De La, French early 19th century, CH1/11/89	*Mⁱˢ de La Marche fᵗ 1821* (from drawing: black chalk, pen & grey ink with grey wash)
MARCKE, Jean or Jules Baptiste van, French 1798-1849, B,CH10/28/87	*Jean van Marcke.*
MARCONI, Rocco or Tocco, Italian ac.1504-1529, (1480?-1529) B,H,M,TB,DAV93,SOT 4/5/90,SOT(LON)7/3/91,CH1/12/94	ROCVS DE MARCHONJ P.
MARECHAL, Jean Baptiste, French ac.1779-1824, B,DAV93,CH1/11/94	*Marechal* *1784* < FROM DRAWING OF BLACK CHALK, PEN & BROWN INK, AND BROWN WASH.
MARESCALCHI (or MARESCALCO), Pietro (called LO SPADA), Italian 1520/22-1584/89, B,H,DAV93,CH5/21/92	PFT.ˢ DI MARI.ˢ P. M.D.LXIIII
MARIENHOF, Jan, Dutch ac. 1640-1649, B,H,DAV94,SOT(LON) 12/12/90&4/20/94	*Marienhof. f.* *1652*
MARIN, Joseph Charles, French 1759-1834, B,H,M,TB,DAV93, CH1/10/90	*C. Marin 1768* (pencil)

MARKO, Carl, Sr., Hungarian 1791-1860, B,H,M,TB,DAV93, SOT(LON)6/19/85, BB3/22/89,DOR11/18/92	*C.MarKo 1838 C.MarKo*
MARLET, Jean Henri, French 1771-1847, B,M,TB,DAV93, SOT(MON)6/15/90, CH(LON)12/11/90& 12/15/92	*Henry Marlet* *J h marlet*
MARLOW, William, English 1740-1813, B,H,M,TB,DAV93, WES12/8/90,CH(LON) 4/12/91,SOT(LON) 11/19/92	*W. Marlow* <(signature from watercolor) *W. marlow.* <(from a 1765 drawing: black chalk, pen, grey ink & watercolor)
MARREL, Jacob, Dutch 1613/14-1681, B,H,M,TB,DAV93, SOT1/15/93,SOT(AMS) 11/17/93,CH1/11/95	*+ IACOBVS + MARRELLYS +* *A+1.6.3.4.* *Jacob Marrell f.* *JMB ·1·6·47·*
MARSEUS VAN SCHRIE(C)K, Otto (called SNUFFELAER), Dutch 1619-1678, B,H,DAV93,SOT6/2/89, CH1/13/90,SOT(LON) 10/28/92	*Marseus. D. Schriek.* *1662* (signature spelling is correct) *O. Marseus D. Schrieck* *O: Marseus:f*

MARSHALL, Ben(jamin),
English 1767-1835,
A,B,H,M,TB,DAV93,
SOT6/8/90&6/5/92&
6/4/93

B Marshall
(1804)

Marshall 1816

MARTELLI, Lorenzo
(probably),
Florentine 17th century,
B,CHE1/8/90

MARTELLI

MARTIN, John,
English 1789-1854,
B,H,M,TB,DAV94,
PH(LON)7/2/93&
11/8/93

J.Martin 1843

SIGNATURE FROM WATERCOLOR & BODYCOLOR

John Martin 1849

FROM PENCIL & WATERCOLOR WITH SCRATCHING OUT

J.Martin.

J.Martin.1829 <(signature from drawing of brown
wash with scraping out on tan
paper)

MARTSZEN (or MARTOZEN
or MARTES DE JONGE),
Jan or Jacob,
Dutch c.1609-after 1647,
B,H,M,TB,DAV93,
CH(AMS)11/12/90,
SOT(LON)7/3/91&
4/21/93

M.D.Jonge.f <(signature from drawing of
black chalk, pen & brown
ink & grey wash)

M.D.Jonge.1633.

MASTER E S,
German ac.1450-1470,
H,M,R,WIN4/3/92

°e°1°2°6°1°S° (.e.1.4.6.7.s.)
INITIALS & DATE FROM ENGRAVING

MASTER N H,
Dutch 16th century,
M,R

·H·N· OR ·N·H·
INITIALS FROM WOODCUTS

MATHAM, Jacob,
Dutch 1571-1631,
B,H,M,TB,DAV93,
SOT(LON)4/30/90,
SOT1/13/93

Mattham fc·1605
(MATTHAM) (fe 1605)
(Signature from pen & brown ink drawing)

Iac.Matham
Fecit Anno 1621-
(FROM DRAWING OF BLACK CHALK, PEN & BROWN INK
ON VELLUM)

MATHAM, Jan,
Dutch 1600-1648,
B,H,CH12/11/92

Mathan

MATHAM, Theodor Dirck,
Dutch 1606-1676,
B,H,M,TB,DAV93,
CH1/9/91

Theod·Matham Fe.1626
(signature from drawing of black & red chalk,
pen & brown ink on vellum)

MATTENHEIMER, Theodor,
German 1787-1850,
B,H,M,DAV93,
SOT1/26/79

·Th·Mattenheimer. J.M.
1849

MAURER (or MURER),
Christoph,
Swiss 1558-1614,
B,H,M,TB,SOT(LON)
12/8/93,SOT1/12/94
CONTINUED

CM CM ·C·

MAURER (or MURER), Christoph, CONTINUED	*GM 1608* FROM DRAWING OF PEN & BLACK INK, GREY & BROWN WASH
MAYER, Luigi, Italian ac. late 18th century, B,DAV93,CH5/19/93, CH(LON)5/17/91& 7/2/91	*Luigi Mayer*
MAYER, Marie Francois Constance, French 1775-1821, B,H,M,TB,DAV94, CH10/6/94	*C Mayer*
MAZZOLINI, Ludovico, Italian 1470/80-1528/30, B,H,M,TB,DAV93, SOT(LON)7/8/92, BB5/20/92,SOT1/12/95	*·LODOVIGO·MAZOLII·PI·M·CCCCQXI*
MECKENEM, Israel, German 1430/45-1503/17, B,H,M,R,TB,DAV93, SOT(LON)10/3/92, SOT5/13/93	*Israhel v M.* *IM M* *IVM* (ALL INITIALS FROM ENGRAVINGS)
MEER, Barend van der, Dutch c.1659-1690/1702, B,H,M,DAV93,SOT(LON) 10/28/92&10/27/93& 12/7/94	*BVdermeer 1689*
MEER (or VERMEER VAN HAARLEM), Jan van der II, Dutch 1656-1705, B,H,M,DAV93,PH(LON) 6/19/90&11/24/92, SOT(AMS)11/17/93	*Jv dermeer de jongr f 1698.* (signature from drawing: black chalk, touches of pen, brown ink heightened with white)

MEI, Bernardino, Italian c.1615-1676, B,H,DAV93,CH1/14/86& 5/21/92	B·M·F·1636
MEIL, Johann Wilhelm, German 1733-1804, B,H	J.W.M.
MEILLON, Henry Clifford de, English?/French? ac.1823-1856, DAV93,CH(SK)11/15/90, CH(LON)7/15/94	H·C. De Meillon < SIGNATURE FROM WATERCOLOR Pictorial & biographical information in catalogue Christie's London 7/15/94 H. C. D. Meillon (signature from watercolor)
MELDEMANN, Nicolaus, German ac.1520-1531, B,H,R	NM INITIALS FROM WOODCUT
MELDER, Gerard, Dutch 1693-1754, B,H,DAV93, SOT(LON)7/4/90	G M
MENAGEOT, Francois Guillaume, French 1744-1816, B,H,M,TB,DAV93, SOT5/30/91&5/28/92, SOT(MIL)10/5/93	Par f. g. Menageot en 1810 Menageot
MENENDEZ (or MELENDEZ), Luis, Spanish 1716-1780, B,H,DAV93,SOT1/10/91, CH(LON)7/4/91, BON10/10/92	Lˢ E.Mᶻ Dᶻº ISᵀº Pᵉ ANO 1765

MENGS, Anton Raphael, German 1728-1779, B,H,M,TB,DAV93, SOT1/8/91,CH(LON) 7/4/91,FAL11/7/92	*a. R. Mengs* <(signature from drawing of black & white chalk on greenish-gray paper)
MERCIER, Philippe Le, French 1689-1760, B,H,M,TB,DAV93, SOT(LON)11/14/90, PH(LON)7/2/91, CH1/16/92	*Ph. Mercier* *fecit. an. 1742* *Ph. Mercier fecit* *Ano. 1740*
METSU, Gabriel, Dutch 1629-1667, B,H,M,TB,DAV93, CH1/10/91,LH3/10/91, SOT1/15/93	*G. MetSu*
METZ, Conrad Martin, English 1749-1827, B,H,DAV93,PH(LON) 12/4/89,SOT(LON) 4/30/90	*C.M.Metz* *1791* <(signature from red chalk drawing)
MEULEN, Siewert van der, Dutch ac. 1697-1730, B,DAV93,SOT(AMS) 11/22/89	*S.V. Meulen 1697* *S v M* (drawing: black ink & grey wash)
MEULENER, Pieter, Dutch 1602-1654, B,H,DAV93,CH(AMS) 5/2/91,CH5/31/91, SOT(LON)7/8/92	*P. MEVLENER* *1631*
MEXICAN SCHOOL, late 18th century, SOT5/18/94	*R.*
MEYER, Conrad, Sr., Swiss 1618-1689, B,DAV93,SOT(AMS) 11/21/89,PH(LON) 7/2/91	*CM:F 1595* (Initials: brown ink. Date: black ink. Pen & black ink)

MEYER, Hendrick de I,
Dutch 1620-1683,
B,DAV93,SOT(LON)
7/4/90,SOT1/14/94

MEYER, Hendrick de II,
Dutch 1737-1793,
B,H,DAV93,SOT(LON)
7/5/93,SOT1/13/93&
1/14/94

(signature from pen &
wash drawing)

< FROM DRAWING OF GREY WASH,
HEIGHTENED WITH WHITE, ON
BLUE PAPER.

MEYER, Johann Jakob,
Swiss 1787-1858,
B,DAV94,SOT(MON)
6/15/90

<(signature from watercolor)

MEYERLING, Aelbert,
Dutch 1645-1714,
B,DAV94,CH(LON)
7/5/91,SOT1/14/94

MEYNOU, S.,
French ac.1736,
CH1/11/94

FROM DRAWING OF A GUARD SHIP FOR THE PORT OF MARSEILLE,
BLACK CHALK, PEN AND BLACK INK, AND GREY WASH.

MEZZERA, Rosa,
Italian 1791-1826,
B,DAV94,CH4/6/89,
CH(LON)3/1/91

MICHAU, Theobald, Flemish 1676–1765, B,H,M,TB,DAV94, CH(MON)12/4/93, CH10/7/93	*T. Michau.* *T. Michau* *T Michau.*
MIEREVELT, Michiel Jansz van, Dutch 1567–1641, B,H,DAV94,CH5/19/92, SOT(LON)7/6/94	*M. Mierevelt*
MIERIS, Frans van, Dutch 1689–1763, B,H,M,TB,DAV94, SOT(LON)7/8/92	*F. V. Mieris Fecit* *F. V. Mieris* *F. 1747-*
MIERIS, Frans van, Sr., Dutch 1635–1681, B,H,M,TB,DAV94, SOT7/22/93,SOT(AMS) 5/10/94	*Fran. Mieris* *Anno 1660* FROM DRAWING OF BLACK CHALK AND GREY WASH, ON VELLUM.
MIERIS, William van, Jr., Dutch 1662–1747, B,H,M,TB,DAV94, CH(AMS)11/25/92, SOT5/20/93	*W. Van Mieris*
MIGLIARA, Giovanni, Italian 1785–1837, B,H,M,TB,DAV94, PH(MAR)7/7/89, PH(LON)12/11/90, FIN(R)6/8/93	*Migliara* *G. Migliara* (1816) (KNOWN TO SIGN DRAWINGS GIO. MIGLIARA)
MIGNARD, Nicolas, French 1606–1668, B,H,M,TB,DAV94, CH1/10/91,PH(LON) 7/2/91,SOT(MON) 7/2/93	N·MIGNARD 1650

MIJN, Hieronymus van der,
Dutch 1687-1761,
DAV94,SOT(LON)12/12/90,
SOT(ARC)7/17/91

H. Vand^r
Mij.Fec^t
A° 1723

MILBERT, Jacques Gerard,
French 1766-1840,
B,H,M,TB,CH(SK)
5/25/89

J. Milbert <(signature from engraving)

MILES, John (of Northleach),
English ac. early 19 c.,
DAV94,SOT6/5/86,
WES1/14/89

J.Miles Northleach

MIND, Gottfried,
Swiss 1768-1814,
B,H,M,TB,DAV94,
SOT(Z)12/1/88,
CH(LON)10/5/90,
BAS12/4/92

Mind <(signature from watercolor)

MINOZZI, Flaminio Innocenzio,
Italian 1735-1817,
B,DAV94,SOT1/16/86,
CH1/11/94

Flaminio Minozzi

FROM ARCHITECTURAL DRAWING OF BLACK CHALK, PEN AND BROWN INK, AND BROWN WASH.

MIROU, Anton,
Flemish c.1570-1653,
B,H,M?,DAV94,
SOT(LON)2/28/90,
SOT5/30/91&10/8/93

AMirov F

MITELLI, Guiseppe Maria,
Italian 1634-1718,
B,H,DAV94,SOT(MON)
6/18/92,SOT(LON)
7/5/93

MI TE FE.1707

MOINE, Antonin Marie,
French 1796-1849,
B,M,TB,SOT(MON0
7/2/93

Antonin Moine
1846

MOLENAER, Bartholomeus,
Dutch ac.1650-1668,
B,H,DAV94,CH(LON)
7/20/90,SOT(ARC)
7/16/92,SOT(AMS)
11/16/94

B·M· ·B·MR·

MOLENAER, Jan Miense
(Circle of),
Dutch 1610-1668,
B,H,M,TB,DAV94,
CH4/6/89

I·M·

MOLENAER, Jan Miense,
Dutch 1610-1668,
B,H,M,TB,DAV94,
CH10/7/93,SOT10/8/93&
1/12/95

J.M. Molenaer MR

Jn molenaer

JMR < JMR monogram. The R possibly
could refer to the last letter
in Molena<u>er</u>.

MOLENAER, Klaes
(or Nicolaes),
Dutch 1630-1676,
B,H,M,TB,DAV94,
SOT5/22/92,SOT(AMS)
5/7/93,SOT(LON)12/7/94

Kmolenaen Cy M (1650)

MOLINA, Antonio de,
Spanish ac. Seville 1802,
SOT(LON)4/1/92

Antonio de Molina
(1802)

MOLTENI, Guiseppe,
Italian 1800-1867,
B,H,DAV94,CH(LON)
5/5/89

G. Molteni J.

MOLYN (or MOLIJN),
Pieter,
Dutch 1595-1661,
B,H,M,TB,DAV94,
CH4/16/91,CH(LON)
7/9/93,SOT(AMS)
11/17/93

Molyn. 1656. *M*

SIGNATURE FROM DRAWING OF CHALK & GREY WASH

Molyn 1656

MOMMERS, Hendrick,
Dutch 1623-1697,
B,H,M,TB,DAV94,
CH10/10/90,SOT5/22/92,
SOT(AMS)11/16/93

Mommers

MOMPER, Joos de,
Dutch 1564-1635,
B,H,M,TB,DAV94,
SOT1/15/93,SOT(LON)
4/20/94&12/7/94

JDM

MONFORT, Octavianus,
Italian ac. late 17c.,
DAV94,CH5/31/89,
SOT(MIL)12/10/93

*Octaviaᵈ monfort
fecit 1683*

MONGIN, Antoine Pierre,
French 1761/62-1827,
B,H,M,TB,DAV94,
SOT1/12/90

mongin
1795 <(signature on gouache) *Mongin*

*Mongin
1816.*

MONINKX, Cornelis,
Dutch c.1623-1666,
B,SOT(AMS)11/16/93

C Moninckx-. < FROM DRAWING OF
GRAPHITE ON VELLUM

MONNOYER, Jean Baptiste,
French 1634/36-1699,
B,H,M,TB,DAV94,
CH(LON)7/4/91&12/10/93,
SOT(LON)12/7/94

J. Baptiste

J. Baptiste Pinxit 1696

MONOGRAMMIST A W,
Dutch early 17th century,
SOT(LON)7/6/94

A.W. IN·F.

MONOGRAMMIST A W,
French/Flemish 17c.,
SOT(AMS)11/16/94

16 ⋈ 28 Possibly circle of
Louis de Caullery

MONOGRAMMIST G S,
16c.,
SOT1/13/93

G·S·
·1·5·4·7· <(from pen & brown ink drawing)

MONOGRAMMIS I H,
ac. Flanders 17c.,
SOT(MON)6/18/88

I H. fecit

MONOGRAMMIST I Z,
German ac.1520,
SOT(LON)12/12/90

·Z· 1520

MONOGRAMMIST P H B,
Dutch ac. c.1650s,
CH(AMS)5/11/94

PB 1652

MONOGRAMMIST P. v. B.,
Dutch? ac.1598,
CH(AMS)5/11/94

(P) ᵥB F 1598

MONSIAU(X), Nicolas Andre,
French 1754-1837,
A,B,H,M,TB,DAV94,
CH(MON)12/7/90,
SOT1/13/93

Monsiau
(inscription signature)

<(signature from drawing of black chalk with white on brown paper)

Monsiau

MONTEN, Heinrich
Maria Dietrich,
German 1799-1843,
B,H,M,TB,DAV94,
CH(LON)11/24/88

D. Monten 1838

<(signature from a drawing of pencil & watercolor heightened with white)

MONTEYNE, V. J.,
French?/Dutch ac. 1st
quarter 18th century,
SOT(AMS)5/10/94

V J or B Monteyne
FIRST INITIALS NOT LEGIBLE TO RECORD

MOOR, Karel de,
Dutch 1656-1738,
B,H,M,TB,DAV94,
CH10/10/90,SOT1/17/91,
SOT(LON)12/8/93

C.D.Moor 1603
C.D.Moor

MOORE, William,
English 1790-1851,
B,H,M,TB,DAV94,
SOT(LON)4/27/88&
10/18/92

W.Morre.1832

<(signature from a pencil drawing with watercolor)

MORAT, J., Austrian/German ac. mid 19c., CH(LON)5/20/93	*fec J. Morat* (1842) (SIGNATURE FROM BODYCOLOR & WATERCOLOR)
MOREAU, Jean Michel, French 1741-1814, B,H,M,TB,DAV94, SOT(LON)4/13/92	*J. M. Moreau le Jeune.* *1781* (FROM DRAWING OF PEN, BLACK INK & BROWN WASH)
MOREAU, Louis Gabriel (called L'AINE), French 1740-1806, B,H,M,TB,DAV94, CH(LON)6/15/90& 7/2/93,SOT1/13/93	*LM 1784* <(initials from gouache) *LM* *L.M. 1796* < FROM WATERCOLOR AND GOUACHE
MOREELSE, Paulus, Dutch 1571-1638, B,H,M,TB,DAV94, WD2/19/92,CH(LON) 4/20/94	*M.1636*
MOREL, Jan Evert, Sr., Dutch 1777-1808, B,H,DAV94,DU7/19/91, SOT10/11/90&10/29/92	*J.E. Morel f.*
MORGENSTERN, Johann Ludwig Ernst, German 1738-1819, B,H,M,TB,DAV94, CH(LON)7/5/91, SOT(LON)7/8/92	*Morgenstern. Jun: pinxit*
MORLAND, George, English 1763-1804, B,H,M,TB,DAV94, CH5/31/91&10/15/92& 10/7/93	*G. Morland* *G. Morland* *1791*

MORLAND, Henry Robert,
English 1712-1797,
B,H,M,TB,DAV94,
CH(LON)7/12/91&
7/14/92

< (MONOGRAM FROM PASTEL)

**MORLETE RUIZ, Juan
Patricio,**
Mexican 1715-c.1780,
B(MORLET),DAV94,
CH5/15/91&11/7/93

**MORSE, Samuel Finley
Breeze,**
American 1791-1872,
B,D,F,H,I,M,TB,DAV94,
CH6/19/90,WES5/22/93

MORTEL, Jan,
Dutch c.1650-1719,
B,H,DAV94,
CH5/31/90,CH(LON)
7/20/90,SOT(LON)
12/9/92

MORTIER, (Reverend) J.,
English ac.1820s,
DAV94,CH(LON)
7/16/93

< FROM DRAWING OF PEN, INK &
WATERCOLOR ON PAPER WATER-
MARKED 'WHATMAN 1822'.

MOS(S)CHER, Jacob van,
Dutch ac.1595-1655,
B,H,M,TB,DAV94,
PH(LON)7/2/91,
SOT(AMS)11/16/93

MOSTAERT, Gillis, Sr.,
Flemish 1534-1598,
B,H,M,TB,DAV94,
PH(LON)12/5/89,
CH(LON)7/4/91,
CH10/15/92

MOUCHERON, Frederick de, Dutch 1633-1686, B,H,M,TB,DAV94, PH7/3/90,CH(LON) 7/4/91,CH1/14/93	*Moucheron* *Moucheron.* (signature from a drawing of pen, brown ink & grey wash over black chalk)
MOUCHERON, Isaac de, Dutch 1667-1744, B,H,M,TB,DAV94, SOT(LON)7/2/90,PH(LON) 7/2/91,SOT1/13/93	*J. Moucheron Fecit* <(signature from drawing of pen & brown ink & wash over black chalk) *J. d. Moucheron* *J. Moucheron* FROM DRAWING OF PEN, BLACK INK & GREY WASH
MULREADY, William, Irish 1786-1863, B,H,M,TB,DAV94, CH(SK)9/27/90, PH(LON)3/26/91, SOT(LON)11/18/92	*W* *W Mulready*
MUNN, Paul Sandby, English 1773-1845, B,H,M,TB,DAV94, SOT(LON)7/11/91, PH(LON)11/8/93	*P.S.Munn* < FROM WATERCOLOR (1833) HEIGHTENED WITH WHITE
MUNTZ, Johann Heinrich, German 1727-1798, B,H,M,TB,DAV94, CH3/22/91	*J. H. Muntz 1775* FROM DRAWING OF PEN & BROWN INK, GREY WASH, BROWN INK FRAMING LINES, D & C BLAUW WATERMARK
MURILLO, Bartolome Esteban, Spanish 1618-1682, B,H,M,TB,DAV94, BB5/20/92,CH(LON) 5/29/92,CH1/11/95	*M°* <(FROM DRAWING OF BLACK CHALK, PEN & BROWN INK, & BROWN WASH)
MURRAY, Amelia Jane (Lady OSWALD), English 1800-1896, CH(LON)6/3/94	*Emily Murray* **AJM** SIGNATURE & INITIALS FROM 1920s PENCIL & WATERCOLOR. EXTENSIVE BIOGRAPHY & 32 WORKS SHOWN IN CATALOGUE: CHRISTIE'S LONDON 6/3/94

MURRAY, W. (probably William), English 18/19c., DAV94,SOT6/10/88	W. Murray 1808
MUSSCHER, Michiel van, Dutch 1645-1705, B,H,M,TB,DAV94, SOT1/10/91,CH1/14/93, SOT(LON)12/8/93	M. v. Musscher (pinxit A°: 1670)
MUS(S)I, Agostino called VENEZIANO, Italian 1490-1540, B,H,M,R,TB,DAV94	AV INITIALS FROM ENGRAVING
MYN, George van der, Dutch 1723-1763, B,M,TB,DAV94, CH1/11/95	G. Vander Myn.1763.
MYTENS, Jan, Dutch c.1614-1670, B,H,M,TB,DAV94, CH(LON)7/4/91, CH(AMS)5/7/92, SOT1/12/95	Mijtens F. A° 1662 Mijtens F.

NACHTMANN, Franz Xaver,
German 1799-1846,
B,H,M,TB,DAV94,
CH10/15/91,
CH(LON)11/17/94

Nachtman 1831
FROM DRAWING OF PENCIL & WATERCOLOR.

NAIGEON, Jean Claude,
French 1753-1832,
B,H,M,TB,DAV94,
AUD12/16/91

Naigeon

NAIWJNCX, Hermann,
Flemish 1619/24-1651/54,
B,H,M,TB,DAV93,
CH5/31/90,BAS6/4/93

H: Nawwjncx

NANI, Giacomo or Jacobus,
Italian 1698/1701-1770,
B,H,DAV93,SOT(F)
11/27/89,CH7/2/90,
SEM4/1/93

Giacomo Nani f.

Jacobus Nani

NANTEUIL, Robert,
French 1623-1678,
B,H,M,TB,DAV94,
CH(MON)6/20/94

Nanteuil

FROM DRAWING OF BLACK CHALK & PASTEL, BLUE
WATERCOLOR, HEIGHTENED WITH WHITE.
Note: There are no documented oil paintings
by Robert Nanteuil.

NASMYTH, Patrick or
Peter,
English 1781-1831,
B,H,M,TB,DAV93,
BB1/17/90,CH(LON)
7/12/91,CH(AUS)4/20/93

P.N.

NATOIRE, Charles Joseph,
French 1700-1777,
B,H,M,TB,DAV93,
CH1/9/91,SOT1/13/93&
1/12/94&1/10/95

C. Natoire 1756

(red & black chalk, pen &
brown ink, grey wash
heightened with white)

Natoire

(above: both signatures
done in brown ink)

C. Natoire <(signature from watercolor)

Natoire f. 1741.

NATTES, John Claude,
English 1765-1822,
B,H,M,TB,DAV93,
CH(LON)11/14/80,
SOT(SUS)5/20/91

J. C. Nattes

(from pencil & grey wash drawing, c.1803)

NATTIER, Jean Marc,
French 1685-1766,
B,H,M,TB,DAV93,
CH1/11/91&12/11/92,
SOT(LON)12/7/94

Nattier pinxit. 1740

NAVARRA, Pietro,
Italian ac.1690-1700,
B,DAV93,SOT(LON)
12/12/90,SOT1/15/93,
CH(LON)7/9/93

PN

NAVEZ, Francois Joseph,
Belgian 1787-1869,
B,H,M,TB,DAV93,
CH(AMS)4/29/89,
PH(LON)6/18/91,CH
12/11/92

F.I.NAVEZ1825

F.J. Navez

NEAGLE, John,
American 1796-1865,
B,D,F,H,I,M,TB,DAV93,
WES1/12/91&2/16/91,
CH5/26/93

John Neagle

NECK, Jan van,
Dutch 1635-1714,
B,H,M,TB,DAV94,
CH4/4/90&10/6/94,
SOT1/12/95

NEDHAM (or NEEDHAM),
William,
British ac.1823-1849,
DAV93,SOT6/9/89&
7/11/90&6/4/93

NEEFS, Frater Lodowyk,
Dutch c.1616/17- ,
B,H,M,TB,DAV93,
PH(LON)4/10/90

NEEF(F)S, Pieter, Jr.,
Flemish 1620-1675,
B,H,M,TB,DAV93,
PH(LON)12/5/89,
CH10/15/92

NEEFFS (or NEFS),
Pieter, Sr.,
Flemish 1578-1656/61,
B,H,M,TB,DAV93,
SOT1/15/93,SOT(MON)
7/2/93,CH1/12/94

NEER, Aert van der, Sr.,
Dutch 1603-1677,
B,H,M,TB,DAV93,
CH(AMS)11/10/92,
CH5/31/91,SOT(LON)
10/8/93

NEERGAARD, Hermania
Sigvardine,
Danish 1799-1875,
B,DAV93,CH(LON)
3/29/90,SOT1/17/90&
10/29/92

NEGRE, Mat(t)hieu van,
Flemish ac. 1590–1644,
B,H,PH(LON)7/2/91

MATHIEV
VANNEGRE
FECIT
1617

NELLIUS, Martinus,
Dutch ac. 1670–1706,
B,H,M,TB,DAV93,
CH(AMS)5/6/93

Nellius Nellius

NESFIELD, William Andrews,
English 1793–1881,
B,H,M,TB,DAV93,
CH(LON)7/24/84&
4/9/91,SOT(LON)
10/19/89

W.A.Nesfield
1850

NESSELTHALER, Andreas,
Austrian 1748–1821,
B,H,WIE4/20/94

A. Nesselthaler
1798

**NETSCHER, Caspar or
Gaspar,**
German/Dutch 1639–1684,
B,H,M,TB,DAV93,
PH(LON)4/16/91,
SOT10/8/93,CH1/11/95

C·Netscher F
1678

Netscher.
1680

NEVE, Cornelis,
Flemish 1612–1678,
B,H,TB,CH(LON)
12/10/93,SOT(LON)
12/7/94

Co:N. (1636)

**NEYN (or DENEYN),
Pieter de,**
Dutch 1597–1639,
B,H,DAV93,CH(AMS)
11/10/92,CH10/9/91&
5/14/93

Pleyn 1638

NEYTS (or NYTS),
Aegidius Gillis,
Flemish 1623-1687,
B,H,M,TB,DAV93,
CH(LON)7/2/91,
CH1/9/91&1/14/93

g·neyts·f· <(signature from drawing of pen & brown ink, grey wash, brown ink framing lines)

gillis·nyts·f· 1650 <(SIGNATURE FROM DRAWING OF BLACK CHALK WITH PEN & BROWN INK ON VELLUM)

g:nyts 1666

·neyts·F < SIGNATURE FROM DRAWING OF PEN, BROWN INK, AND BROWN AND GREY WASH

NICOLLE, Victor Jean,
French 1754-1826,
B,M,TB,DAV93,
CHE1/8/90,
SOT1/13/93&1/12/94

V.i.Nicolle. <(pen & brown ink with blue and brown wash)

V.J:Nicolle (pen & brown ink, brown wash)

SIGNATURE FROM WATERCOLOR > *VJ.Nicolle·*

NIEULAND(T), Adriaen
van I,
Flemish 1587-1658,
B,H,M?,TB?,DAV93,
SOT(MON)6/17/88,
SOT(AMS)1/12/94

Adriaen van Nieuland Fecit. 1614

NIJMEGEN (or NYMEGEN),
Dionijs van,
Dutch 1705-1789,
B,H,M,TB,DAV94,
WD1/22/92,SOT(AMS)
11/16/94

Nijmegen f

V Nijmegen

NIJMEGEN (or NYMEGEN),
Willem van,
Dutch 1636-1698,
B,H,CH(AMS)6/12/90

W. van Nymegen 1679

(signature from a Trompe-l'Oeil painting)

NIXON, John,
English c.1750-1818,
B,H,M,TB,DAV93,
SOT(LON)7/11/91,
CH(LON)7/14/92&
11/17/94

(J) *Nixon* (INITIAL J WAS NOT LEGIBLE)
1803
FROM DRAWING OF PENCIL, PEN, INK & WATERCOLOR.

John Nixon fecit)786
(FROM DRAWING OF PEN & GREY INK & WATERCOLOR)

NOEL, Alexandre Jean,
French 1752-1834,
B,H,M,TB,DAV93,
CH1/9/91&1/13/93,
SOT1/12/94

Noelf. <(signature from bodycolor drawing)
(1796)

noel <(SIGNATURE FROM GOUACHE)

NOEL, Alexis Nicolas,
French 1792-1871,
B,H,M,TB

Noël

NOLPE, Pieter,
Dutch 1613-1653,
B,H,M,TB,DAV93,
SOT4/7/88,CH(LON)
7/5/90,AUD4/26/93

N *PV* *AJ*

NONNOTTE, Donatien,
French 1708-1785,
B,H,M,TB,DAV93,
PH(LON)4/16/91,
SOT(LON)10/27/93,
CH(LON)12/10/93

Nonnotte
pinx.1746

NOOMS, Reinier
(called ZEEMAN),
Dutch c. 1623-1667,
B,H,M,DAV93,CH(AMS)
11/28/89,SOT4/5/90,
SOT(LON)4/17/91

R.ᵛ Zeeman R Zeeman.

Zeeman <(signature from etching)

NOORT, Lambert van,
Dutch 1520-1570/71,
B,H,M,TB,DAV93,
SOT5/20/93,
SOT(AMS)11/17/93

L·V·N
Inven:
·1555·

< INITIALS FROM DRAWING OF PEN,
BROWN INK AND BLUE WASH

NOORTIG, Jan,
Dutch mid 17th century,
B,H,DAV93,
SOT5/22/92

Jan Noortig 1655

NOVALLES, Amede,
Dutch? 18/19th century,
PH(LON)7/2/90

Novalles <(signature from drawing of black
chalk heightened with white)

NOVELLI, Pietro Antonio,
Italian 1729-1804,
B,H,M,TB,DAV94,
SOT(LON)4/13/94,
SOT1/10/95

Novelli feut.
Pid Ar Novelli.

BOTH SIGNATURES FROM DRAWINGS OF PEN & BLACK INK
& GREY WASH OVER BLACK CHALK

OAKLEY, Octavius,
English 1800-1867,
B,H,M,TB,DAV94,
CH(LON)11/1/90&11/9/93

O.OAKLEY Fect.
1860
FROM PENCIL & WATERCOLOR WITH SCRATCHING OUT.

OBERMAN, Anthony,
Dutch 1781-1845,
B,H,DAV93,SOT(LON)
10/18/89&4/11/90,
SOT(AMS)4/20/93

A:Oberman

OCHTERVELT, Jacob,
Dutch 1634-1708/10,
B,H,M,TB,DAV93,
PH(LON)7/2/91,
CH(LON)10/23/92,
SOT1/12/95

ahtErЯЕСt f.

ODERKEKEN, Willem van,
Dutch ac.1631-1677,
DAV93,CH(MON)
12/7/90

W. oDeƶKeKeⲛ f.

OETS (or OUTS), Pieter,
Dutch 1721-1790,
B,DAV93,SOT10/13/89

<(signature from
pastel portrait)

OET(T)INGER, F.,
Swiss? ac.1783,
CH1/13/93

F. Oetingerpinxt.Froch.1783
(black chalk, bodycolor on vellum)

OLIS, Jan,
Dutch 1610-1676,
B,H,M,TB,DAV93,
PH(LON)10/30/90,
LEM12/2/92,CH
1/11/95

J.olis

OL(L)IVIER, Michel
Barthelemy,
French 1712-1784,
B,H,M,TB,DAV93,
CH5/21/92&1/12/94

MB·OLLiViER·f

OMMEGANCK, Balthasar Paul, Flemish 1755-1826, B,H,M,TB,DAV94, CH5/28/93,SOT5/26/94& 1/12/95	*PB Ommeganck*
OORT, Hendrik van, Dutch 1775-1847, B,DAV93,CH10/16/87	*H.Van Oort*
OOSTEN, Isaak van, Flemish 1613-1661, B,H,DAV93, SOT10/11/91,CH1/11/91, CH(LON)12/10/93	*J.V.oosten fe* *J.V.O.*
OOSTERHUIS, Haatje Pieters, Dutch 1784-1854, B,DAV93,CH(AMS) 11/20/89	*H.P.Oosterhuis del.1828.* (signature from drawing: pen & grey ink & grey wash)
OOSTVRIES (or OOSTFRIES), Chatharyna, Dutch 1636-1708, B,CH(AMS)11/29/88& 6/12/90	*Catharina OofEries 1678*
OPITZ (or OPIZ), George Emmanuel, German 1775-1841, B,H,M,TB,DAV93, SOT(LON)2/15/90,PH(LON) 3/12/91,WIN4/3/93	*OPITZ* *G.OPIZ*
OPPENHEIM (MORITZ), Moritz Daniel, German 1800-1882, B,H,M,TB,DAV93	

OPPENORD, Gilles Marie,
French 1672-1742,
B,H,M,TB,DAV93,
CH(LON)7/2/91,
CH1/11/94,SOT1/10/95

<(O P D SIGNATURE FROM DRAWING OF BLACK CHALK, PEN & BLACK INK, WITH GREY & PALE PURPLE WASH WITH WHITE)

<(FROM ARCHITECTURAL DRAWING OF BLACK CHALK, PEN & BROWN INK, PEN & GREY INK, GREY WASH & WATERCOLOR)

< FROM ARCHITECTURAL DRAWING OF PEN AND BROWN INK.

FROM DRAWING OF PEN, BLACK INK, GREY WASH OVER BLACK CHALK

ORLEY, Hieronymus van III,
Flemish ac.c.1656 (1595?-),
B,H,DAV93,CH5/31/91

ORLOVSKII, Aleksandre
Osipovich,
Polish 1777-1832/38,
B,H,M,TB,DAV93,
CH(LON)10/10/90,
AGR10/11/92

(signature from drawing of red & black chalk)

<(A O monogram from pencil drawing)

ORMEA, Willem,
Dutch 1611-1665,
B,H,M,TB,DAV93,
SOT(LON)4/11/90,
PH(LON)7/3/90

OR(R)ENTE, Pedro,
Spanish 1570/80-1644/45,
B,H,M,TB,DAV93,
SOT(MAD)5/18/93,
SOT(LON)12/8/93

Pedro Orente

(SIGNATURE FROM DRAWING)
Note: Also, Known to sign work with a
monogram P.O.F., SOT(MAD)5/18/93,Lot 17.

OS, Georgius Jacobus
Johannes van,
Dutch 1782-1861,
B,H,M,TB,DAV93,
CH10/7/93,SOT(AMS)
11/17/93,SOT1/10/95

GJJ Van Osf. *Van Os*

(Signature: brown ink. Watercolor)

GJJ Van Os
1842

G.J.J. van Os

OS, Jan van,
Dutch 1744-1808,
B,H,M,TB,DAV93,
BB3/21/90,SOT5/20/93,
CH1/12/94

Jan Van Os, fect
1765

J. Van Os.f.

I. Van Os. Fecit

OS, Pieter Gerardus van,
Dutch 1776-1839,
B,H,M,TB,DAV93,
SOT(MON)6/15/90,
SOT(AMS)3/20/93

P van Os f 1824
(signature in brown ink from brown
ink & grey wash drawing)

OSTADE, Adriaen van,
Dutch 1610-1685,
B,H,M,TB,DAV93,
CH(AMS)11/13/90&
5/6/93,SOT1/12/95

A.o *A. Ostade.*

A. oftade

OSTADE, Isaak van,
Dutch 1621-1649,
B,H,M,TB,DAV93,
SOT(LON)4/1/92&
12/8/93

J.vo

OSTENDORFER, Michael,
German 1490-1559,
B,H,M,TB,CH(LON)
7/7/92

MO <(ATTRIBUTED)
(FROM DRAWING OF BLACK, WHITE & RED CHALK)

OTIS, Bass,
American 1784-1861,
B,D,F,H,I,M,TB,
DAV93,FR4/14/87&
10/8/92

B. Otis

OUDRY, Jacques Charles,
French 1720-1778,
B,H,M,TB,DAV93,
SOT1/15/93,SOT(LON)
12/8/93

*JC.oudry
1753*

OUDRY, Jean Baptiste,
French 1686-1755,
B,H,M,TB,DAV93,
SOT5/20/93,SOT(MON)
7/2/93,CH(MON)
CONTINUED

*JB.oudry JB.oudry
1739*

OUDRY, Jean Baptiste,
CONTINUED
7/3/93

Boudry f <(from drawing of black & white
chalk on blue paper)

OUWATER, Isaac,
Dutch 1750-1793,
B,H,DAV93,SOT(LON)
4/17/91,SOT5/22/92,
SOT(LON)12/7/94

I.OVWATER 1788

J.ᵏ Ouwater

OVERBECK, Johann Friedrich,
German 1789-1869,
B,H,M,TB,DAV93

OVERBEEK, Leenert,
Dutch 1752-1815,
B,H(overbeck),DAV93,
CH(AMS)11/25/92

L:Overbeek <(from drawing of pen,
grey ink & watercolor)

OVERSCHEE, Pieter van,
Dutch mid 17th century,
B,H,DAV94,SOT(LON)
7/6/94

P.V.O.

PAEZ, Jose or Joseph,
Mexican 1720–1790,
V,M?,DAV93,
CH11/19/91,
SOT11/24/92&5/18/93

Joseph de Paez
pinxit a 1764

Paez

PAGANI, Matteo,
Italian 17th century,
B,Parke Bernet–NY
City 3/16/79

MP

PAGANO, Michele,
Italian 1697?/after 1750,
B,H,DAV93,
SOT(MIL)5/21/91

**MICHE
LE
PAGANO
P 1729**

PAGE, William,
English 1794–1872,
H,CH(LON)11/8/94

W. Page 1820

SIGNATURE FROM PENCIL AND WATERCOLOR

PAGGI, Giovanni Battista,
Italian 1554–1627,
B,H,M,TB,DAV93,
CH(MON)6/15/90,
FIN5/13/93,CH(LON)
7/9/93

 <(initials from drawing of black
chalk & brown wash)

PAJOU, Augustin,
French 1730–1809,
B,H,DAV93,
SOT10/26/90,
CH1/13/93

Pa. fe <(from drawing of black & red chalk)
1777

PAJOU, Jacques
Augustin Catherine,
French 1766–1828/29,
B,H,M,TB,CH(MON)
12/7/90

A Pajou <(inscription signature from a
drawing of black chalk with
white on blue paper)

PALAGI, Pelagio, Italian 1775-1860, B,H,M,TB,DAV93, SOT(MIL)5/17/90	*P. Palagi* ⟨(signature from drawing)
PALAMEDES(Z.), Anthonie, Dutch 1601-1673, B,H,M,TB,DAV93, CH(LON)7/9/93, CH(AMS)11/18/93, SOT1/12/95	*A. Palamedes.*
PALAMEDESZ.,Palemedes **(called STEVAERTS),** Dutch 1601-1638, B,H,M,TB,DAV93, SOT10/10/91,CH(LON) 7/5/91&4/1/92	*PALAMEDES? 1622*
PALMA (or NEGRETTI), Jacopo (called IL GIOVANE), Italian 1544-1628, B,H,M,TB,DAV93, CH10/7/93,SOT(LON) 12/7/94,SOT1/10/95	*Giac° Palma* ⟨(signature from drawing of pen & brown ink heightened with white over black chalk & washed pale brown)
PANINI (or PANNINI), Giovanni Paolo, Italian 1691-1765, B,H,M,TB,DAV93, CH(LON)7/9/93, CH1/12/94&1/11/95	*I.P.P.1751* I·P·PANINI
PAOLINI, Pietro, Italian 1603-1681/82, B,H,DAV93,CH 5/21/92,SOT(LON) 12/9/92,CH(LON) 12/10/93	P. P.
PARELLE, Marc Antoine, French ac. 2nd half 18th century, B,DAV94,CH(LON) 12/11/90,SOT1/12/95	*M. parelle* *1774*
PARIS, Carlo de, Spanish 1800-1861, B,TB	*C. P.*

PARIZEAU, Philippe Louis,
French 1740-1801,
B,H,DAV93,SOT(MON)
12/2/89,CH1/10/90

Ph.L Parizeau 1774

PARKER, Henry Perle,
English 1795-1873,
B,H,M,TB,DAV93,
PH(LON)1/30/90&
4/30/91,CH(LON)
6/11/93

H. P. Parker 1828 *H.P.Parker 1852*

PARMIGIANO, Francesco,
Italian 1503-c.1540,
B,H,M,R,TB,DAV94,
CH1/9/91,SOT7/17/91

Permegiano < PERMEGIANO IS CORRECT

SIGNATURE FROM DRAWING OF BLACK CHALK WITH WHITENING.

PARPETTE, Philippe,
French 1755-1806,
B,DAV93,SOT(MON)
6/18/92

Parpette 1773

PARRIS, Edmond Thomas,
English 1793-1873,
B,H,M,TB,DAV93,
CH(SK)9/27/90,
CH(LON)5/16/91,
SOT5/26/93

E.T.Parris 1838

PARROCEL, Charles,
French 1688-1752,
B,H,M,TB,DAV93,
CH(LON)7/7/92,SOT(MON)
7/2/93,SOT1/12/94

Parrocel <(signature in pen & ink from
red & black chalk drawing)

Note: Known to sign drawings with initials,
CH(MON)7/2/93 lot 63.

PARROCEL, Etienne,
French 1696-1776,
B,H,M,TB,DAV93,
CH(LON)7/2/91,
CH(MON)7/2/93

Stefanus parrocel 1744

SIGNED 'STEFANUS PARROCEL', FROM
DRAWING OF RED CHALK

PARROCEL, Joseph Francois,
French 1704-1781,
B,H,M,DAV93,
SOT(LON)7/5/93,
SOT10/8/93&1/10/95

Parrocel 1759

SIGNATURE FROM DRAWING OF
BLACK & WHITE CHALK ON
BEIGE PAPER >

JF Parrocel

PASSARI, Bernardino,
Italian c.1540-c.1590,
B,H,SOT1/8/91

Bernardin Passari

(signature from drawing of pen & brown ink)

PASSAVANT, Johann David,
German 1787-1861,
B,H,TB

PASSINI, Johann Nepomuk,
Austrian 1798-1874,
B,H,TB,DAV93

J.P.

PATCH, Thomas,
English c.1720-1782,
B,H,M,TB,DAV93,
CH(LON)4/12/91,
PH(LON)5/10/93

P.
1768 <(MONOGRAM FROM ETCHING)

PATEL, Antoine Pierre II,
French 1648-1707,
B,H,M,TB,DAV93,
CH1/11/94,SOT1/12/94,
SOT(LON)12/7/94

P. PATEL
1691 <(signature from
gouache on vellum)

FROM DRAWING OF BODYCOLOR
ON VELLUM >

A PATEL
1693

PAYNE, William,
English 1744/45-1833,
B,H,M,TB,DAV93,
SOT(LON)4/27/88&
7/11/91,CH(LON)
CONTINUED

W. Payne <(signature from watercolor)

PAYNE, William
CONTINUED
7/14/92

W Payne <(FROM DRAWING OF PENCIL, PEN &
GREY INK AND WATERCOLOR)

PEALE, Ann Claypoole,
American 1791-1878,
B,D,F,H,I,M,TB,DAV93,
CH3/10/89&11/20/90&
6/23/93

Anna C Peale 1824 *Anna C Peale 1824*

(signatures above & to the right
were taken from watercolors on
ivory)

A. P. 1866

PEALE, Charles Wilson,
American 1741-1827,
B,D,F,H,I,M,TB,DAV93,
CH5/29/87&11/30/90&
5/28/92

CW Peale

Chas W Peale

PEALE, Harriet Cany,
American c.1800-c.1869,
H,DAV93,CH5/22/91&
6/26/91

H. C. Peale 1848 *H. Peale 1844*

PEALE, James, Jr.,
American 1789-1876,
B,D,H,I,DAV93

J. Peale 1869 <(signature from watercolor)

PEALE, James, Sr.,
American 1749-1831,
B,D,F,H,I,M,TB,DAV93,
CH5/23/90,SOT5/24/90&
1/28/93

JP 1797 *J Peale (1819)*

PEALE, Margaretta Angelica,
American 1795-1882,
D,H,DAV93,CH9/28/89,
SOT2/1/90

M.P.

PEALE, Raphaelle,
American 1774-1825,
B,D,F,H,I,M,TB,DAV93,
BB11/7/90,SOT5/23/91,
CH9/23/92

Raphaelle Peale 1813

Raphaelle Peale Augt. 5th 1814

Raphaelle Peale

PEALE, Rembrandt,
American 1778-1860,
B,D,F,H,I,M,TB,DAV93,
CH3/14/91,SOT5/23/91&
5/27/93

R.Peale *R.Peale*

Rembrandt Peale *R.P. 1826*

PEALE, Rubens,
American 1784-1865,
B,D,F,H,M,TB,DAV93,
CH9/27/90

R Peale Rubens Peale

PEALE, Sarah Miriam,
American 1800-1885,
B,D,F,H,I,M,TB,DAV93,
SOT5/24/89&6/26/91&
10/25/92

S.P.

PEALE, Titian Ramsay II,
American 1799-1885,
A,B,D,F,H,I,M,TB,
DAV93,SOT10/19/89
CONTINUED

T.P. <(initials from pencil drawing)

PEALE, Titian Ramsay II **CONTINUED**	*J.R.Peale* <(signature from watercolor) (1833) T R P <(initials from watercolor)
PEETERS, Bonaventura, Flemish 1614-1652, B,H,M,TB,DAV93, SOT(ARC)7/16/92& 7/22/93,SOT(LON) 12/7/94	B·P 1639 B·Peeters
PEIGNE, Madame, French ac.1790-1815, B,CH(LON)7/6/93, CH1/11/94	M^{de} Peigné FROM DRAWING OF BLACK CHALK, WATERCOLOR, AND BODYCOLOR.
PEIRANO, Italian late 17th century, SOT5/22/92	Peirano.Genovese.F
PELEGRIN, Honore, French 1793-1869, DAV93,CH(MON) 12/7/90	Pellegrin 1852
PELLION, J. Alphonse, French? ac.1817-1820, DAV94,CH(LON) 7/16/93&7/15/94	AP. < FROM WATERCOLOR, PEN & INK
PENNY, Edward, English 1714-1791, B,H,M,TB,DAV93, CH1/10/90	Edw. Penny 1756
PERALTA, Juan Pedro, Spanish ac. 1st half 18th century, B?,CH(LON)12/10/93	PERALTA A & L CONJOINED IN SIGNATURE

PERCIER, Charles,
French 1764-1838,
B,H,DAV94,CH(LON)
7/2/91,CH(MON)
6/20/94,SOT1/10/95

FROM WATERCOLOR WITH BLACK CHALK, > *CP.*
PEN & GREY WASH. *1815*

PERIGNON, Alexis Nicolas,
French 1726-1782,
B,H,DAV93,CH(LON)
12/11/90,SOT(LON)
7/1/91,CH1/13/93

n Perignon F. 1776 <(drawing of black
chalk, watercolor & bodycolor)

A n Perignon

PERRET, Pieter,
Flemish? ac.1631-before
1671,
CH(LON)12/10/93

P. P. f.
1643.

**PERRON(N)EAU, Jean
Baptiste,**
French 1715-1783,
B,H,M,TB,DAV93,
SOT5/20/93,CH(MON)
7/3/93

Perreneau <(PERRENEAU IS CORRECT)
(pinx) ⌐(SIGNATURE FROM PASTEL
1748 MOUNTED ON BOARD)

Perronneau pinx 1747

Perronneau pinx 1747

Perroneau 1750 < FROM PASTEL

PERRONEAU WITH ONE N IS ALSO CORRECT

PESCHEL, Carl Gottlieb,
German 1798-1879,
B,H,M,TB,DAV93,
SOT(MUN)12/10/92

CP *CP*

**PETEL (or PETLE or
BETLE), Georg or Jorg,**
German 1593-1634,
B,H,M,TB,DAV93,
SOT(LON)7/5/93

j Betle. < SIGNATURE FROM DRAWING
OF RED CHALK

PETITOT, Ennemond
Alexandre,
French 1727-1801,
B,M,TB,DAV93,
CH1/11/94

FROM DRAWING OF BLACK CHALK, PEN AND BROWN INK,
BROWN WASH, ON LIGHT BROWN PAPER.

PETRICH, Andras,
Hungarian 1765-1842,
B

PETRIE, John L.,
Scots/English 18-19th
century,
B,H

PETTER, Franz Xaver,
Austrian 1791-1866,
B,H,M,TB,DAV94,
SOT1/22/92,
WIE9/28/94

PETTY, Richard,
English late 18th
century,
SOT(LON)3/10/88

(signature from a gouache & watercolor)

PEYRON, Jean Francois
Pierre,
French 1744-1814,
B,H,M,TB,DAV93,
CH(MON)7/2/93

< SIGNATURE FROM
DRAWING OF BLACK
& BROWN WASH

PFORR, Johann Georg,
German 1745-1798,
B,H,M,TB,DAV93,
CH10/15/92,CH(LON)
4/23/93

PHILIP(P) (or PHILLIPPS), Michael, German ac. 1659-1687, B,DAV93,SOT1/13/88, CH(LON)7/7/92	*Michael prifliÿ: Dantzig Anno 1652.* (FROM DRAWING OF BLACK CHALK, PEN AND BLACK INK, & GREY AND BROWN WASH HEIGHTENED WITH WHITE)
PHILIPS, Jan Vaspar, Dutch 1700-1773, B,PH(LON)12/12/90	*J.C.Philips fecit.1749* (signature from drawing of pen & grey wash & traces of red chalk)
PIAZZETTA (or PIAZETTA), Giovanni Battista, Venetian 1682-1754, B,H,M,TB,DAV93, SOT1/13/93&1/12/94& 1/10/95	*Gio Batta Piazzetta.* <(signature in red chalk. Red chalk, touches of white chalk, on buff paper)
PICART (or PICARD), Bernard, French 1673-1733, B,H,DAV93,CH(LON) 7/2/91,CH1/13/93, CH(MON)7/2/93	*B.Picatt.F* <(signature from drawing: black chalk, pen & grey ink & grey wash) *B.Picart†* *1730* <(from red chalk drawing) *B.Picart·fecit.1716.* SIGNATURE FROM DRAWING OF BLACK CHALK, BROWN AND GREY WASH ON BEIGE PAPER
PICOT, Francois Eduard, French 1786-1868, B,H,M,TB,DAV93, SOT6/1/89,SOT(MON) 12/5/92	*Picot*
PIERRE, Jean Baptiste Marie, French 1713-1789, B,H,M,TB,DAV93, SOT5/22/92,CH1/14/93, CONTINUED	*B.Pierre* <(signature in pen & brown ink. Red chalk heightened with white chalk, buff paper)

PIERRE, Jean Baptiste
Marie
CONTINUED
CH(MON)7/2/93

Pierre <(brown ink signature from gouache)

PIERSON, Christoffel,
Dutch 1631-1714,
B,H,M,TB,DAV93,
SOT(AMS)11/11/92,
SOT(LON)4/1/92

Chr. pierson
f 1687

PIETRI (or PETRI),
Pietro Antonio dei,
Italian 1663-1716,
B,H,M,DAV93,CH
1/9/91,CH(LON)
3/20/93,SOT1/12/94

Pietro de Pietri

(signature from drawing of black
chalk, pen & brown ink)

PIGAL, Edme Jean,
French 1798-1872,
B,H,M,TB,DAV94,
CHE10/15/93

Pigal 1834

PILLEMENT, Jean Baptiste,
French 1727-1808,
B,H,M,TB,DAV93,
CH2/11/92&10/7/93,
SOT1/10/95

J. Pillement Jean Pillement

(signature on black chalk drawing)

Pillement < INK SIGNATURE FROM
BLACK CHALK DRAWING

PINCHON, Jean Antoine,
French 1772-1850,
B,DAV93,SOT10/26/90

Pinchon. 1806.

(signature from drawing of black
chalk heightened with white)

PINELLI, Bartolomeo,
Italian 1781-1835,
B,H,M,TB,DAV93,
CH2/26/91,CH(MON)
6/20/92,SOT(LON)
7/5/93

Pinelli 1831

PINGRET, Edouard Henri
Theophile,
French 1788-1875,
B,H,M,TB,DAV93,
SOT5/18/93,SOT(MON)
7/2/93

E. Pingret.
1852.

PINK, Edmund,
English ac. early 1820s,
CH(LON)7/15/94

E.PINK *E.Pink.1823.*

E.Pink_1822. *E.Pink_1821—*
ALL THESE SIGNATURES ARE FROM WATERCOLOR/SKETCHES.
SIZEABLE BIOGRAPHICAL & PICTORIAL INFORMATION CAN
BE FOUND IN CATALOGUE — CHRISTIE'S LONDON 7/15/94.

PITLOO, Antonie Sminck,
Dutch?/German 1790-1837,
B,H,M,TB,DAV93,
CH(LON)11/25/88&10/5/90,
CH(R)11/19/92

A.Pitloo

PLANSON, Joseph Alphonse,
French 1799- ,
B,DAV94,PH(LON)
3/15/94

Planson 1836

PLASSCHAERT, Jacobus,
Belgian 1725?-1765,
B,H,DAV93,SOT(LON)
4/17/91

J.Plasschaert
1747

PLATZER, Johann Georg,
Austrian 1704-1761,
B,H,M,TB,DAV93,
SOT(LON)7/3/91,
CH(LON)5/20/93&
7/9/93

Jg Plazer (ON COPPER)

(PLAZER IS CORRECT)

POCOCK, Nicholas,
English 1740-1821,
B,H,M,TB,DAV93,
PH(LON)11/12/90,
CH(LON)4/9/91,
SOT(LON)5/12/93

N Pocock 1809 <(signature from watercolor)

POEL, Egbert van der,
Dutch 1621-1664,
B,H,M,TB,DAV93,
CH(LON)7/9/93,
CH(AMS)11/18/93,
SOT1/12/95

POELENBURGH (or POELEN-
BORCH), Cornelis van,
Dutch 1586-1667,
B,H,M,TB,DAV93,
SOT(LON)12/9/92,
CH(LON)7/9/93,SOT1/14/94

POIROT, Achille,
French 1797-after 1852,
B,DAV94,SOT(MON)
12/2/94

POL, Christiaen van,
Dutch 1752-1813,
B,H,M,TB,DAV93,
SOT(MON)12/2/89,
SOT(LON)12/8/93

POLLARD, James,
English 1792/97-1859/67,
B,H,M,TB,DAV93,
CH3/1/90,BB11/13/91,
PH(LON)4/27/93

POMPE, Gerrit, Dutch 1655-1705, B,H,M,TB,DAV93, CH5/21/92,SOT(LON) 7/8/92&10/27/93	*G Pompe. 1691* *GP*
PONCE, Antonio, Spanish 1608-after 1662, B,H,DAV93,CH(LON) 5/29/92,SOT(MAD) 5/18/93	*Antº Ponce.* *fa*
POORTER, Willem de, Dutch 1608-after 1648, B,H,M,TB,DAV93, SOT5/30/91, CH12/11/92&1/11/95	*W.D.P. 1640*
POPE, Alexander, English 1668-1744, B,H,M,TB	*A. Pope 1723*
PORCELLIS, Jan, Dutch c.1584-1632, B,H,M,TB,DAV93, CH(AMS)11/12/90, CH5/31/91,SOT1/15/93	*Joannesporsellis* *IP* (initials from drawing of pen, brown ink & wash)
POST, Frans, Dutch 1612-1680, B,H,M,TB,DAV93, SOT10/11/90, CH1/16/92, SOT(LON)12/7/94	*F. Post* *F.Post.1640* *F.Post .1640* *F.Post. 1657*
POT, Hendrick Gerritsz., Dutch c.1585-1657, B,H,M,TB,DAV93, CH5/31/91&5/21/92, CH(LON)7/9/93	*HP*
POTTER, Paul or Paulus, Dutch 1625-1654, B,H,M,TB,DAV93, SOT6/5/86,PH(MAR) 10/26/90 CONTINUED	*Pauwelis Potter. 1644*

POTTER, Paul or Paulus
CONTINUED

Paulus Potter. F: 1652

POWEL(L), Charles Martin,
English 1775-1824,
B,H,M,TB,DAV93,
PH(LON)12/13/88,
SOT(LON)5/22/91,
STU5/20/93

Powell 1823

POYNTER, Ambrose,
English 1796-1886,
B,H,DAV93,SOT(LON)
5/22/86

·AMBROSE POYNTER ARCHT.

PRETRE, Jean Gabriel,
French 1800-1840,
DAV93,CH1/11/94

J G Pretre

·FROM DRAWING OF PENCIL & WATERCOLOR ON VELLUM.

PREUDHOMME, Jerome,
French late 18th century,
B,DAV93,CH(LON)
11/24/88,AUD11/19/92

Jerome Preudhomme fecit 1798

(signature from a drawing of pencil, pen, black
ink & watercolor heightened with white)

PREVOST, Jean Jacques,
French 1735- ,
H,DAV93,SOT(MON)
6/15/90,CH1/10/91,
SOT(LON)12/8/93

Jean Prevost (177(0))

PREVOST, Jean Louis,
French 1760-1810,
B,H,M,TB,DAV93,
CH(LON)3/17/89,
SOT1/15/93&1/12/94
CONTINUED

L.J. Prevost. *J.L. Prévost*

PREVOST, Jean Louis
CONTINUED

J.L. Prevost. < FROM GOUACHE ON BLUE PAPER

PRINS, Johannes Huibert,
Dutch 1757-1806,
B,H,M,TB,DAV93,
CH(AMS)11/25/92,
SOT(LON)7/5/93

J.H.Prins <(from pencil & watercolor)
1792
Note: Also, known to sign name with the
J H in ligature.

PRINSEP, Emily Rebecca,
English 1798-1860,
DAV93,SOT6/15/90,
CH(LON)6/15/90

June 24 1854
EmR Prinsep <(signature from watercolor)

PRINSEP, William,
British ac.1819-1858,
DAV94,CH(LON)
11/12/91&11/9/93

WP (Feb. 1858)
INITIALS FROM PENCIL & WATERCOLOR

PRITCHETT, Edward,
English ac.1828-1864
(died 1864),
B,H,M,TB,DAV94,
CH5/27/93,SOT(LON)
6/9/93

S Pritchett
INITIAL S IS CORRECT

PROCCACINI, Camillo,
Italian c.1546-1629,
B,H,M,TB,DAV93,
WES2/24/90,PH(LON)
3/5/91,CH(MON)
6/20/92

Cam.° Proccacini
(signature from drawing of ink & wash)

PRON(C)K, Cornelis,
Dutch 1691-1759,
B,H,M,TB,DAV94,
SOT(AMS)11/15/94

C.pronk d.L: ad VW: 1730.
FROM DRAWING OF PEN & BLACK INK & GREY WASH

PROUT, Samuel,
English 1783-1852,
B,H,M,TB,DAV93,
CH2/26/91,CH(LON)
6/13/91&7/14/92
CONTINUED

S.Prout *Prout* *P*
(signature from watercolor) from watercolor

PROUT, Samuel
CONTINUED

Prout. <(signature from pencil drawing)

PRUD'HON, Pierre Paul,
French 1758-1823,
B,H,M,TB,DAV93,
CH5/21/92&1/11/94,
SOT1/12/95

Prud'hon

FORM DRAWING OF BLACK CHALK.

P.P. Prud'hon

FROM DRAWING OF BLACK CHALK, PEN AND
BROWN INK AND BROWN WASH.

PUGET, Pierre,
French 1620-1694,
B,H,M,TB,DAV93,
CH(LON)3/1/91,
SOT(MON)12/5/92

PUGET <(from india ink drawing on vellum)

PUGIN, Augustus Charles,
French 1762/69-1832,
B,H,M,TB,DAV93,
LH10/14/89,SOT(ARC)
7/17/92

A. Pugin

A. Pugin K. <(FROM DRAWING OF CHARCOAL,
BROWN CRAYON & WHITE CHALK)

PUNT, Johannes or Jan,
Dutch 1711-1779,
B,H,M,TB,DAV93,
CH1/9/91

J. Punt fecit 1741 <(from drawing of
black chalk, pen
& grey ink, grey wash)

PURSER, William,
English c.1790-c.1852,
B,H,DAV93,SOT(LON)
2/15/90,CH(LON)
7/14/92

W. Purser <(SIGNATURE FROM PENCIL &
WATERCOLOR WITH TOUCHES
OF WHITE & GUM ARABIC)

PUT(T)ER, Pieter de, Dutch 1605-1659, B,H,M,TB,DAV93, CH(AMS)5/6/93, CH(LON)12/10/93	*DVT^R F.* *DVT.^R*	<(PD linked V T R is correct)
PYLE, Robert, French/English 1705-1781?, B,H,DAV93,SOT(LON) 10/31/90	*Pyle*	
PYNA(C)KER, Adam, Dutch 1622-1673, B,H,M,TB,DAV93, SOT1/10/91,CH10/9/91, SOT(LON)4/21/93	*Rynacker*	
PYNAS, Jan Sijmonsz., Dutch 1583-1631, B,H,M,TB,DAV93, CH(AMS)6/12/90, SOT(LON)2/18/91, SOT1/14/94	*Pynas f* *1613*	
PYNE, James Baker, English 1800-1870, B,H,M,TB,DAV93, PH(LON)11/13/90,CH(LON) 6/14/91,SOT(LON) 4/6/93	*J.B.PYNE 1861* *PYNE: 30* *J.B.Pyne 1842* *J.B.PYNE1869*	

QUADAL (or CHWATAL),
Martin Ferdinand,
Austrian 1736-1811,
B,H,M,TB,DAV93,
SOT1/11/90,CH(LON)
4/18/91,PH(LON)7/2/91

M. F. Quadal *M.F. Quadal*
1788

QUAST, Pieter Jansz.,
Dutch 1606-1647,
B,H,M,TB,DAV93,
CH(AMS)11/25/92,
SOT(AMS)11/17/93,
SOT(LON)12/7/94

1646

<(from drawing of
black lead on
vellum)

PQuast *PQuast 1636*
1628

QUERFURT, August,
German 1696-1761,
B,H,M,TB,DAV93,
SOT4/11/91,SOT(MIL)
5/12/92,SOT(LON)
12/7/94

AQ *AQ* *A. QuerFurt 1749*

QUESNEL, Jacques,
French -1629,
B,H,DAV93,CH(LON)
7/2/91,CH1/11/94

Jacques quesnel. 1588

(FROM DRAWING OF BLACK CHALK,
PEN AND BROWN INK)

QUINKHARD (or QUINCK-
HARDT), Jan Maurits,
Dutch 1688-1772,
B,H,M,TB,DAV93,
SOT(LON)4/20/88,
SOT(AMS)5/12/92

JM Quinkhard 1731

JM Quinkhard

RADEMAKER, Abraham,
Dutch 1675-1735,
B,H,M,TB,DAV93,
CH(LON)7/2/91,
CH(AMS)11/25/92,
SOT1/12/94

<(from drawing of pencil & watercolor
heightened with white)

FROM GOUACHE

RAFFALT, Ignaz,
Austrian 1800-1857,
B,H,DAV94,WD11/15/90,
WIE4/20/94

RAIMONDI, Marcantonio,
Italian c.1480-1527/34,
B,H,M,R,TB,DAV94,
SOT(LON)7/2/90

MONOGRAMS FROM ENGRAVINGS

THE F IN MAF IS FOR FECIT

RAMBERG, Johann Heinrich,
German 1763-1840,
A,B,H,M,TB,DAV93,
CH(LON)7/9/85,
BAS12/4/92

RAMBOUX, Johann Anton
Alban,
German 1790-1866,
B,H,M,TB,DAV93,
LEM12/2/92

RAMIREZ, Felipe,
Spanish ac.1628-1631,
B,H,CH(LON)5/29/92

(1631)

RAULIN, Alexandre, French 19th century, B?,SOT(MON)12/5/92	A Raulin 1848
RAVEN, Samuel, English 1775-1847, B,H,DAV93,PH(LON) 12/12/89	S. Raven
RAVENSWAY, Jan van, Dutch 1789-1869, B,H,DAV93,CH(AMS) 4/24/91,LEM12/2/92	JvR 1831
RAVESTEYN, Hubert van, Dutch 1638-after 1691, B,H,M,TB,DAV93, CH6/2/88&5/31/90	H Ravensteyn HR H·V·R
REALFONSO, Tommaso, Italian 18th century, B,H,DAV93,SOT6/2/89, CH(LON)5/10/90, SOT(LON)4/17/91	T.R.
RECCO, Gaetano, Italian 17th century, CH(LON)7/8/94	D. Caetanus Recco Fecit
REDOUTE, Pierre Joseph, French 1759-1840, B,H,M,TB,DAV93, CH(LON)7/2/91, SOT(LON)11/30/93, SOT1/10/95	P. J. Redoute pinx 1803 (from drawing: pencil & watercolor, heightened with white on vellum) P. J. Redoute . (from drawing of black chalk & watercolor on vellum)

REGEMORTER, Ignatius
Josephus Pieter van,
Dutch 1785-1873,
B,H,M,TB,DAV93

REGNAULT, Jean Baptiste,
French 1754-1829,
B,H,M,TB,DAV93,
PH(LON)12/12/90,
CH(LON)7/2/91

<(signature from a drawing of
pen, brown ink & wash)

REGNIER (or RENIERI
or RAMEDIUS), Niccolo,
Flemish 1591-1667,
B,H,M,TB,DAV93,
SOT(LON)12//2/90,
CH5/21/92&10/7/93

REGTERS, Tiebout,
Dutch 1710-1768,
B,H,DAV93,CH(AMS)
11/28/89,SOT(AMS)
5/7/93

REHBENITZ, Theodor Marhus,
German 1791-1861,
B,M,TB,DAV93

REICHMANN, Georg Friedrich,
German 1798-1853,
B,H,M,TB

REINAGLE, Philip,
English 1749-1833,
B,H,M,TB,DAV94,
WD5/19/93,CH(LON)
3/25/94

REINHOLD, Heinrich,
Austrian 1788-1825,
B,H,M,TB,DAV94,
CH(LON)10/13/94

Reinhold f. 1824

REMBRANDT, or Rembrandt
Harmensz van RIJN,
Dutch 1606-1669,
B,H,M,TB,DAV93,
CH(LON)7/4/91,
CH5/31/91,CH(AMS)
11/25/92

Rembrandt.f 1636

Rembrandt f 1636

Rembrandt.f.1650

RL 1630

Rembrandt f. 1637

RL

Rembrandt.f:1633

RL.f.

REMOND, Jean Charles
Joseph,
French 1795-1875,
B,H,M,TB,DAV93,
CH(MON)6/15/90,CH(LON)
5/9/91,SOT(MON)12/5/92

J.Ch.J.Remond

Remond

REMPS, Andrea Domenico,
Italian c.1620-after 1699,
DAV93,SOT(MON)
6/16/90,KOL9/11/92,
CH(LON)7/8/94

Andrea Remps

<(signature from a
Trompe-l'Oeil painting)

RENALDI, Francesco,
English ac.1771-1798,
B,DAV93,CH(LON)
11/18/88

F.s Renaldi Pinxit 1787

RENARD, Jean Augustine,
French? 1744-1807,
DAV93,CH1/10/90

J.A.Renard 1777

(red & black chalk)

RENI, Guido,
Italian 1575-1642,
B,H,M,TB,DAV94,
CH5/21/92,
WIE4/20/94

G.R

RESTOUT, Jean, Jr.,
French 1692-1768,
B,H,M,TB,DAV93,
SOT(MON)7/2/93,
CH(MON)6/20/92&
7/2/93

Restout 1734 *Restout*

Restout < FROM DRAWING OF BLACK &
WHITE CHALK ON BEIGE PAPER

REVOIL, Pierre Henry,
French 1776-1842,
B,H,M,TB,DAV93,
SOT(MON)6/19/92,
CH(MON)6/20/92

'R· <(MONOGRAM FROM DRAWING)

P.R.1826. <(MONOGRAM FROM DRAWING)

REYNOLDS, (Sir) Joshua,
English 1723-1792,
B,H,M,TB,DAV94,
CH5/21/92&10/7/93&
1/11/95

J.Reynolds

RHINE SCHOOL,
17th century,
CH(LON)7/7/92

 <(FROM DRAWING OF BLACK CHALK, PEN
AND BLACK INK AND GREY WASH)

RHODES, Joseph,
English 1782-1854,
B,H,DAV93,CH(SK)
1/31/89,CH(LON)
11/1/90

Rhodes 1845

RHOMBERG, Joseph Anton,
German 1786-1853/55,
B,H,M,TB,DAV93

RIBERA, Jose or Jusepe de,
Spanish 1588/91-1652/56,
B,H,M,TB,DAV93,
CH(LON)7/2/91,
SOT1/15/93,SOT(LON)
7/5/93

<(both of these monograms were in the same engraving, spaced as shown, circa 1621)

Jusepe de Ribera

Jusepe de Ribera

Joseph de Ribera fª 1628

(old attribution signature from a red ink brush drawing)

RICHARDSON, Thomas
Miles, Sr.,
English 1784-1848,
B,H,M,TB,DAV93,
BB11/13/91,CH(LON)
4/9/91,PH(LON)5/10/93

J.M. Richardson. Senior

RICHE, Adele,
French 1791-1878,
B,H,DAV93,
SOT1/8/91

Adele Riche <(signature from watercolor)

RICOIS, Francois Edme,
French 1795-1881,
B,M,TB,DAV93,
SOT(MON)6/15/90&
7/2/93

Ricois 1861, <(signature from watercolor)

RICQUIER, Louis,
Belgian 1792-1884,
B,H,DAV93,
SOT11/24/87,
CH(LON)6/24/88

L. Ricquier.

RIDINGER (or RIEDINGER),
Johann Elias,
German 1698-1767,
B,H,M,TB,DAV93,
SOT10/26/90,CH(LON)
7/2/91&7/7/92

Joh:Elias Ridinger der 1748 (brown ink)

ER *ER* *Joh:Elias:Ridinger 1721* (signature from pen & ink dr.)

ER 1757.

RIEDEL, August Heinrich
or Johann,
French 1797-1890,
B,H,M,TB,DAV93,
CH(AMS)10/28/92,
SOT(LON)4/7/93

AR AR AR

RIETSCHOOF, Hendrik,
Dutch 1678/87-1746,
B,H,DAV93,SOT(AMS)
11/21/89

HRiets <(grey ink)
(grey ink & wash, touches of white over black chalk)

RIETVELD, G. Antonie,
Dutch 1789-1868,
DAV93,CH10/26/88,
CH(LON)10/5/90,
CHE5/28/93

G Rietveld 18⅗50 G Antonie 1857 Rietveld

RIGAUD, Stephen
Francis Dutilh,
English 1777-1861,
B,H,M,TB

S. Rigaud

RIJCKERE (or RYCKERE or RYCKE), Bernaert de,
Dutch 1535-1590,
B,H,M,DAV93,
SOT(AMS)11/21/89

. *1561* . <(date & initial in brown ink)

. B . (drawing: pen, brown ink & wash)

RIVAL(T)Z, Antoine,
French 1667-1735,
B,H,M,TB,DAV93,
CH(MON)6/20/92

Rivalz

(SIGNATURE FROM DRAWING OF BLACK CHALK & GREY WASH)

ROBART, P. A.,
Dutch ac. late 18th century,
DAV93,PH(LON)12/4/89,
SOT(LON)10/31/90

P.A. ROBART
FECIT 1791

ROBERT, Hubert,
French 1733-1808,
B,H,M,TB,DAV93,
SOT(MON)7/2/93,
SOT1/14/94&1/10/95

H.ROBERTi <(signature from sanguine drawing) HR
1762 (1804)

H.R.:83 H·ROBERT

H·ROBERT HRobert

ROBERT-FLEURY,
Joseph Nicolas,
French 1797-1890,
B,H,M,TB,DAV93,
CH10/29/86&10/26/88

R.F. R.Fy.

Robert-fleury.

ROBERTO ROBERTI,
Fernando di,
Italian 1786-1837,
DAV93,DU11/16/90,
CH5/27/93

Ferd. Roberto. <(SIGNATURE FROM GOUACHE)

ROBERTS, David,
English 1796-1864,
B,H,M,TB,DAV93,
BB11/7/90,CH(LON)
4/9/91&7/14/92

David.Roberts R.A. 1854
(signature from watercolor & ink)

D.Roberts 1859

D. Roberts. 1835
FROM PENCIL & WATERCOLOR WITH SCRATCHING OUT

RODLER (or ROEDLER),
Joseph,
Austrian 1800-1865,
B,WIE4/20/94

J. Roedler

ROEDIG, Johan Christiaan,
Dutch 1751-1802,
B,H,DAV93,CH5/21/92,
CH(LON)12/10/93

J.C. Roedig

C. Roedig

ROEHN, Jean Alphonse,
French 1799-1864,
B,H,M,TB,DAV93,
SOT2/24/88,PH(LON)
6/19/90,FR4/22/93

aL. Roehn 1827.

ROESTRATEN, Pieter
Gerritsz.,
Dutch 1627-1700,
B,H,M,TB,DAV93,
SOT(LON)12/6/89&
12/9/92,SOT1/14/94

P: Roestraten

ROETTIERS, Joseph Charles,
French 18th century,
B,H,SOT1/10/95

C: Roettiers FROM RED CHALK DRAWING
DESIGN FOR A MEDAL

IS EITHER JOSEPH CHARLES 1692-1779 OR JOSEPH CHARLES
1722-1803

ROGERS, Hephzibah,
English ac. 1820,
B?,H?,CH(LON)
7/13/93

Hephzibah Rogers

FROM PENCIL & WATERCOLOR, HEIGHTENED WITH
BODYCOLOR

ROG(H)MAN(N), Roland
or Rolaert,
Dutch 1597-1686,
B,M,TB,DAV93,CH(LON)
3/23/90,CH(AMS)11/25/92,
SOT(AMS)11/17/93

Roelaert Roghman

SIGNATURE FROM DRAWING OF
PEN & BROWN INK, BROWN &
GREY WASH > *R. Roghman*

ROMA, Jose,
Spanish 1784-1858,
B,SOT(MAD)5/18/93

José Romã

ROMBOUTS, Adriaen,
Belgian 17th century,
B,SOT(LON)5/27/87,
DOR11/4/92&3/9/93

A·Rombaould
∧(letter a in signature is also correct)

ROMBOUTS, Salomon,
Dutch ac.1652-before 1702,
B,H,M,TB,DAV94,
CH(LON)7/4/91,
CH(AMS)11/17/94

RomBovts

ROMEYN, Willem van,
Dutch 1624-1694,
B,H,M,TB,DAV93,
KOL9/11/92,CH(LON)
7/9/93,SOT10/8/93

VXROMeYN *W. R.*

VXROMEYN < SIGNATURE FROM DRAWING OF
BRUSH IN GREY INK AND WASH
OVER BLACK CHALK

RONMY, Guillaume
Frederic,
French 1786-1854,
B,H,DAV94,WD
5/19/93,SOT(MON)
6/19/94

Ronmy

ROOKER, Michael Angelo,
English 1746-1801,
B,H,M,TB,DAV94,
SOT(LON)7/11/91,
CH(LON)11/9/93,
CONTINUED

MRooker

SIGNATURE FROM PENCIL & WATERCOLOR

ROOKER, Michael Angelo
CONTINUED
SOT 1/12/95

MRooker

FROM PEN & INK & WATERCOLOR

ROOS, Johann Heinrich,
German 1631–1685,
B,H,M,TB,DAV 93,
CH(LON) 7/9/93,
SOT 10/8/93

HRoos fecit

FROM DRAWING OF PEN & BROWN & BLACK INK, GREY WASH, GREY INK FRAMING LINES.

ROOS, Johann Melchior,
German 1659–1731,
B,H,M,TB,DAV 93,
PH(LON) 10/30/90,
SOT(LON) 10/28/92

JMRoos
1728

ROOS (or ROSA), Joseph,
German &/or Austrian
1726–1805,
B,H,DAV 93,
SOT 4/17/86

I Roos.

ROSA, Salvator,
Italian 1615–1673,
B,H,M,TB,DAV 93,
SOT(LON) 7/5/93,
SOT 1/12/94 & 1/10/95

Rosa

ROSEX, Nicoletto
(da MODENA),
Italian 1450–1516,
B,H,M,R,TB,DAV 94,
PH(LON) 10/29/91

SIGNATURE FROM ENGRAVING

ALSO KNOWN AS ROSA, ROSSI, SEGNA, NICOLETI OR NICOLETTO

ROSLIN, Alexandre,
Swedish 1718–1793,
B,H,M,DAV 93,
CH 12/11/92,
SOT(LON) 4/21/93

Roslin.
1766

Pc pl. Cheu Roslin.
1781

ROSSUM, Gerard van,
Dutch c.1699–1772,
B,DAV 93,CH(AMS)
11/12/90 & 11/24/92

G.V. Rossum
1760

<(signature from drawing of pencil & grey wash)

ROTA, Giuseppe,
Italian 1777-1821,
B,H,M,DAV93,
PH2/12/80,BUK
5/17/93

G Rota.

ROTTENHAMMER, Hans
or Johann,
German 1564-1625,
B,H,M,DAV93,PH(LON)
7/2/91,CH(LON)7/7/92,
SOT1/12/94

HR. J-Rottenhammer

H Roffnhamer R·

H Roffnfamar
1595 Roma

(signature from drawing of red & black chalk)

ROTTMAN, Carl Anton
Joseph,
German 1798-1850,
B,H,M,DAV93,SOT(MUN)
12/10/92

CR.

ROUBILLAC, Louis Francois,
French 1695/1705-1762,
B,H,M,DAV93

L. F. Roubillac

ROUX, Antoine,
French 1765-1835,
B,DAV93,CH(MON)
12/7/90,SOT(MON)
12/5/92

Antee Roux 1808

Ante Roux. 1823

ROWBOTHAM, Thomas
Leeson Scarse, Sr.,
English 1783-1853,
B,H,DAV94,
CH(LON)4/12/94

T L.R
1834 < FROM PENCIL AND WATERCOLOR,
SCRATCHING OUT AND TOUCHES
OF GUM ARABIC.

ROWLANDSON, Thomas,
English 1756-1827,
B,H,M,DAV93,
CH1/9/91&1/13/93,
SOT(ARC)7/22/93

Rowlandson

T. Rowlandson

Rowlandson

ROY, Jean Baptiste de,
Belgian 1759-1839,
B,H,M,DAV93,
CH(AMS)5/7/92

J B *DeRoy* 1794

RUBENS, Peter Paul,
Flemish 1577-1640,
B,H,M,DAV93,
CH1/16/92&1/12/94,
SOT1/13/94

P. RVBENS.

RUISDAEL, Isaac van,
Dutch 1599-1677,
B,H,DAV93,PH(LON)
10/25/88,KLI12/2/92,
CH1/11/95

IVRuisdael:1645

RUISDAEL (or RUYSDAEL),
Jacob Isaakszoon,
Dutch 1620-1683,
B,H,M,DAV93,CH(LON)
7/9/93&12/10/93,
CH1/11/95

Ruisdael Ruisdael

R

RUOPPOLO, Giuseppe,
Italian c.1639-1710,
B,H,M,DAV93,
SOT4/7/89,SOT(MON)
7/2/93

Gioseppe Rop.

RUSH, William,
American 1756-1833,
B,D,F,H,I,M,TB,
DAV93,SOT12/3/87,
CH3/10/89

Wm Rush

RUSSELL, John,
English 1745-1806,
B,H,M,DAV93,SOT(MON)
6/22/91,CH5/21/92,
SOT10/8/93

l Russell Pinxt
1767

J Russell
1798 < SIGNATURE FROM PASTEL

RUYSCH (or RUISCH),
Rachel,
Dutch 1664-1750,
B,H,M,DAV93,
SOT(ARC)12/9/92,
CH11/13/90&1/12/94

Rachel Ruysch

R Ruysch

Rachel Ruysch

RUYSDAEL, Jacob
Solomonsz. van,
Dutch c.1630-1681,
B,H,M,DAV93,
SOT1/10/91,CH5/19/93

JR. *JR*

Ruysdael

RUYSDAEL, Solomon Van, Dutch 1600-1670, B,H,M,DAV93,CH(LON) 12/10/93&7/9/93, CH1/11/95	SvR $SVRvysdael$ $S.VRuysdael\ 1642$
RYCKAERT, David III, Flemish 1612-1661, B,H,M,DAV93,CH(LON) 2/7/92,SOT4/11/91& 5/22/92	$D.R.$ $David\ Ryekaert$
RYCKAERT (or RYKAERT), Marten, Flemish 1587-1631, B,H,M,DAV93,SOT(LON) 12/9/92,CH(LON)7/9/93& 12/10/93	RYKAERT 1631 $MR\ 1622$

SABLET, Francois Jean,
Swiss 1745-1819,
B,H,M,DAV94,
DUM5/22/94,
SOT1/12/95

Sablet (1796)

SADELER, Aegidius II,
Dutch c.1570-1629,
B,H,M,DAV93,
SOT(AMS)11/21/89

EG: Sadeler Fecit· ÆS
(signature in black chalk - drawing: grey ink
& wash, white over black chalk)

Æg: Sadeler Fecit 1596
(signature in brown ink - drawing: pen & brown ink
& wash heightened with gold over black chalk)

SAEYS, Jacob Ferdinand,
Flemish 1658-1725,
B,H,DAV94,CH(LON)
7/10/92,CH5/18/94,
SOT1/12/95

IF SAEÿS Fe 1717

**SAFTLEVEN (or
SACHTLEVEN), Cornelis,**
Dutch 1607-1681,
B,H,M,DAV93,
SOT1/8/91&1/15/93,
CH1/12/94

CS 1655 <(grey wash)
(black chalk & grey, pink & yellow wash)
C Saftleven

**SAFTLEVEN (or
SACHTLEVEN or
ZACHTLEVEN), Herman,**
Dutch 1609-1685,
B,H,M,DAV93,CH(MON)
7/3/93,SOT(MON)
7/2/93,SOT1/12/95

HS 1670 <(black chalk, grey wash,
ink framing lines)

HS <(MONOGRAM FROM DRAWING OF BLACK
CHALK AND BROWN WASH)

SAINT AUBIN, Augustin de,
French 1736–1807,
A,B,H,M,DAV93,
SOT4/30/90&1/12/94&
1/10/95

A·S· < INITIALS FROM PEN, BROWN INK AND WASH

SAINT AUBIN, Gabriel Jacques de (disciple of),
French 1724–1780,
CH(MON)6/16/89

SAINT AUBIN, Gabriel Jacques de,
French 1724–1780,
B,H,M,DAV93,SOT
1/14/92,AUD11/19/92,
SOT1/10/95

N. deS.ʳ aubin f.ᵗ
(inscription signature from a drawing of black chalk, pen & brown ink)

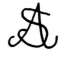

G. d. S. d.
1776
<(INITIALS FROM DRAWING OF BLACK CHALK, PEN AND GREY INK)

G d-S Aubin 1779

SIGNATURE FROM DRAWING OF BLACK CHALK, PEN & BROWN INK, BROWN WASH, HEIGHTENED WITH WHITE.

SAINT JEAN, Monsieur de,
French ac. 1770–1777,
B,H,DAV93,CH(MON)
6/22/91

De St Jean <(from mixed media drawing)

SALIMBENI, Ventura di Arcangelo,
Italian 1568–1613,
B,H,M,DAV93,CH(LON)
7/2/91&4/11/93,
CH10/7/93

.VENTVRA.SALIMBENI.SEN.
. 1608 .

SALM, Adriaen van,
Dutch ac. 1706–1719,
B,DAV93,SOT(LON)
4/11/90,CH(AMS)
11/25/92&11/18/93
CONTINUED

A.Salm. *A.V.Salm*

SALM, Adriaen van
CONTINUED

A. V. Jolm

SALMON, Robert W.,
American 1775-1844,
B,D,F,H,I,M,TB,DAV93,
CH3/12/92,SOT6/8/90&
6/4/93

RS RS

SANDBY, Paul,
English 1725-1809,
B,H,M,DAV93,SOT(LON)
7/11/91,CH(LON)7/9/91&
7/14/92

PS PS

(initials from
watercolor & pencil)

P Sandby. 1779

DRAWING OF PENCIL, PEN AND GREY INK,
AND WATERCOLOR ON WHATMAN PAPER.

SANQUIRICO, Alessandro,
Italian 1777/80-1849,
B,H,M,TB,DAV93,
CH1/11/94

Alexandro Sanquirico

FROM DRAWING OF PEN & BLACK INK & GREY WASH.

SARAZIN DE BELMONT,
Louise Josephine,
French 1790-1870,
B,H,SOT(MON)6/18/88

Jne S de B.

SARTORIUS, Francis,
English 1734-1804,
B,H,M,DAV93,
CH2/23/89,SOT6/5/92,
SOT(MON)7/2/93

Fs Sartorius. Pinxt. 1775

SARTORIUS, John Nost,
English 1755/59-1828,
B,H,M,DAV93,SOT(LON)
11/18/92,CH6/5/93

JNSartorius

SARTORIUS, Willem, English ac. London 1773-1779, SOT(LON)2/28/90	*WS*
SARTORIUS, William, English c.1775-1831, DAV93,CH(AMS) 11/28/89,SOT6/8/90, CH(LON)7/12/91	*W Sartorius fet*
SAUERWEID, Alexandre Ivanovitch, Russian 1783-1844, B,H,M,DAV93, SOT(MON)7/2/93	*AB.* *A* (1813)
SAVERY, Roelandt, Dutch 1576-1639, B,H,M,DAV93, CH5/14/93,CH(LON) 7/9/93,SOT(AMS) 11/17/93	*R·Savery* *R·SAVERY* *1613* *ROELANDT.* *SAVERY. FE* *1627*
SCHADOW, Friedrick Wilhelm von, German 1788/89-1862, B,H,M,TB,DAV93	*WSchadow* *WS*
SCHADOW, Johann Gottfried, German 1764-1850, B,H,M,TB,DAV93, SOT5/22/91, BAS12/4/92	*GS—W*
SCHALCKE, Cornelis Symonsz. van der, Dutch 1611-1671, B,H,M,TB,DAV93, PH(LON)4/16/91, SOT(AMS)11/16/93	*CVS* *CSV Schalcke*

SCHALCKEN (or SCHALKEN), Godfried,
Dutch 1643-1706,
B,H,M,DAV93,SOT(LON)
7/3/91,SOT10/14/92,
SOT(LON)12/7/94

G·Schalcken. *G·Schalcken*

G·S·f. <(initials in red chalk)
(red chalk drawing)

SCHEFFER, Ary,
French 1795-1858,
B,H,M,DAV93,CH(AMS)
4/24/91,SOT(MON)
12/5/92&7/2/93

Ary Scheffer *A. Scheffer*

(SIGNATURE FROM DRAWING)

Ary Scheffer

(1841)

SCHELFHOUT, Andreas,
Dutch 1787-1870,
B,H,M,TB,DAV93,
PH(LON)11/21/89,
CH(AMS)10/30/90,
SOT5/26/93

A·Schelfhout *A.Schelfhout*

A. Schelfhout *Schelfhout.*

A.S. (signature from water-
color heightened with
bodycolor over pencil)

SCHENKL, Joseph,
Austrian 1794-
B,CHE4/28/93

Schenkl

**SCHMETTERLING,
Christina Josepha,**
German 1796-1840,
B,DAV94,CH(LON)
6/18/93

*Christina Josepha
Schmetterling* < FROM WATERCOLOR

fec:1838

SCHMIDT, Heinrich,
German 1740-1821,
B,H,NAG2/26/93,
SOT1/14/94

Schmidt pt. 1815

SCHMUZER (or SCHMUTZER),
Jakob Mathias,
Austrian 1733-1811,
B,H,M,DAV93,
CH1/10/90,CHE1/10/91,
SOT1/12/94

Schmuzer 1796.

(black chalk, pen & grey ink, grey wash)
(note: drawing signature style rather consistent)

SCHNEBBELIE, Robert
Blemmel,
English c.1780-1849,
A,B,H,M,DAV94,
SOT(LON)4/11/91,
CH(LON)7/13/93

Robert Blemme Schnebbelie
1819 —
FROM DRAWING OF PENCIL, PEN &
GREY INK, & WATERCOLOR WITH SCRATCHING OUT

SCHNETZ, Jean Victor,
French 1787-1870,
B,H,M,DAV93,
SOT10/26/90,
MIL12/1/92

Jean V Schnetz <(signature from a
drawing of colored
chalks)

SCHNITZLER, J.
(Johann?) Michael,
German 1782-1861,
B,H,M,TB

SCHNORR VON CAROLSFELD,
Julius Viet Hans,
German 1794-1872,
A,B,H,M,TB,DAV93,
CH(LON)6/24/88&
5/20/93,SOT(ARC)
7/23/93

CONTINUED

18 $ 26

$

$
1842
 <(MONOGRAM FROM DRAWING
OF PEN AND GREY INK)

SCHNORR VON CAROLSFELD,
Julius Viet Hans
CONTINUED

<(FOX'S HEAD SIGNATURE FROM DRAWING
OF BROWN INK & PENCIL -- 1826)

SCHODLBERGER (or SCHO-
DELBERGER), Johann Nepomuk,
Austrian 1779-1853,
B,H,TB,DAV93,
DOR6/2/93(attributed)

Joh.Nep.Schödlberger **NS**

SCHOEFF, Johannes,
Dutch 1608-after 1666,
B,H,M,DAV93,SOT(LON)
4/21/93,CH(AMS)
11/18/93

Schoeff 1643 *Schoeff 1643*

SCHOEVAER(D)TS, Mathys,
Flemish 1665-1723,
B,H,M,DAV93,CH(LON)
7/4/91,CH12/11/92,
SOT(LON)4/21/93,
CH1/11/95

M. SCHOEVAERDTS.F

M. SCHOEVAERDTS. F.
(oil on copper)

M. SCHOEVAERTS.F.
(SIGNATURE WITHOUT D IS ALSO CORRECT)

SCHONGAUER, Martin,
German 1430/50-1491,
B,H,M,DAV93,
SOT2/27/88,
CH5/14/91&5/11/93

M ✠ S <(from engraving, circa 1480-90) M ✠ S

SCHOOCK, Hendrik,
Dutch 1630-1707,
B,H,SOT(MON)
12/7/90,CH(MON)
12/4/93

H. Schoock. Pinxit

SCHOONEBEECK, Adriaan,
Dutch 1657/58-1705,
B,H,SOT(AMS)5/10/94

A:S: fec.
FROM DRAWING OF PEN & BLACK INK,
GREY WASH HEIGHTENED WITH WHITE.

SCHOOR, Abraham van der, Dutch ac. 1643–1658, B,SOT(AMS)5/12/92& 11/16/93	XX Schoor AbV Schoor 1658
SCHOOTEN, Floris van, Dutch c. 1605–1655 (1590–1665)?, B,H,DAV93,PH(LON) 12/11/90,SOT1/15/93& 10/8/93	F.V.S. 1620 Also, known to use initials F. S.
SCHOTANUS, Petrus, Dutch 1601–c.1675, B,H,DAV93,PH(LON) 7/4/89,SOT1/15/93, CH(AMS)5/6/93	P.S.
SCHOTEL, Johannes Christiaan, Dutch 1787–1838, B,H,M,DAV93,CH 10/30/90;CH(LON) 6/21/91,WIN4/3/93	J.C.Schotel
SCHOUMAN, Aert, Dutch 1710–1792, B,H,M,DAV93, CH1/10/90,SOT(AMS) 11/11/92&11/17/93	A.Schouman (Black & white chalk on blue paper) A:Schouman.1744 (black chalk, watercolor heightened with white, signature on border in gold) A:Schouman. A S 1747. (black chalk, watercolor, bodycolor & gold ink) A.SCHOUMAN 1738
SCHOUMAN, Martinus, Dutch 1770–1848, B,H,M,DAV94, CH(AMS)2/8/94	M.Schouman f 1803 SIGNATURE FROM PEN, BLACK & BROWN INK AND WATERCOLOR

SCHUT, Cornelis,
Flemish 1597-1655,
B,H,M,DAV93,SOT(AMS)
11/21/89,SOT(LON)
7/3/91

C. Schut <(brown ink) *C.S.*

(pen & brown ink, grey & grey brown wash, black chalk)

Cornelis Schut .f. <(brown ink) §

(pen & brown ink & wash over black chalk)

SCHUZ (or SCHUTZ),
Christian Georg,
German 1718-1791,
B,DAV93,SOT4/11/91,
CH1/14/93,SOT(LON)
12/7/94

Schüz. (fecit.) *SCHÜZ*

(device)> ✗➚ 1748 (fecit)

SCHWERDGEBURTH, Karl
or Carl August,
German 1785-1878,
B,H,TB,DAV93

C,$A

SEDELMAYER (or SEDL-
MAYER), Joseph Anton,
German 1797- ,
B,H,TB,DAV93

ℋℋ

SEEKATZ, Johann Conrad,
German 1719-1768,
B,H,M,DAV93,SOT(LON)
7/8/92&4/1/92,SOT1/14/94

JCS

SEINSHEIM, August Karl,
German 1789-1869,
B,H,TB

AS AS ASB

SELBY, Prideaux John, English 1788-1867, H,DAV93	*P J Selby*
SENG(S), Johann or Jacob Christian or Christoph, German 1727-1796, B,DAV93,PH(LON) 12/5/88,ADE11/27/92	*J.C.Seng* <(signature from gouache)
SERIN, Hermanus, Dutch ac. c.1720, B?,H?,DAV94?, SOT(AMS)11/16/94	H:SERIN:
SERNE, Adrianus, Dutch 1773-1853, B,H,DAV94,CH(AMS) 10/19/93	A SERNÉ 1836
SERRES, John Thomas, English 1759-1825, B,H,M,DAV93, SOT6/5/92	*J. T.Serres 1825*
SEVERN, Joseph, English 1793-1879, B,H,M,DAV94, CH(LON)11/4/94	J Severn
SEVILLA, Juan de, Spanish 1643?-1695, H,DAV93,SOT(LON) 7/3/91	SEVILLA
SEVIN, Pierre Paul, French 1650-1710, B,DAV93,SOT(LON) 4/30/90	*P. Sevin f.* <(signature from drawing of brown ink & wash)

SEYMOUR, James, English c.1702–1752, B,H,M,DAV93, PH(LON)4/27/93, SOT6/4/93	*JS 1752*
SHARPLES, James, Anglo/American 1751–1811, B,D,F,H,I,M,DAV94, CH(LON)4/7/92, CH1/28/95	*JSharples.*
SHAW, Joshua H., Anglo/American 1776–1860, B,D,F,H,I,M,DAV93, CH5/25/89&1/28/95	*J. Shaw. 1851*
SHAW, William, English –1773, B,DAV93,CH(LON) 2/9/90,SOT6/5/92& 6/4/93	*WShaw 1757* *Wm. Shaw 1757*
SHAYER, William, Sr., English 1788–1879, B,H,DAV93,FR4/11/91, SOT5/26/93,SOT(ARC) 7/23/93	*WShayer* *WShayer 1836*
SHELBURNE, S., English late 18th century, SOT(LON)3/10/88	*S. Shelburne 1766* <(signature from a gouache & water-color)
SHEPHERD, George Sidney, English 1784–1862, B,H,M,DAV93(dates sic), SOT(LON)1/30/91, CH(LON)7/14/92	*Geo. Sidney Shepherd 1850* (FROM DRAWING OF PENCIL & WATERCOLOR, SOME WHITE & GUM ARABIC) *G. Shepherd 1822.* <(FROM PENCIL & WATERCOLOR DRAWING)

SHEPHERD, Thomas Hosmer,
English 1793-1864,
B,H,M,DAV94,
CH(LON)4/12/94

T. HOSMER SHEPHERD
SIGNATURE FROM A PENCIL AND WATERCOLOR.

SIBERECHTS (or SIBRECHTS), Jan,
Flemish 1627-1703,
B,H,M,DAV93,
CH1/11/89,CH(LON)
7/4/91&6/10/92

J. Siberechts.
1683

SILLET, James,
English 1764-1840,
B,H,DAV93,SOT(LON)
5/16/90&7/11/91,
PH(LON)4/27/93

J.Sillet

SIMONS, Michiel,
Dutch -1673,
DAV93,CH(AMS)
6/12/90&5/6/93,
SOT1/14/94

M. SIMONS M.Simons.

M.Simons M.S.

SLINGELAN(D)T, Pieter van,
Dutch 1640-1691,
B,H,M,DAV93,CH(AMS)
11/12/90,SOT10/14/92,
SOT(AMS)11/17/93

PV Slingelant-Fe 1676
(signature from drawing of black chalk,
watercolor & bodycolor heightened with
gold, on vellum)

(The D in last > PSlingeland (1683)
name is correct)

SMART I, John,
English 1741-1811,
B,H,M,DAV93,
CH3/22/91,SOT(LON)
7/11/91,PH(LON)
7/15/91

JS

SMETS, F., Dutch 17th century, CH(AMS)5/11/94	*F: SMETS · fec.*
SMITH, (probably Charlie Loraine), English 1751-1835, B,H,DAV93	*C{ora Smith 1794*
SMITH, Edwin Dalton, English 1800-1866?, B,H,DAV93,SOT(LON) 2/28/90(attributed)	*E. D. Smith 1832*
SMITH, George (of Chichester), English 1714-1776, B,H,M,DAV93,CH(LON) 7/12/90&7/12/91, SOT5/22/92	*Geo. Smith* *Geo Smith*
SMITH, John Rubens, Anglo/American 1775-1849, B,D,F,H,I,M,DAV93, CH1/22/93	*I R Smith 1840* *I R Smith.* *N. Y. 1819*
SMITH, William (of Chichester), English 1707-1764, B,H,M,DAV94,SOT(LON) 5/16/90,PH(LON) 6/21/94	*W.'" Smith. 1760*
SMITS, Dirck, Dutch 1635-after 1659, SOT(AMS)11/16/93 <u>CONTINUED</u>	*T. SMITS 1657*

SMITS, Dirck
CONTINUED

Paintings signed D or T or Th Smits, or with initials, typically small still lifes on panel, usually including crabs, seem to be by one distinctive hand. Presumably the artist named Theodor(us), of which the Dutch diminutive is Dirck. His surname is sometimes given as 'Sauts'; this appears to be due to a misreading of the signatures on certain paintings. Improbably the artist has been linked by Thieme-Becker, Wurzbach and others with Caspar Smits, a painter of pedestrian still lifes influenced by Roestraten, quite unlike Dirck Smits, who was active in England and Ireland in the 1660s and who earned himself the sarcastic sobriquet 'Magdelene Smith'

SNYDERS, Frans,
Flemish 1579-1657,
B,H,M,DAV93,CH(LON)
4/19/92,SOT(AMS)
11/17/93,CH1/11/95

F. Snyders. fecit

F. Snyders. fecit.

SNYERS, Pieter,
Flemish 1681-1752,
B,H,M(Snyders),DAV93,
SOT7/17/91,CH5/19/93&
1/11/95

P: Snyers

PEETER. Snyers

SODERMARK, Olaf Johan,
Swedish 1790-1848,
B,H,DAV93,CH(AMS)
9/19/89,BUK5/17/93

OJ Södermark fer Roma 1839

SOLDI, Andea,
Italian 1682/1703-1771,
B,H,M,DAV94,
SOT5/19/94

A'' Soldi
Pinx: A°: 1753

SON, Joris van,
Flemish 1623-1667,
B,H,M,DAV93,SOT(LON)
4/11/90,SOT10/14/92,
CH(LON7/9/93
CONTINUED

Js V Son *J.V.S.*

SON, Joris van
CONTINUED

J. CAN SON 1662

Joris. vN. SON. J

SONJE, Jan,
Dutch 1625-1707,
B,H,M,DAV94,CH(LON)
4/18/91,CH(AMS)
11/15/94

Jsonje f. (1670)

FROM DRAWING OF PEN & BROWN INK, BROWN & GREY
WASH, OVER TRACES OF BLACK CHALK.

SONNIUS, Hendrik,
Dutch -1662,
B,H,SOT(AMS)
11/16/93

Sonnius

SORGH, Hendrik Martensz,
Dutch c.1611-1670,
B,H,DAV93,CH12/11/92,
SOT(AMS)11/16/93,
SOT(LON)12/7/94

M.Sorgh

MS 1642
(initials from black chalk
drawing)

ALSO, KNOWN TO SIGN H. Sorgh.

SOUKENS, Hendrik,
Dutch 1680-1711,
B,DAV94,SOT(AMS)
5/10/94

HSoukens

FROM DRAWING OF PEN, BROWN
INK, WASH OVER BLACK CHALK

SPAENDONCK, Corneille
or Cornelis van,
Dutch/French 1756-1840,
B,H,M,DAV93,SOT
10/10/91,SOT(MON)
12/2/89&12/5/92
CONTINUED

Corneille Van Spaendonck. 1798.

**SPAENDONCK, Corneille
or Cornelis van
CONTINUED**

Cornelis Vanspaendonck f. 1814

**SPAENDONCK, Gerard van,
French 1746-1822,
B,H,M,DAV93,CH1/11/91,
SOT(MON)7/2/93,
SOT(AMS)11/17/93**

G. VanSpaendonck
(signature on watercolor)
(also known to sign watercolors with initials GSp,
Sotheby's - London 12/14/92, lot 106)

G. VanSpaendonck.

**SPENCER, Thomas,
English 1700-1763/65,
H,DAV93?,SOT6/10/88&
6/5/92&6/3/94**

T.S. 1751—

**SPERLING, Johann Christian,
German 1690/91-1746,
B,N,CH1/16/92**

J.C.Sperling

**STALBEMT, Adriaen van,
Flemish 1580-1662,
B,H,DAV93,CH4/4/90,
SOT(LON)12/8/93,
CH(LON)12/10/93**

A·S *A· STALBENT*

**STANFIELD, William Clarkson,
English 1793-1867,
A,B,H,M,DAV93,
SOT(SUS)5/20/91,
SOT(LON)4/6/93**

Stanfield RA.1846
(from watercolor over pencil with bodycolor)

STANLEY, Caleb Robert,
English 1795-1868,
B,H,DAV93,CH(LON)
2/12/88,SOT(LON)
10/18/89

C. R. STANLEY

STANZIONE, Massimo,
Italian c.1585-c.1656/58,
B,H,M,DAV93,
CH5/31/91,SOT(LON)
7/3/91

STARK, James,
English 1794-1859,
B,H,M,DAV93,
CH(LON)7/12/91,
CH5/27/93

James Stark '54

STEEN, Jan Havicksz,
Dutch 1625/26-1679,
B,H,M,DAV93,
SOT(LON)4/11/90,
CH5/31/89&12/11/92,
SOT1/12/95

STEENWYCK, Hendrik van,
Flemish 1580-c.1649,
B,H,M,DAV93,CH1/16/92,
CH(LON)6/10/92,
SOT(AMS)11/16/93

H·V·S
1625

H:V:STEENWŸCK

STEIGER, Rudolf Von,
Swiss 1791-1824,
SOT(T)5/17/89

R·Steiger 1814

SERVED IN SWISS REGIMENT OF BRITISH COLONIAL ARMY
IN CANADA 1813-1816

STELLA, Jacques,
French 1596-1657,
B,H,M,DAV93,PH(LON)
3/5/91,SOT(MON)
6/22/91&12/5/92

J.Stella 1644

STERENBERG (or
STARRENBERG), Johann,
Dutch -1759,
B,H?,SOT1/14/94

Sterenberg

STEUBEN, (Baron)
Charles de,
French 1788-1856,
B,H,M,DAV93,
SOT10/26/90

Steuben 1830.

STEWART, (Sir) David,
Scots 1772-1829,
H,M,SOT5/19/93

Sir David Stewart

STIMMER, Tobias,
Swiss 1539-1584,
B,H,M,DAV93,
CH(LON)7/2/91&
7/7/92

<(FROM DRAWING OF PEN AND
BLACK AND BROWN INK)

STOCKLIN, Christian,
Swiss 1741-1795,
B,SOT(AMS)5/22/90&
11/11/92,CH5/21/92

C · Stöcklin Pinxit 1790

CHRISTIAN STOCKLEI · PT· NWEN

STOK, Jacobs van der,
Dutch 1795-1864,
B,DAV93,CH(LON)
5/5/89,CH(AMS)
4/21/93

J v d Stok

STOLKER, Jan,
Dutch 1724-1785,
B,H,CH5/21/92

J.Stolker Pinx <(SIGNATURE FROM
OIL ON COPPER)

STOMME (or BOELEMA DE
STOMME), Maerten Boelema de,
Dutch ac. 1642-1664,
B,DAV93,CH5/31/90

M.B. de Stomme.

STOOP, Dirk or Daniel /Thierg/
Theodor or Rodriguez,
Dutch 1610-1686,
B,H,M,DAV93,CH(LON)
7/5/91,SOT(LON)
12/9/92,CH10/7/93

D. Stoop

STOOTER, Cornelis Leonardsz.,
Dutch c.1600-1655,
B,H,DAV93,CH(AMS)
11/29/88&11/18/93

STO *STO*

STORCK (or STORK or
STURK), Abraham,
Dutch 1635-1710,
B,H,M,DAV93,CH
1/12/94,SOT1/14/94,
SOT(LON)12/7/94

A.Storck *A:Storck*

A:Storck -1677
(from drawing of pen & brown ink,
grey & blue wash)

STORCK, Jacobus,
Dutch 1641-1687,
B?,H,M?,DAV93,
CH5/31/91,CH(AMS)
11/18/93,CH1/11/95

Jacobus Storck

STRAET, Jan van der
(called STADANUS),
Flemish 1523-1605,
B,H,DAV93,SOT1/12/90,
CH(LON)7/2/91,
SOT(LON)10/28/92,
CH1/11/95
CONTINUED

STradanus (brown ink)

Strada <(signature from drawing of pen & brown
ink & wash, traces of white heightening)

1587
IoA STRADANYS <(FROM DRAWING OF BLACK CHALK,
PEN & BROWN INK, BLUE WASH)

STRAET, Jan van der (called STADANUS) CONTINUED

(FROM DRAWING OF BLACK CHALK, PEN & BROWN INK, BROWN WASH WITH WHITE) >

F Stzadanus

STRANOVER (or STRANOVIUS), Tobias, Czechoslovakian 1684–1724, B,DAV93,SOT5/22/92& 5/20/93,CH(LON) 7/9/93

Stranover

T. Stranover.

STRAUCH, Lorenz, German 1554–c.1630, B,H,M,DAV93,PH(LON) 12/5/89&4/10/90, SOT(LON)4/21/93

AÑO: 1583.

S. S.1617

STREET, Robert, American 1796–1865, B,D,F,I,M,TB,DAV93, CH6/10/92,FR12/3/92, BB12/9/92

R STREET 1835

STRICKLAND, William, American 1787–1854, D,F,H,I,M,DAV93

W.ᵐ Strickland.

STRINGER, Francis, British ac.1760–1780, DAV93,CH(LON) 3/1/91,SOT6/7/91& 6/5/92

T. Stringer 1780.

T. Stringer. *F. S 1763*

STRUTT, Jacob George, English 1790-1864, B,H,M,DAV93,CH(LON) 2/8/91,SOT(MON)7/2/93	*J. G. Strutt Romae 1840* SIGNATURE FROM GOUACHE
STRY, Jacobus van, Dutch 1756-1815, B,H,M,DAV93, SOT4/11/91,BB11/13/91, SOT(ARC)7/16/92	*Stry* *J. van Stry* <(from drawing of & black & brown ink, & grey wash)
STUART, Gilbert Charles, American 1755-1828, B,D,F,H,I,M,DAV93, CH3/14/91,CH(LON) 7/12/91,SOT5/27/93	*Gilbert Stuart*
STUBBS, George, English 1724-1806, B,H,M,DAV93, SOT6/5/92&6/4/93& 6/3/94	*Stubbs 1786* *Geo. Stubbs 1800* *Geo. Stubbs pinxit 1804*
STURMER (or STUERMER), Johann Heinrich, German 1774-1855, B,H,TB,DAV93	*HStH* (monogram)
STUVEN, Ernst, German 1660-1712, B,M,DAV93,SOT(LON) 7/4/90,CH5/31/90& 12/11/92	*E Stuven* *E.S.*
SULLY, Thomas, American 1783-1872, B,D,F,H,I,M,DAV93, CH5/28/92&5/26/93, SOT5/27/93 CONTINUED	*TS 1837* *TS*

SULLY, Thomas
CONTINUED

SUSEMIHL, Johann Theodor,
German 1772– ,
B,DAV93,SOT6/4/93

SUSENIER, Abraham,
Dutch 1620?–after 1664,
B,H,DAV93,PH(LON)
12/5/89,SOT1/10/91,
CH(MON)6/20/92

SUTTER, Joseph II,
Austrian 1781–1866,
B,H?,TB

SWAIN(E), Francis,
English ac.1740–died 1782,
B,H,M,DAV93,CH(LON)
6/19/91,SOT(LON)
7/10/91,CH5/22/92

FROM DRAWING OF BLACK CHALK,
PEN & GREY INK & WATERCOLOR

SWANEVELT, Herman van,
Dutch c.1600–1655,
B,H,M,DAV93,PH(LON)
4/16/91,CH5/31/92,
SOT(MON)7/2/93

SWEBACH, Bernard Edouard,
French 1800–1870,
B,H,M,DAV93,SOT10/28/87&
10/23/90,SOT(ARC)7/17/91

SWEBACH(-DESFONTAINES),
Jacques Francois Joseph,
French 1769–1823,
B,H,M,DAV93,SOT10/10/91,
CH5/21/92&10/7/93
CONTINUED

SWEBACH(-DESFONTAINES),
Jacques Francois Joseph
CONTINUED

< SIGNATURE FROM WATERCOLOR

SZTIOJNOY (or SZTROJNOY),
Joseph,
Continental 19th century,
DAV93,SOT10/15/87,
CH1/11/89(lot 206)

TAILLASSON, Jean Joseph,
French 1745/46-1808/09,
B,H,M,DAV93,SOT(LON)
12/8/93

Tail. n.
1783

Taillasson JJ

Taillasson

TASSAERT, Nicolas Francois
Octave,
French 1800-1874,
B,H,M,DAV93,
WES12/8/90,SOT(MON)
6/19/92

Oc T. <(INITIALS FROM DRAWING)

O Tassaert

TATHAM, Charles Heathcote,
English 1772-1842,
B,H,SOT(MON)12/5/92

CHARLES HEATHCOTE TATHAM 1796

TAUNAY, Nicolas Antoine,
French 1755-1830,
B,H,M,DAV93,
SOT(MON)7/2/93,
CH10/15/92,CH(LON)
7/9/93

Taunay
1823

TAUNAY

Taunay

TAVERNER, William,
English 1703-1772,
B,H,M,DAV93,
SOT(LON)7/14/88

W. Taverner fe <(signature from drawing
of colored washes over
pencil, with white)

TAYLOR, John called
OLD TAYLOR,
English 1739-1838,
B,H,M,DAV93,
SOT(ARC)1/20/93

J. Taylor 1773

TEERLINK, Abraham, Dutch 1776–1857, B,H,DAV93,SOT(LON) 11/28/90,SOT(MON) 6/22/91	*Teerlink*
TEGELBERG, Cornelis, Dutch ac. mid 17th century, B,SOT(AMS)11/17/93	CTB
TENGNAGEL (or TYNAGEL), Jan, Dutch 1584–1635, B,H,DAV93,PH(LON) 7/3/90,CH1/9/91, KLI12/2/92	*Hengnagel: fecit* *A 1624*
TENIERS, David II, Flemish 1610–1690, B,H,M,DAV93, LH3/10/91,CH(LON) 7/9/93,CH1/11/95	*D. TENIERS* *D.T.* *DT* *D·T* *D·TENIERS F.*
TENNANT, John F., English 1796–1872, B,H,M,DAV93,CH(LON) 3/1/91,PH(LON)4/27/93, CH5/27/93	*FTennant* *J. Tennant* *1850*
TERWESTEN, Augustinus, Dutch 1649–1711, B,H,DAV93,PH(LON) 12/11/90,CH1/11/94	*A. Terwesten·* *AW:* < FROM DRAWING OF BLACK CHALK, PEN & BROWN INK, BROWN AND RED WASH.

THEIL, Johann Gottfried,
German 1745-1797,
B,SOT1/13/93

Theill del. 1779 <(from drawing of pen & black
ink with gray wash)
(THEI**LL**)

THEOTOKOULOS, Domenikos
Called EL GRECO,
Spanish 1541-1614,
B,H,M,TB,DAV93,
SOT(MIL)5/18/92,
CH(LON)5/29/92&
12/10/93,CH1/11/95

<(A FAIR FACSIMILE
IN GREEK)

< CURSIVE
GREEK,
FAIR
FACSIMILE

THEVENIN, Charles,
French 1764-1838,
B,H,DAV93,SOT(LON)
4/21/93

C. *Thevenin*
·*1793*·

THIELE, Alexander Johann,
German 1685-1752,
B,H,DAV94,CH(LON)
7/9/93,SOT1/12/95

AThiele

THIENON, Anne Claude,
French 1772-1846,
B,H,DAV93,SOT(MON)
6/19/92,ADE3/31/93

C·*Thiénon* <(SIGNATURE FROM DRAWING)

THIER, Barend Hendrik,
Dutch 1751-1814,
B,M,TB,DAV93,
PH(LON)7/2/90

B *Thier* B.H. *thier*
1775
<(signature from a
drawing of pen & ink
with watercolor)

THIERR(I)AT, Augustin Alexandre, French 1789-1870, B,H,DAV93,SOT(MON) 6/15/90,SOT11/15/90, CH3/22/92	*Thierriat de Lyon 1824* (signature from watercolor & gouache)
THIERRY (or THYRY), Wilhelm Adam, German 1761-1823, B,H,SOT(AMS) 11/22/89,MIL12/1/92	*W. Thyry f:* <(pencil) (black chalk & brown wash)
THIRTLE, John, English 1777-1839, B,H,M,DAV94, SOT(LON)1/30/91, CH(LON)11/9/93	*J. Thirtle 1827.* SIGNATURE FROM PENCIL & WATERCOLOR, WITH SOME SCRATCHING OUT.
THOMAS, Jan, Flemish 1617-1678, B,H,M,SOT(LON) 4/11/90&10/26/94	**IOAN THOMAS** *Joannes Thomas*
THUILLIER, Pierre, French 1799-1858, B,H,M,DAV94, CH(LON)7/16/93, PH(LON)6/14/94	*Pierre Thuillier*
THYS, Pieter, Dutch 1624-1677, B,H,M,DAV93, SOT(LON)7/3/91	(Pieter)*THYS*
TIEPOLO, Giambaptista, Italian 1696-1770, B,H,M,DAV93, SOT1/13/93&1/13/94& 1/10/95	*Tiepolo*
TIEPOLO, Giovanni Dominico, Italian 1727-1804, B,H,M,DAV94,SOT1/14/92& 1/17/92&1/10/95 CONTINUED	*Dom: Tiepolo f.* (black chalk, pen & brown ink, brown wash)

TIEPOLO, Giovanni Domenico
CONTINUED

Tiepolo <(FROM DRAWING OF BLACK CHALK, PEN & BROWN INK & BROWN WASH)

Dom. Tiepolo f <(brown ink signature)

(pen, brown ink & gray-brown wash over black chalk)

TILBORCH (or TILBORG or
TILBURGH), Gillis van, Jr.,
Flemish c.1625-c.1678,
B,H,M,DAV93,CH10/7/93,
SOT(AMS)11/17/93,
SOT(LON)12/7/94

I.B. TIILBURGH TB.

TILBORCH. f ^(166?)

TILLEMANS, Peter,
Belgian 1684-1734,
B,H,M,DAV93,CH(LON)
7/4/91,SOT6/4/93

P. Tillemans. F.

TINGELER, J. W.,
Dutch? 18th century,
CH5/19/93

J: W: Tingeler 1788

TINTORETTO called
(ROBUSTI, Jacopo),
Italian 1518/19-1594,
B,H,M,DAV93,CH(LON)
7/9/93,SOT(LON)
12/9/92,SOT1/12/94

tintoretto

Tintoretto <(signature from drawing of
black chalk on blue paper)

TISCHBEIN, Carl or
Karl Ludwig,
German 1797-1855,
B,H,TB,DAV93?

TISCHBEIN, Johann Friedrich August, German 1750-1812, B,H,M,DAV93,SOT(MON) 12/2/89,SOT(LON) 10/8/93	*Tischbein F Tischbein.* *1811*
TISCHBEIN, Johann Heinrich Wilhelm, German 1751-1829, B,H,M,DAV93,CH(LON) 5/24/91,SOT(MON) 6/18/92	*W. Tischbein 1802*
TOBAR (or TOVAR), Alonso Miguel de, Spanish 1678-1758, B,H,M,DAV93, SOT10/8/93	*A. M de Tobar* *AM de Tobar.*
TOBIN, George, English 1768-1838, H,DAV94,CH(LON) 7/16/93&7/15/94, Mitchell Library/Sydney	*G T 1813.* < SIGNATURE FROM WATERCOLOR Pictorial reference & biographical notes Christie's London catalogue 7/15/94 *GT 1814* < SIGNATURE FROM WATERCOLOR
TOL, Dominicus van, Dutch 1635-1676, B,H,M,DAV93, CH1/11/89,PH(LON) 7/4/89,SOT(AMS) 11/11/92	*D.V. T O L*
TOMA, Matthias Rudolf, Austrian 1792-1869, B,H,M,DAV93, CH(LON)2/16/89	*Moma* *1836*
TOMSON, Clifton, English 1775-1828/35, B,H,M,DAV93,SOT 6/10/88,CH(LON)2/9/90 (THOMSON sic),SOT(LON) 3/6/93	*Clifton Tomson*

TOORENBURGH, Gerrit,
Dutch 1732–1785,
B,H,SOT5/19/94

Toorenburg
Fecit

TOORENVLIET (or TOORN-
VLIET or TORENVLIET),
Jacob,
Dutch 1635–1719,
B,H,M,DAV93,CH(LON)
7/4/91,SOT5/22/92,
SOT(LON)12/14/92

JToorenvliet-1679

*J.Toornvliet inventor
et Fecit 1704*

(red chalk drawing)

TORRE, Nicolas Andres,
Spanish/Mexican 1678– ,
B,SOT11/24/92

NA Torre

TOWN(E), Charles, Sr.,
English 1763–1840/42,
B,H,M,DAV93,SOT
6/7/91&6/5/92,PH(LON)
4/27/93

*C.Towne
1827*

*Ch. Towne
'99*

Cha.^s Towne 1799

*C. J.
1820*

TOWN(E), Charles, Jr.,
English 1781–1854,
B,H,M,DAV93,CH(LON)
5/21/91,SOT6/7/91,
LH10/19/92

C.Towne.

TOWNE, Francis,
English 1740–1816,
B,H,M,DAV93,SOT(LON)
3/10/88&4/11/91,
CH(LON)7/14/92

*J. Towne
1775*

<(signature from drawing of
pen, grey ink & watercolor)

TOWNLEY, Charles, English 1746-1800, B,H,M,DAV93, SOT6/5/92	*Chas Townley 1797*
TRAUTMAN(N), Johann Georg, German 1713-1769/72, B,H,M,DAV93,PH(LON) 4/16/91,SOT(LON) 4/11/90&3/16/93	*M* *J.G.Trautman*
TROGER, Paul, Austrian 1698-1762, B,H,M,DAV94, SOT1/15/93&1/10/95	*Troger fec.* < PENCIL SIGNATURE FROM DRAWING OF BLACK CHALK
TROOST, Cornelis, Dutch 1697-1750, B,H,M,DAV93,SOT(LON) 12/14/92,SOT(AMS) 11/17/93,SOT1/10/95	*C.Troost 1748*
TROOST, Wilhelm I, Dutch 1684-1759, B,H,SOT(LON)7/6/92, SOT(AMS)11/15/94	*W.* *TR OOST* (Signature in white. Gouache.) *INV F.*
TROOST-NIKKELEN (or NICKELE or NIKKELEN), Jacoba Maria, Dutch 1690- , B,SOT(AMS)11/22/89	*J.MARIA TROOST*
TROY, Francois de, French 1645-1730, B,H,M,DAV93, CH1/10/91&5/19/93, SOT5/20/93	*F. de Troy* *F. de Troy* *En 1717*
TROY, Jean Francois de, French 1679-1752, B,H,M,DAV93,SOT(MON) 6/18/92,CH(LON)7/9/93, SOT1/12/95	*DE TROY 1733* *ΠTROY.*

**TROYEN (or TROIJEN),
Rombout van,
Dutch c.1605-1650,
B,H,DAV93,CH(AMS)
11/10/92&5/6/93,
SOT(AMS)11/16/93**

R.Troyen fer 1652

*1641
R.Troyen*

R.T. fecc < INITIALS IN RED CHALK,
DRAWING OF BLACK CHALK
HEIGHTENED WITH WHITE, BUFF PAPER

**TURCHI (or VERONESE),
Allessandro,
Italian 1578-1649,
B,H,M,DAV93,
SOT5/22/92&1/15/93,
CH1/11/95**

ALEXANDER
VERONENS:

**TURNER, Daniel or David,
English ac.1782-1817,
B,H,M,DAV94,SOT(LON)
11/13/91,CH(LON)
7/13/93**

D. TURNER

**TURNER, Francis Calcraft,
English ac.1782-1846,
B,M,DAV93,SOT6/9/89,
SOT(LON)4/6/93,
SOT(ARC)7/23/93**

F. C. Turner 1845.

Painted by F.C. Turner 1838

F. C. Turner. 1840

**TURNER, Joseph Mallard
William,
English 1775-1851,
B,H,M,TB,DAV93,
BB11/13/91,CH2/19/92,
CH(LON)7/14/92
CONTINUED**

Turner

I W Turner NA
(signature from watercolor)

JMW Turner <(signature from
pencil drawing)

TURNER, Joseph Mallard William
CONTINUED

Turner 1794
(FROM DRAWING OF PENCIL & WATERCOLOR)

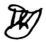

SIGNATURE FROM PENCIL & WATERCOLOR, WITH BODYCOLOR
& SCRATCHING OUT, ON WHATMAN TURKEY PAPER 1822.

TWOPENNY, William,
English 1797-1873,
A,B,TB

W. T.

UDEN, Lucas van,
Flemish 1595-1672/73,
B,H,M,DAV93,CH(AMS)
5/6/93,CH(LON)
7/9/93,SOT1/12/94

L.V.UDEN

LVV
(L V U)

ULFT, Jacob van der,
Dutch 1627-1689,
B,H,M,DAV93,CH(AMS)
11/12/90,SOT1/12/90&
1/13/93

Jac: vander Ulft F
(signature from drawing of black
lead, pen & brown ink & brown wash)

Jac· vand
ulft fece (signature on gouache)

URSELINCK, Jan,
Dutch c.1598-1664,
B,H,CH(MON)6/20/92,
SOT(LON)12/8/93

g.vrselinck

UTRECHT, Adriaen van,
Flemish 1599-1653,
B,H,M,DAV93,PH(LON)
4/16/91,CH(LON)
12/10/93

Adriaen van Wtrecht
fe i650

NOTE: WTRECHT IS CORRECT

ALSO, SIMILAR SIGNATURE SIGNED UTRECHT

A·VAN
VTRECHT

UYTEWAEL (or WTEWAEL),
Jaochim Anthonisz.,
Dutch 1566-1638,
B,H,M,DAV93,
CH5/19/93,SOT1/14/94

Jo·wte·Wael
fe

ф wte Wael

ф Wte Wael fecit

VACCARO, Andrea, Italian 1598?-1670, B,H,M,DAV93,PH(LON) 7/2/91,CH5/31/91& 5/21/92	XX
VADDER, Lodewyk de, Flemish 1605-1655, B,H,M,DAV93,CH(AMS) 11/25/92,CH5/31/90& 10/7/93	*L.D.V.*
VAILLANT, Wallerand, Dutch 1623-1677, B,H,M,DAV93,CH(LON) 7/2/91&7/7/92, CH1/11/95	Wollerand Vaillant 1658
VALADE, Jean, French 1709-1787, B,H,M,DAV93,SOT(MON) 6/22/91	PAR I.VALADE·1767
VAL(C)KENBORCH, Lucas van, Flemish 1530-1597/1625, B,H,M,DAV93,CH1/16/92, CH(AMS)11/18/93, SOT1/12/95	L̲ V V 1592 1577· TEMPERA ON PAPER > L MOUNTED ON PANEL V V
VAL(C)KENBORCH, Martin van, Sr., Flemish 1535-1612, B,H,DAV93,CH1/10/90	M M V V V V
VAL(C)KENBURG, Theodor Dirk, Dutch 1675-1721/25, B,H,M,DAV93,SOT(LON) 12/12/90	D.Valckenburg Fecit
VALDES, Lucas de, Spanish 1661-1724, B,H,M,SOT(MON) 12/2/89	*Lucas De Valdes* <(signature from drawing: pen & black ink, grey wash, blue-grey, red & brown)

VALLAYER-COSTER (or
COSTER), Anne,
French 1744-1818,
B,H,DAV93,SOT(MON)
6/22/91&6/18/92,
CH(LON)7/9/93

Vallayer Coster

Vallayer Coster

M^{lle} Vallayer
1777

VALLEJO, Francisco
Antonio,
Mexican ac.1752-1784,
B,H,M,DAV93,
SOT5/19/92

Vallejo
1781

VALLIN, Jacques Antoine,
French c.1760-after 1831,
B,H,M,DAV94,SOT(MON)
6/19/94

Vallin 1836

VANDERBANK (or BANCK),
Johan or Jan van der BANK,
English 1694-1739,
B,H,DAV93,PH(LON)
11/13/90,SOT(LON)
11/19/92&5/12/93

Jn. Vanderbank. Fecit. 1729.

J.V. 1718 < FROM DRAWING OF PENCIL
AND BROWN WASH.

VANNI, Francesco,
Italian 1563-1610,
B,H,M,DAV93,
CH5/30/91,CH(LON)
7/2/91&6/7/92

F. V. <(from drawing of red,
black & white chalk
on blue paper)

VARLEY, Cornelius,
English 1781-1873,
B,H,M,DAV94,CH(LON)
9/12/91&7/12/94

(Corn.s) *Varley*
1853

< FROM PENCIL & WATERCOLOR,
HEIGHTENED WITH TOUCHES OF
WHITE & GUM ARABIC.

FROM PENCIL DRAWING > *C Varley 1817*

VARLEY, John, Sr.,
English 1778-1842,
B,H,M,DAV93,CH(LON)
7/9/91,SOT(LON)
10/21/92&3/1/93

J.VARLEY. J.Varley 1835 J.Varley.

VEEN, Balthasar van der,
Dutch 1596-after 1657,
B,H,DAV93,SOT11/5/86,
PH(LON)12/6/88

B.Veen.

VEEN, Rochus van,
Dutch c.1640-1706,
B,H,DAV93,SOT(AMS)
11/16/93

R.v.Veen 1665

SIGNATURE FROM DRAWING OF WATERCOLOR AND GUM
ARABIC OVER TRACES OF BLACK CHALK

VELDE, Adriaen van de,
Dutch 1636-1672,
B,H,M,DAV93,CH(LON)
7/2/91&7/9/93,
SOT1/12/95

A.V.Velde Velde f

(signature from drawing
of red chalk)

VELDE, Esaias van de, Sr.,
Dutch 1590-1630/60,
B,H,M,DAV93,CH1/10/90,
SOT(LON)12/9/92,
SOT4/1/92

*E V VESDE
1624*

(black chalk & grey wash)

*E VANDEN
VEIDE·1615*

*E.V.YELDE.
1625*

E.V.V. 1630

VELDE, Jan van De II, Dutch 1593–1641, B,H,M,DAV93, SOT11/20/86, CH5/21/92	*J. Velde fec.* <(signature from an engraving, c.1620)
VELDE, Pieter van de, Flemish 1634–after 1687, B,H,M,DAV94, SOT1/15/93,CH(LON) 7/9/93	*PVV*
VELDE, Willem van de, Sr., Dutch c.1611–1693, B,H,M,DAV93,SOT1/8/91, DOL12/3/92,CH1/13/93	*W. Pinxt-Velde.*
VELDE, Willem van de, Jr., English 1633–1707, B,H,M,DAV93,CH(LON) 7/2/91,CH1/13/93, SOT(LON)12/7/94	*W. V. V. J* <(from drawing: black lead & grey wash) *W. V Velde* *WVV* *W.m Velde*
VENNE, Adriaen Pietersz. van de, Dutch 1589–1662, B,H,M,DAV93,SOT 5/22/92,CH(AMS) 11/10/92&5/6/93	*A.v. Venne* ⟨monogram⟩
VERBEECK, Francois Xavier Henri, Flemish 1686–1755, B,H,M,DAV93, CH10/9/90,CH(AMS) 5/2/91	*Fx Verbeeck. f*
VERBEE(C)K, Jan or Hans, German ac.1598–1618, B,H,DAV93	*i.verbeec. 15.98-*

VERBEECK, Pieter Cornelis,
Dutch 1599-1658,
B,H,M,DAV93,SOT
5/22/92,SOT(AMS)
11/16/93

VERBEEK, Cornelis,
Dutch 1590-1631,
B,H,DAV93,SOT(MON)
7/2/93,SOT(LON)
10/27/93

VERBOECKHOVEN, Eugene
Joseph,
Belgian 1799-1881,
B,H,M,TB,DAV93,
CH(LON)11/30/90,CH5/23/91,
SOT5/26/93,SOT(ARC)
1/19/95

VERBOOM, Adriaen
Hendriksz.,
Dutch c.1628-1670,
B,H,DAV93,SOT1/8/91,
SOT(AMS)11/16/93,
SOT1/12/95

SIGNATURE FROM DRAWING OF BLACK CHALK, BRUSH
AND GREY INK AND WASH
(ALSO THE SAME ON AN OIL)

VERBRUGGEN, Gaspar
Pieter II,
Flemish 1664-1730,
B,H,M,DAV93,SOT(MON)
7/2/93,CH(LON)7/9/93,
SOT1/14/94

VERBURGH, Rutger,
Dutch 1678/80-c.1746,
B,DAV93,CH1/15/88,
SOT(AMS)5/22/90,
SOT(LON)4/21/93

VERDIER, Francois,
French 1651-1730,
B,H,M,DAV93,
CH1/10/91,SOT(LON)
7/6/92

<((SIGNATURE FROM DRAWING OF BLACK CHALK & GREY WASH)

VERDOEL, Adriaen,
Dutch 1620-1695,
B,H,M,DAV93,PH(LON)
4/10/90

(1694?)

VERDUSSEN, Jan Peeter,
Flemish 1700-1763/73,
B,H,M,DAV93,SOT(LON)
2/25/90,ADE4/26/93,
SOT(LON)12/7/94

VERHAERT, Dirck,
Dutch c.1631-after 1664,
B,H,DAV93,CH5/21/92&
10/7/93,CH(AMS)11/18/93

VERHEY(D)EN, Jan Hendrik,
Dutch 1778-1846,
B,H,M,DAV93,PH(LON)
2/11/90,SOT(LON)
3/17/93&6/16/93

**VERKOLJE (or
VERKOLYE), Jan,**
Dutch 1650-1693,
B,H,M,DAV93,PH(LON)
4/18/89,CH(AMS)11/25/92,
SOT(LON)12/7/94

VERMEULEN, Andries,
Dutch 1763-1814,
B,H,M,DAV94,
CH5/21/92,CH(LON)
7/8/94

A. Vermeulen

VERNET, Antoine Charles
Horace (dit Carle),
French 1758-1836,
B,H,M,DAV93,
SOT5/28/92,CH(MON)
12/4/92

Carle Vernet

(from ink and chalk drawing)

VERNET, Claude Joseph,
French 1714-1789,
B,H,M,DAV93,CH(LON)
7/9/93,CH1/12/94,
SOT(LON)12/7/94

J. Vernet. 1775
(gouache)

J. Vernet.
J. V.

J. Vernet. S·1780·

Joseph Vernet

VERNET, Emile Jean Horace,
French 1789-1863,
A,B,H,M,TB,DAV93,
CH(MON)6/15/90,CH2/26/91,
SOT(MON)12/5/92

HV Roma 1835

HV

H Vernet

H Vernet

H.VERNET

Vernet (1840)

Horace Vernet (1826)

J.E.H.V. <(INITIALS FROM WATERCOLOR)

VERON, Alexandre Paul
Joseph,
French 1773-1838?,
B,H,DAV93,SOT(MON)
6/19/92

VERON-MDCCCXXXV
(SIGNATURE FROM WATERCOLOR)

VERONESE called,
(CALIARI, Paolo),
Italian 1528-1588,
B,H,M,DAV93,CH(LON)
7/9/93,SOT1/12/94&
1/10/95

Paolo Veroneſe <(signature from drawing of black chalk heightened with white chalk on blue paper)

PAVLVS CALIARI VERONESIs

VERRY(C)K (or VERRIJK or
VEREYK), Theodor or Dirk,
Dutch 1734-1786,
B,H,DAV93,SOT(AMS)
11/22/89,CH(AMS)
11/25/92

T: Verryk. fecit <(signature from watercolor, heightened with white)

(black chalk, grey ink & wash, brown ink border border lines, signed in margin) *Tr:Verryk: A°1771*

VERSCHUIR, Lieve,
Dutch c.1630-1686,
B,H,M,DAV94,SOT(LON)
4/21/93&4/20/94

L. verſchuir

VERSCHURING, Hendrik,
Dutch 1627-1690,
B,H,M,DAV93,SOT(LON)
4/1/92,CH(MON)6/20/92,
SOT(AMS)11/16/93

H. verſchuring f 1662 <(SIGNATURE FROM A GREY WASH DRAWING)

VERSPRONCK, Johannes
Cornelisz,
Dutch 1597-1662,
B,H,M,DAV94,CH(LON)
4/23/93,CH1/11/95

Joh. Espronck a° 1651

VERTANGEN, Daniel,
Dutch c.1598-after 1684,
B,H,M,DAV93,PH(LON)
7/2/91,SOT(AMS)
5/12/92,SOT1/12/95

D: Vertangen..

VERWER, Abraham, Dutch ac. 1617-1650, B,H,DAV93,PH(LON) 7/2/90,CH(AMS) 11/25/92	*Verwer* *verwer* <(signature from a drawing of pen, brown ink & watercolor)
VESTIER, Antoine, French 1740-1824, B,H,M,DAV93,SOT(MON) 6/15/90,CH1/14/93& 10/7/93	*Vestier* <(signature from drawing: pen & black ink, pen & brown ink, grey & colored washes) *Vestier 1792*
VICKERS, Alfred, Sr., English 1786-1868, B,H,M,DAV93, BB5/20/92,PH(LON) 4/27/93,SOT(ARC) 1/19/95	*A.Vickers 1862* *A.V.* *A Vickers 1841*
VICO (or VICUS or VIGHI), Enea, Italian 1523-c.1567, B,H,M,R,DAV94	*Enea Vico* SIGNATURE FROM ENGRAVING
VICTORS, Jan or Johan, Dutch 1620-1676, B,H,M,DAV93, CH1/11/89,SOT1/15/93	*Jan Victors f.*
VIDAL, Emmeric Essex, English 1791-1861, B,H,DAV93,SOT5/29- 30/84,CH(LON)7/15/94	*E.E.Vidal* *E.E.Vidal* SIGNATURE FROM PENCIL AND WATERCOLOR.
VIDAL, Francisco, Spanish 18th century, SOT(MON)6/22/91	*Franco Vidal* <(signature from watercolor)
VIEN, Joseph Marie, French 1716-1809, B,H,M,DAV93,SOT(MON) 6/18/92&7/2/93,CH(MON) 12/4/93	*J.V.* *Vien*

VIET, Philipp(e),
German 1793-1877,
B,H,M,TB,DAV93

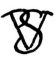 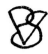

VIGEE, Louis,
French 1715-1767,
B,H,M,DAV93,
SOT5/20/93,
SOT(LON)7/4/94

C. Vigee <(SIGNATURE FROM PASTEL MOUNTED ON CANVAS)

SIGNATURE FROM PASTEL > *L. Vigee*

VIGEE-LEBRUN, Marie Louise Elisabeth,
French 1755-1842,
B,H,M,DAV93,
CH5/21/92,CH(MON)
12/4/92,SOT1/14/94

1801 L. E. Vigee Le Brun
(signature from pastel on paper)

E. V. Le Brun 1811 <(from pastel)

L. E. Vigee Le Brun

Le Brun <(signature from pastel)
1818 (Also signs Le Brun on oils)

VIGNAUD, Jean,
French 1775-1826,
B,H,CH5/19/93,
SOT(ARC)5/20/94

J. B. Vignaud
1809

VILLAPANDO, Cristobal,
Mexican 1649-1714,
SOT11/23/93

C. Villal
panao
1701

VILLERET, Francois Etienne,
French 1800-1866,
B,H,DAV93,AUD11/19/92

Villeret <(signature from watercolor)

VINCENT, Francois Andre,
French 1746-1816,
B,H,M,DAV93,CH(MON)
7/2/93,SOT1/12/94,
SOT(LON)12/7/94

Vincent.

SIGNATURE FROM PEN, BROWN
INK & WASH OVER BLACK CHALK > *Vincent fe.*

VINCENT, George,
English 1796-1831,
B,H,M,DAV93,
SOT1/17/91,CHE
4/28/93

G 1827

VINCENT, Henriette
Antoinette,
French 1786-1830,
B,H,DAV93,SOT(MON)
6/18/88

M^me. Vincent

VINCKBOONS, David,
Flemish 1576-1629/32,
B,H,M,DAV93,SOT
1/15/93,SOT(AMS)
5/7/93,CH(LON)
12/10/93

DVB 1606

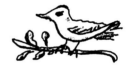

VINNE, Jan Laurens van der,
Dutch 1699-1753,
B,CH(AMS)11/12/90

Jan Vander Vinne Pinxit

(signature from drawing of pencil & watercolor)

VINNE, Vincent Laurensz.
van der I,
Dutch 1629-1702,
B,H,M,DAV93,CH(AMS)
11/10/92

V *Vand Vinne J684/30*

(1684)

VISENTINI, Antonio,
Italian 1688-1782,
B,H,DAV93,CH4/8/88,
SOT1/12/94

Ant. Visentini del. 1761.

FROM DRAWING OF PEN, BROWN INK AND GREY WASH

VISPRE, Francois Xavier,
French c. 1730-1790,
B,H,M,DAV93,
SOT4/7/88

Vispre

VISSCHER, Claes Jansz.,
Dutch 1587-1652,
B,H,DAV94,CH(AMS)
11/24/92,SOT(AMS)
5/10/94

J.C. Visscher. Fec.

FROM DRAWING OF PEN, BROWN INK & BLUE WASH.

VISSCHER, Cornelis,
Dutch 1629-1658,
B,H,M,DAV94,SOT(AMS)
5/10/94

C.C. Visscher

FROM DRAWING OF BLACK CHALK ON VELLUM.

VITO, Camillo de,
Italian early 19th century,
DAV94,ADE10/23/92,
SOT1/10/95

Camillo de Vito 1829.

SIGNATURE FROM GOUACHE

VLEUGHELS, Nicolas,
French 1668-1737,
B,H,M,DAV94,SOT(LON)
7/8/92,CH(MON)6/19/94,
SOT1/12/95

N.V. 1722

VLIEGER, Simon Jacobsz de,
Dutch 1600-1653,
B,H,M,DAV93,
SOT7/19/90,CH5/14/91,
CH(AMS)11/18/93

SDV S·DE·VLIEGER

S. DeVlieger DV

VLIET, Hendrik Cornelisz. van,
Dutch 1611-1675,
B,H,M,DAV93,CH1/11/91&
5/21/92,SOT1/14/94

H. Van Vliet H. Vliet
1657

VOGEL, Georg Ludwig, Swiss 1788-1879, B,H,M,TB,DAV93, CH(LON)11/24/89& 10/1/93	*L.Vogel* *L.V.*
VOGEL VON VOGELSTEIN, Carl or Karl Christian, German 1778/88-1868, B,H,M,TB,CH(LON) 5/20/93	(1838)
VOILLE, Jean, French 1744-after 1804, B,H,M,DAV93,SOT(MON) 6/15/90	*Voille*
VOIS, Arie de, Flemish c.1632-1680, B,H,M,DAV93,CH(AMS) 11/25/92,SOT(ARC) 7/22/93,SOT1/12/95	*A Vois* (oil on copper) *Vois f. 1680*
VOLLERDT, Johann Christian, German 1708-1769, B,H,M,DAV93,SOT 1/15/93,CH1/12/94, SOT(LON)12/7/94	*Vollerdt p.* *1759* *vollerdt pinxit*
VONCK, Jan, Dutch c.1630-c.1662, B,H,M,DAV93,CH10/16/87, CH(AMS)5/6/93,SOT(AMS) 11/16/94	*J. Vonck.F* *J. Vonck fecit*

VOORHOUT, Jan or Johannes,
Dutch 1647-1723,
B,H,M,DAV93,PH(LON)
12/12/90,SOT(LON)
7/3/91,CH5/21/92

(signature from drawing ofpen & brown ink over
black chalk with wash heightened with white)

J voorhout 1680

VOROB'EV (or WOROBIEFF),
Maksim Nikiforovich,
Russian 1787-1855,
B,M,DAV93,CH(LON)
10/6/88

<(signature from water-
color, pen & ink)

VOS, Maerten de,
Flemish 1532-1603,
B,H,M,DAV93,CH(MON)
6/20/92,SOT(LON)
7/6/92,CH1/11/94

·M·D·V·
1593

<(INITIALS FROM DRAWING OF
BLACK CHALK, PEN, BROWN INK
AND BROWN WASH)

·M·D·VOS·E
1582

<(FROM DRAWING OF PEN & BROWN
INK, & BROWN & GREY WASH)

M D VOS F· 1587
(FROM DRAWING OF PEN, BROWN INK & WASH)

MERTEN DE VOS·FCIT 1582
FROM DRAWING OF PEN & BROWN INK AND BROWN WASH

VOS, Simon de,
Flemish 1603-1676,
B,H,M,DAV94,
CH(LON)7/8/94

S·D·Vos.

VRANCX, Sebastiaen,
Flemish 1573-1647,
B,H,M,DAV93,SOT10/14/92,
SOT(LON)10/28/92,
CH5/14/93

VRIES, Roelof Jansz. van,
Dutch c.1631–after 1681,
B,H,M,DAV93,SOT(LON)
4/21/93,CH5/21/92&
1/12/94&1/11/95

VROOM, Cornelis,
Dutch c.1591–1661,
B,H,M,DAV93,CH(AMS)
11/12/90,CH12/11/92

<(inscription signa-
ture from a drawing
of pen & brown ink)

VRO(O)MANS, Isaac,
Dutch c.1655–1719,
B,H,DAV94,CH(LON)
11/21/91,CH5/18/94

VUCHT, Herrit van,
Dutch c.1610–1697,
B,H,DAV93,CH11/13/90,
CH(AMS)5/2/91,CH(LON)
7/10/92

WACHTER (or WAECHTER), Georg Friedrich Eberjard, German 1762-1852, B,H,M,TB	*EW*
WAEL (or WAAL), Cornelis de, Flemish 1592-1667, B,H,M,DAV93,CH1/9/91, SOT(LON)7/8/92& 10/27/93	*De Wael* <(signature from drawing pen & brown ink with browm wash)
WAGNER, Carl or Karl Ernest Ludwig Friedrich, German 1796-1867, B,H,M,TB,DAV93, BB5/17/89,ZEL10/7/92	*GWf*
WAILLY, Charles de, French 1729-1798, B,H,M,DAV93,CH(LON) 7/2/91,SOT1/14/92	*DesVailly 1756* (SIGNATURE FROM DRAWING OF BLACK CHALK, PEN & BLACK INK, BROWN & GREY WASH HEIGHTENED WITH WHITE)
WALDMULLER, Ferdinand Georg, Austrian 1793-1865, B,H,M,DAV93,SOT 5/28/92&5/20/93, WIE4/20/94	*Waldmuller. F.* *Waldmüller 1851*
WALL, William Guy, Irish/American 1792-1864, B,D,F,H,I,M,DAV93, WES2/25/89,SOT12/3/92	*W. G. Wall*
WALSCAPPELLE, Jacob van, Dutch 1644-1727, B,H,M,SOT5/22/92& 1/12/95	*JvW*

WARD, James, English 1769-1859, B,H,M,TB,DAV93, SOT6/8/90&6/4/93& 10/8/93	*JWR RA. 1829. JHS* *NB RA 1839 J.Ward-1797* *JHS NB JWard.*
WARD, John (of Hull), English 1769-1859, B?,CH(LON)2/9/90	J·W·
WARD, Martin Theodore, English 1799-1874, B,H,M,DAV93, BB12/5/88,SOT6/4/93	M.T.Ward
WARNBERGER, Simon, German 1769-1847, B,H,M,DAV94,PH(LON) 6/14/94	S Warnberger 1810
WASSENBERGH, Elisabet Geertruida, Dutch 1726-1782, B,CH(AMS)5/6/93	Elisabet Geertruida Wassenbergh
WATERLOO, Anthonie, Flemish c.1610-1690, B,H,M,DAV93,CH(AMS) 11/14/88,SOT(LON) 12/14/92,SOT(AMS) 11/17/93	AWaterloo <(drawing: black chalk, grey wash & scraping) AW AW <(black chalk, grey wash & touches of white) FROM DRAWING OF PEN, BLACK A.Waterloo INK, GREY WASH & RED CHALK

WATERLOO, Denis, Flemish 17th century, DAV94?,BB5/20/92?, CH(LON)7/9/93	D W
WATTEAU, Louis Joseph, French 1731-1798, B,H,M,DAV93, SOT5/20/93,SOT(LON) 10/8/93	*L. Watteau*
WATTS, Frederick Waters **or William,** English 1800-1862, B,H,M,DAV94,PH(LON) 7/21/92,CH(LON) 6/11/93	*F. W. Watts 31*
WAUTIER (or WOUTIER), Michaelina, Flemish 1627?- , B,H,SOT(AMS)11/16/93	*Michaelina Wautier fecit 1652*
WEAVER, Thomas, English 1774-1843, B,H,M,DAV93,SOT6/9/89, CH(SK)11/1/90,PH(LON) 4/27/93	*Th Weaver* (1833) *Tho.ˢ Weaver 1823* *T Weaver P. 1811*
WEBBER, John, English 1750/52-1793, B,H,M,DAV94, CH(LON)7/15/94	J. *Webber pinxt 178* ? ∧ J WAS NOT LEGIBLE
WEBSTER, Thomas, English 1800-1878, B,H,DAV93,BB5/17/89, CH(SK)2/1/90, CHE10/15/93 CONTINUED	18 W 40 T.Webster

WEBSTER, Thomas
CONTINUED

T. Webster 1837.

WECHLEN, Hans van,
Dutch c.1537- ,
SOT(LON)4/1/93(see
catalog for biography)

NOTE: BOTH MONOGRAMS WERE FROM THE SAME PAINTING.
THE FIRST MONOGRAM WAS THE BOTTOM OF THE OTHER,
WHICH HAS AN H V AT THE TOP. THIS H V & THE
VERTICAL LINE IS EITHER PART OF THE MONOGRAM OR
PART OF THE LINES OF THE BARK OF THE TREE WHERE
THE MONOGRAM WAS PLACED.

WEDIG, Gotthardt de,
German 1583-1641,
B,PH(LON)12/11/90,
SOT5/22/92,CH5/14/93

GDW F. 1637.

WEENIX, Jan,
Dutch c.1642-1719,
B,H,M,DAV93,
SOT4/7/89,CH(LON)
7/9/93,CH1/12/94

J. weenix f.
J. weenix f.

WEENIX, Jan Baptist,
Dutch 1621-1663,
B,H,M,DAV94,SOT
10/10/91&5/19/94&
1/12/95

Gio: Batta.
weenix

WEGMAYR, Sebastian,
Austrian 1776-1857,
B,H,DAV93,SOT7/19/90,
SOT(ARC)1/17/91,
DOR11/11/92

Wegmayr

WEINGARTNER, J. B. C.,
German?/Swiss? 18th
century
SOT(MON)7/2/93

B.J.C. Weingartner

WERTMULLER, Adolf Ulrich,
Swedish 1751-1811,
B,H,M,DAV94,PH(LON)
12/7/93,CH1/11/95

A.W.
1793.

WEST, Benjamin,
American 1738-1820,
B,D,F,H,I,DAV94,
SOT5/20/93,SOT(ARC)
5/20/94,CH1/28/95

B.West 1803 *B West*

(signature from drawing of
black chalk, pen & brown ink)

B.W.90 <(initials from drawing of pen
& brown ink with brown wash)

(signature from drawing of
black chalk, pen & brown
ink & brown wash, 1813)> *Benj.n West*

B.West 1801

Note: Known to have initials
stamped in intaglio on drawings.

DRAWING OF PEN & > *B West 1784*
BROWN INK, INCISED.

WESTALL, Richard,
English 1765-1836,
A,B,H,M,DAV93,
WD5/18/88,BB11/13/91,
CH(MON)6/20/92

R W *R. Westall. 1830.*

WESTENBERG, Pieter George,
Dutch 1791-1873,
B,H,TB,DAV93,SOT(LON)
6/16/93

P.G.W.

WESTHOVEN, Huybert van, Dutch c.1643-before 1687, B,H,DAV94,SOT1/12/95	C H van C westhove PART OF THE H & van WERE NOT DISCERNIBLE
WET, Jacob Willemsz. de, Dutch 1610-1675, B,M,DAV93,SOT(LON) 10/27/93,SOT(AMS) 11/17/93,CH1/11/95	J. D. wet
WEYER, Hermann, German 1569-after 1621, B,SOT(LON)12/12/90, LEM5/15/93	H. HV. W. ·1621·
WEYMANS, Leendert, Dutch? 18th century, SOT(AMS)11/22/89	Leendert Weymans 1770 (Black, brown & red inks & watercolor)
WHEATLEY, Francis, English 1747-1801, B,H,M,DAV93, CH1/16/92,SOT5/22/92& 1/15/93	FWheatley FW 1782 <(initials from a watercolor over pencil) F.Wheatley pxt1794
WHITCOMBE, Thomas, English 1763-1824, B,H,M,DAV93, SOT6/5/92,PH(LON) 4/27/93	T.W. 1785
WIERIX (or WIERX), Anthonie, Flemish c.1552-c.1624, B,H,M,WES2/1/90	Anton.Wierx <(signature from engraving)

WIERIX (or WIRIEX), Johan,
Flemish c.1549–after 1615,
B,H,M,DAV93,CH5/31/90

Iohanwiriex inventor

(signature from drawing of pen & brown ink on vellum)

WIESSENER, Conrad,
German 1796–1865,
B,H,TB

CW

WIGAND, Balthasar,
Austrian 1771–1846,
B,DAV93,CH(LON)
5/20/93,WIE4/20/94

Wigand· <(SIGNATURE FROM WORK DONE IN BODYCOLOR)

Wigand· <(SIGNATURE FROM WATERCOLOR)

WILDE, Samuel De,
English 1747–1832,
B,H,M,DAV94,CH(LON)
11/20/92&11/8/94

S DeWilde Signature from drawing of pencil, pen & black ink & grey wash, paper laid on canvas

WILKIE, (Sir) David,
English 1785–1841,
B,H,M,DAV93,PH(LON)
11/21/88,BB5/20/92,
CH(LON)7/14/92

D. Wilkie 1823

(signature from a pen & brown ink drawing)

D Wilkie *DWilkie* *D.W.*

David Wilkie jr. 1830

> FROM DRAWING OF PENCIL, BLACK & WHITE CHALK & WATERCOLOR, WHITE HEIGHTENING TOUCHES.

WILKINS, J.,
English late 18th century,
H,SOT(LON)10/31/90

I.Wilkins.

WILLAERTS, Abraham, Dutch c.1603–1669, B,H,M,DAV93,SOT(LON) 4/11/90,SOT(AMS) 11/11/92	*AW fect* *A.W.*
WILLAERTS, Adam, Dutch 1577–1664, B,H,M,DAV93,CH12/11/92, SOT(LON)4/21/93, SOT1/12/95	*AD willarts* <(E omitted in signature)
WILLE, Johann Georg, German 1715–1808, B,H,M,DAV93,SOT1/12/90, CH(LON)7/7/92,CH(MON) 7/2/93	*J.G.W. 1739* <(black & white chalk drawing) (FROM DRAWING OF BLACK CHALK & GREY WASH)> *J.G. Wille. 1788* *J.G. Wille 1764* < FROM DRAWING OF PEN & BROWN INK, & REDDISH–BROWN WASH, WATERMARK STRASBURG LILY.
WILLE, Pierre Alexandre, French 1748–1821, B,H,M,DAV93,SOT1/14/92& 1/13/93,CH(MON)7/2/93	*P.A.Wille 1786* *P.A.W.* (initials from watercolor heightened with gouache) *PA Wille* < FROM DRAWING OF BLACK, RED & WHITE CHALK ON BEIGE PAPER
WILLEMSENS, Abraham, Dutch? ac.1627–1672, CH5/14/93,CH(AMS) 11/18/93,CH(LON) 12/10/93	*AB.W F*
WILLEMSENS, Antoon, Dutch? ac.1649–1673, CH(MON)12/4/92	*A.W. INF.*

WILLIAMS, Penry, **English 1798-1885,** **B,H,M,DAV93,CH(SK)** **1/31/89,DRE3/3/93,** **SOT(ARC)7/23/93**	*P. Williams* *1847* Penry Williams 1832
WILSON, Alexander, **Scots/American 1766-1813,** **B,D,F,I,M,DAV93,** **CH6/5/93**	*A. Wilson* <(SIGNATURE FROM HAND COLORED ENGRAVING)
WILSON, Richard, **English 1714-1782,** **B,H,M,DAV93,SOT10/11/90&** **4/11/91,CH(LON)7/14/92**	*Rich-Wilson* *R.W.* (Roma 1754) *RW* *R.W.J.*
WINCK, Johann Amandus, **German c.1748-1817,** **CH1/16/92,SOT1/15/93&** **1/14/94**	*Joan. Amand. Winck.* *J. Winck. 13.* *JAW* *J.W.* *J:A:W:* 1801. *J.A.W.* < 1798
WINT (or DE WINT), Peter de, **English 1784-1849,** **B,H,M,DAV93,BB7/22/87,** **CH(LON)7/14/92**	*P. de Wint.* <(signature from watercolor)

WISSING, Willem,
Dutch 1656-1687,
B,H,M,DAV93,
CH10/10/90&10/9/91

W. Wissing pinxit

WIT, Jacob de,
Dutch 1695-1754,
B,H,M,DAV93,SOT
5/22/92&1/14/94,
CH1/11/95

Jdwit *Jdwit*

Jdwit 1722 *Jdwit*

WIT, Pieter de,
Dutch ac.c.1669,
B,H,SOT(LON)7/6/94

Pr D. Wit

WITHERS, (Mrs.) Augusta
Inness nee BAKER,
English c.1793-c.1865,
DAV93,BB5/20/92,
CH(LON)7/14/92

Mrs Withers Delt 1843

(FROM A PENCIL & WATERCOLOR HEIGHTENED WITH
WHITE AND GUM ARABIC) Noted botanical artist.

WITHOOS, Franz,
Dutch 1657-1705,
B,H,CH10/20/88

F. Withoos

WITHOOS, Johannes or Jan,
Dutch 1648-1685,
B,H,CH11/13/90

J.W. A° 1678

WITHOOS, Matthias,
Dutch 1627-1703,
B,H,M,DAV93,
CH11/13/90,CH(AMS)
5/7/92,SOT1/12/95

M Withooz *M.Withoos*

WITHOOS, Pieter,
Dutch 1654–1693,
B,H,M,DAV93,CH1/10/90,
DOT1/13/93&1/12/94

(pen and black ink,
watercolor & bodycolor)

< FROM DRAWING OF PEN, BROWN
INK AND WATERCOLOR

WITMONT, Herman,
Dutch c.1605–after 1683,
B,SOT(MON)6/16/90,
CH(LON)7/9/93,SOT(LON)
12/8/93

·H·WITMONT·

WITTE, Emmanuel de,
Dutch 1617–1692,
B,H,M,DAV94,SOT10/11/90,
DOR3/10/93

E.De Witte fecit 1684

E.DE WITTE.

**WITTEL, Gaspar van
(called IL VANVITELLI),**
Dutch 1653–1736,
B,H,M,DAV93,SOT(LON)
7/5/93,CH(LON)7/9/93,
SOT1/10/95

G:V:W: Gasp° van Witel

(one T in sur name)

WITTEROOS, Thomas,
Dutch –1575,
CH(AMS)6/20/89

THOMAS WITTE ROOS
ANNO 1566·

WOENSEL, Petronella van,
Dutch 1785–1839,
B,H,DAV93,SOT(LON)
10/18/89,SOT10/10/91,
DOR6/2/93

P. Van Woensel f 1827

WOLSTENHOLME, Dean, Sr.,
English 1757–1837,
B,H,M,DAV93,WES1/14/89,
SOT6/9/89,CH6/5/93

DWolstenholme

WONDER, Pieter Christoffel, Dutch 1777/80-1852, B,H,M,DAV93	P.C.W.F
WOOD, Carlos C., English 1792-1856, SOT5/29/85	C.C.Wood Santiago 1832
WOOD, George, British 18th century, CH10/14/93	George Wood. 1735 FROM DRAWING OF WATERCOLOR, PEN AND INK.
WOODSIDE, John Archibald, Sr., American 1781-1852, B,D,F,H,M,DAV93, SOT12/17/90,CH11/20/90& 6/5/93	J A Woodside 1833 J.A.Woodside. 1808. J.A.WOODSIDE
WOOTTON, John, English 1677/86-1765, B,H,M,DAV93,SOT6/5/92& 6/4/93,PH(LON)4/27/93	Wootton
WORRELL, Abraham **Bruiningh van,** Dutch 1787-1823, B,H,DAV93,PH(LON) 10/25/88	AB van Worrell
WOUTERS, Frans, Flemish 1612/14-1659, B,H,M,DAV93,SOT10/10/91, CH5/21/92,SOT(LON) 12/9/92	.F. W.

WOUWERMAN, Jan,
Dutch 1629-1666,
B,H,M,DAV93,CH(AMS)
5/6/93,SOT5/20/93

WOUWERMAN, Pieter,
Dutch 1623-1682,
B,H,M,DAV93,PH(LON)
7/4/89,CH(AMS)6/12/90,
SOT10/14/92

WOUWERMANS, Philips,
Dutch 1619-1668,
B,H,M,DAV93,SOT
5/20/93,CH1/12/94,
SOT1/12/95

WYCK (or WIJCK or
WYKE), Thomas,
Dutch 1616-1677,
B,H,M,DAV93,
SOT6/2/89&7/19/90,
CH2/11/92

WYNANTS, Jan,
Dutch c.1630-1684,
B,H,M,DAV93,
SOT10/13/89,SOT(AMS)
5/7/93,CH(LON)
7/9/93

YEPES (or HIEPES), Tomas de,
Spanish 1600-1674,
B,H(Yepes & Hiepes),
CH(LON)5/29/92 & 12/11/93,
CH1/12/94 & 1/11/95

T. HIEPES

THOMAS HIEPES

TOMAS HIEPES

YKENS, Pieter,
Dutch 1648-after 1695,
B,H,M,DAV94?,
SOT(AMS)5/10/94

PIETER
YKENS

ZEEHMANN, Dutch ac. 18th century, CH(AMS)11/14/88	*Zeehmann* (from drawing: black lead, water- color & bodycolor)
ZEEMAN, Joost, Dutch c.1776-1845, B,SOT1/13/93	I·Z <(from gouache)
ZERNA, F.?, Mexican late 18th century, SOT11/16/94	*Zerna.F.*
ZOFFANY, Johann Joseph, English 1733-1810, B,H,M,DAV93, SOT6/4/87&6/2/89	
ZUCCARELLI, Francesco, Italian 1748-1821, B?,CH(MON)6/20/94, SOT1/10/95	< FROM DRAWING OF BLACK CHALK, PEN & BROWN INK, GREY WASH, HEIGHTENED WITH WHITE ON BEIGE PAPER.
ZUCCARO, Federico, Italian 1540/43-1609, B,H,M,DAV93,SOT(MON) 6/15/90,SOT1/14/92, CH1/13/93	*Federico Zucharo* (inscription signature from pen & brown wash drawing) FZ *·F. Zuccaro* (SIGNATURE FROM RED CHALK DRAWING) *Federico Zucheri* (signature from drawing of black & red chalk)
ZUCCARO, Taddeo, Italian 1529-1566, B,H,M,DAV93,SOT1/11/90, SOT(MIL)5/18/93(lot 694), SOT1/12/94	*Zuccaro* <(inscription signature from a drawing of pen & brown wash)

ZUCCHI, Antonio Pietro,
Italian 1726-1795,
B,H,M,DAV93,SOT(LON)
7/5/93,CH1/11/94

Zucchi

FROM ARCHITECTURAL DRAWING OF PEN & BROWN INK, BROWN
WASH HEIGHTENED WITH WHITE, ON LIGHT BROWN PAPER.

MONOGRAMS & INITIALS

A	LUINI, Aurelio	*A : f.* < FROM DRAWING OF PEN & BROWN INK, BROWN & GREY WATERCOLOR, AND HEIGHTENED WITH WHITE.
AA	ALTDORFER, Albrecht	< MONOGRAM FROM ENGRAVING c. 1515 >
	ANTHONISSEN, Arnoldus	A.A.
	ARENTSZ, Arent	
	ARMAND, A.	AA. <(black lead, pen & brown ink & brown wash)
	ASCIONE, Aniello	
AB	BARTSCH, Adam	AB
	BLOEMERS, Arnoldus	
	BOSSCHAERT, Ambrosius, Sr.	.16 06.
	BOSSCHAERT, Ambrosius II	
	BOTH, Andries	
	BRUEGHEL, Abraham	

	CUYLENBORCH, Abraham	
	SAINT AUBIN, Gabriel	
ABF	FLAMEN, Albert	
ABS	SUSENIER, Abraham	
ABWF	WILLEMSENS, Abraham	
AC	COOPER, Abraham	
	COOSEMANS, Alexander	
	KALRAET, Abraham	
AD	DUNOUY, Alexandre	
	DURER, Albrecht	
AE	EGOROV, Alexie	
AES	SADELER, Aegidius	

AF	FISHER, Alvin	
	FRANCKEN, Ambrosius I	Æ. INV. ET FEC. A · 1600
AG	ALDEGREVER, Heinrich	<(monogram from engraving)
AGH	HENNIG, Gustaf	
AGL	GIRODET-TRIOSON, Anne-Louis	1800
AH	HONDIUS, Abraham	
	HOUBRAKEN, Arnold	
AHB	HENSTENBURGH, Anton	(bodycolor on vellum)
AI	JOLI, Antonio	AI
AJ	ANONYMOUS A J	< FROM DRAWING OF PEN, BROWN INK AND WATERCOLOR.
AJD	DUBOIS, Alexandre	
AJM	MURRAY, Amelia	AJM circa 1820s From pencil and watercolor
AK	KRUGER, Ferdinand	

AM	GERMAN SCHOOL	A M
AMA	AMOROSI, Antonio	
AO	ORLOVSKII, Alexandre	<(A O monogram from pencil drawing)
AOCO	CASTILLO SAAVEDRA, A.	
AP	PEALE, Anna	
	PELLION, J. Alphonse	< FROM WATERCOLOR, PEN & INK
	PETRICH, Andras	
APP	APPIANI, Andrea	
AQ	QUERFURT, August	
RA	RADEMAKER, Abraham	<(from drawing of pencil & watercolor heightened with white)
	RHOMBERG, Joseph	
	RIEDEL, August	
AS	AMSLER, Samuel	

	SAINT AUBIN, Augustin	A·S· < INITIALS FROM PEN, BROWN INK AND WASH
	SAUERWEID, Alexandre	ℬ. ℬ (1813)
	SCHELFHOUT, Andreas	A.S.
	SCHOONEBEECK, Adriaan	A:S: fec. FROM DRAWING OF PEN & BLACK INK, GREY WASH HEIGHTENED WITH WHITE.
	SCHOUMAN, Aert	A S
	SEINSHEIM, August	AS A AS
	SUSENIER, Abraham	A·S.
ASL	SCHNORR VON CAROLSFELD, Julius	NSL < (MONOGRAM FROM DRAWING OF PEN AND GREY INK) 1842
ATH	HIMPEL, Aernout	AH ATH
ATW	TERWESTEN, Augustinus	AW: FROM DRAWING OF BLACK CHALK, PEN & BROWN INK, BROWN & RED WASH.
AV	MUS(S)I, Agostino	AV INITIALS FROM ENGRAVING
	VACCARO, Andrea	XX
	VICKERS, Alfred	AV.

AVB	BASEROY, Andries	
	BEYEREN, Abraham	
	GERMAN SCHOOL	
AVC	CABEL, Adriaen	
	CUYLENBORCH, Abraham	
AVD	DIEPENBEECK, Abraham	
AVDN	NEER, Aert	<(double monogram)
AVE	EERTVELT, Andries	
	EVERDINGEN, Allaert	<(grey ink signature) (grey wash & watercolor, black chalk) (from drawing of black chalk, pen, grey & brown ink, watercolor, brown ink framing lines)>
AVK	CABEL, Adriaen	(1648)
AVO	OSTADE, Adriaen	
AVS	STALBEMT, Adriaen	

AVV	VENNE, Adriaen	
AW	MONOGRAMMIST A W, French	16 W 28 Possibly circle of Louis de Caullery
	MONOGRAMMIST A W, Dutch	A.W. IN·F.
	WATERLOO, Anthonie	AW AW <(black chalk, grey wash & touches of white)
	WERTMULLER, Adolf	A.W. 1793.
	WILLAERTS, Abraham	AW fect A.W.
	WILLEMSENS, Antoon	A.W. INF.
B	BECCAMFUMI, Domenico	B
	BEWICK, Thomas	B
	BLANKERHOFF, Jan	B B
	BRENET, Nicolas	·B· f·. ·1764·
	RIJKERE, Bernaert	·1561· ·B·
BA	ASSTEYN, Bartholomeus	BA <(from watercolor heightened with white)

BB	BELLOTTO, Bernardo	*B.B.*
	BREENBERGH, Bartholomeus	< MONOGRAM FROM DRAWING OF PEN, BROWN & BLACK INK, AND BROWN WASH , ALSO FOUND ON OIL PAINTINGS. FROM DRAWING OF PEN, BROWN INK AND WASH > *B.f.*
BD	BARRIERE, Dominique	*BD feci* <(SIGNATURE FROM DRAWING OF BLACK CHALK, PEN, BROWN & BLACK INK)
BDC	CARO, Baldassare	*BC*
BM	BRANDMULLER, Michael	*BM*
	MOLENAER, Bartholomeus	*B·M·*
BMF	MEI, Bernardino	*B·M·F·1636*
BMR	MOLENAER, Bartholomeus	*·B·MR·*
BP	PEETERS, Bonaventura	*B·P 1639*
BR	BREVIERE, Louis	*Br*
BVA	AST, Balthasar	*B·V·A*
C	CATEL, Franz	*C C*

CA	ATKINSON, Christopher	*C A pinx^t* 1756	< FROM DRAWING OF PENCIL & WATERCOLOR, HEIGHTENED WITH WHITE & GUM ARABIC.
CAB	AGRICOLA, Karl		
CAT	CARUELLE d'ALIGNY, Claude		
CB	BECCAMFUMI, Domenico		
	BEGAS, Karl		
CBF	COUWENBERGH, Christiaen		
CC	COROT, Jean		
CD	CANUTI, Domenico		
	CHARDIN, Jean		
	DUSART, Cornelis		
	HEEM, Cornelis		
CDW	WEDIG, Gotthardt		
CF	CEULEN, Cornelis CONTINUED		

	CEULEN, Cornelis CONTINUED	
	FASSIN, Nicolas	CALLED CHEVALIER DE FASSIN
CH	HAARLEM, Cornelis	1632 1636 (1600) A° 1697
	HEIDELOFF, Carl	
CJM	MOLENAER, Klaes	
CL	LORICHON, Constant	
CM	MARATTI, Carlo	<(initials from drawing of pen & brown ink with wash heightened with white)
	MAURER, Christoph	7 1608 FROM DRAWING OF PEN & BLACK INK, GREY & BROWN WASH CM .©.
	MEYER, Conrad	CM:F 1595
CON	NEVE, Cornelis	Co:N. (1636)
CP	PARIS, Carlo	C.P.

	PERCIER, Charles	FROM WATERCOLOR WITH BLACK CHALK, > PEN & GREY INK.
	PESCHEL, Carl	
	POELENBURGH, Cornelis	
CR	ROTTMAN, Carl	
CRL	LESLIE, Charles	
CS	SAFTLEVEN, Cornelis	
	SCHUT, Cornelis	
CSA	SCHWERDGEBURTH, Karl	
CT	TISCHBEIN, Carl	
	TOWNE, Charles	
CTB	TEGELBERG, Cornelis	
CV	VOGEL VON VOGELSTEIN, Carl	(1838)
CVB	BROECK, Crispyn CONTINUED	<(from drawing of black chalk, pen & brown ink, brown wash heightened with white)

	BROECK, Crispyn CONTINUED	
	VERBEEK, Cornelis	CVb
CVE	ESSEN, Cornelis	C.V.E.
CVHDK	HEIDECK, Carl	C. v BəK.
CVS	SCHALCKE, Cornelis	C V S
CW	WAGNER, Carl	Cw f
	WIESSNER, Conrad	Cw
CWDH	HAMILTON, Karl	C.W.D.H. 1735
	DAHL, Johan	D 1823
D	DENIS, Simon	D. f. 1790
	DIETRICH, Christian	D. 1762 D
DB	BOISSEAU, Jean	DB. 1782.

FROM DRAWING OF BLACK CHALK

DB ·1799· FROM RED CHALK DRAWING

	BURCKHARDT, Daniel	*D.B. 1784.*
	BURGDORFER, David	
DC	CHODOWIECKI, Daniel	
	COX, David	D.C. < PENCIL & WATERCOLOR
DDB	BLIECK, Daniel	·D·D·B·
DG	GARGIULO, Domenico	
	GHEYN, Jacques	
DH	DUNOUY, Alexandre	
	HALS, Dirck	
	HOPFER, Daniel	D.H <(INITIALS TAKEN FROM ETCHING)
DM	ANONYMOUS D M	D.M 1827
	MOSTAERT, Gillis	D 1559 M

| DPVTR | PUT(T)ER, Pieter | DⅤтᴿ F. | <(PD linked V T R is correct) |

DⅤт.ᴿ

| DR | RYCKAERT, David | Δ.R. |

| DT | TENIERS, David | D.T. Dᴛ D.T |

| DV | DENON, Vivant | Dⅴ. |

| | FELAERT, Dirk | 1544 D☆V | <(initials from etching with engraving) |

| | VLIEGER, Simon | DV |

| DVB | VINCKBOONS, David | DⅤB 1606 |

| DVH | HEIL, Daniel | D.V.H. |

| | VERHAERT, Dirck | DVH |

| DVL | LISSE, Dirck | ·D· |

| DW | WATERLOO, Denis | D W |

	WILKIE, David	D. W.
E	ECKERSBERG, Christoffer	1812. E E E. 72. E_1838
	LAMI, Eugene	E. 1836. < FROM PEN & BLACK INK & WATERCOLOR
EC	COLLIER, Evert	EC E
ED	DELACROIX, F. V. Eugene	E.D L.D. E.D
EHK	HEEMSKER(C)K, Egbert, Sr.	EHK
	HEEMSKER(C)K, Egbert, Jr.	E. HK
EHL	LENGERICH, Immanuel	H
EL	LAMI, Eugene	E.L 1881 <(from watercolor heightened with white) (from watercolor heightened with white) > E.L
EQMX	STANZIONE, Massimo	EMX. F.
ER	RIDINGER, Johann	ER ER ER 1757.

ES	MASTER E S	°ℓ°1°ℓ°6°1°S° (.e.1.4.6.7.s.)
		INITIALS & DATE FROM ENGRAVING
	STUVEN, Ernst	E.S.
EVV	VELDE, Esaias	E.V.V. 1630
EW	WACHTER, Georg	EW
F	FRYE, Thomas	F F
	FUGER, Friedrich	F
FB	BOL, Ferdinand	FB FB
FCJ	JANNECK, Franz	F.C.J.
FDB	DUBOURG, Louis	1740 F.D.B.
FF	FELLNER, Ferdinand	F
	FLORIS, Frans	FF F.
	FRANCKEN, Frans II	1608 FF
FG	GALET, Franz	FG.

	GUARDI, Francesco	*F.G.*
FH	HALS, Frans	
	HUYS, Frans	·F·H· (initials from etching with engraving)
FK	KERCKHOFF, Frans	*F.K.*
FL	LAURI, Filippo	**FL.**
FM	MACKENZIE, Frederick	*FM 1847*
	MANCADAN, Jacob	
FMEFDT	FABRITIUS DE TENGNAGEL, F.	F.E.F.d.T. 1827
FO	OVERBECK, Johann	
FS	STRINGER, Francis	*f.S 1763*
FSFF	FLORENTINE SCHOOL	·F·S·F·F· <(TEMPERA ON LINEN)
FV	VANNI, Francesco	<(from drawing of red, black & white chalk on blue paper)
FVS	SCHOOTEN, Floris	F.V.S. 1620

FW	WHEATLEY, Francis	<(initials from a watercolor over pencil)
	WOUTERS, Frans	
FXF	FABRE, Francois	
FZ	ZUCCARELLI, Francesco	< FROM DRAWING OF BLACK CHALK, PEN & BROWN INK, GREY WASH, HEIGHTENED WITH WHITE ON BEIGE PAPER.
	ZUCCARO, Federico	
G	GREVEDON, Henri	
GA	ASSERETO, Gioacchino	
	GENOELS, Abraham	
GB	BARRET, George	< FROM PENCIL & WATERCOLOR, HEIGHTENED WITH GUM ARABIC.
	BERCKHEYDE, Gerrit	<(initials from drawing of red chalk & grey wash)
GBP	PAGGI, Giovanni	<(initials from drawing of black chalk & brown wash)
GC	ITALIAN SCHOOL	<(initials from drawing of pen & brown ink over black chalk)
GD	DITTENBERGER, Johann	

GDH	HONDECOETER, Gillis	G·dH 1623	G·ⱰH· A1619	G·ⱰH: A1625
GDSA	SAINT-AUBIN, Gabriel	G·d·S·d· 1776	<(INITIALS FROM DRAWING OF BLACK CHALK, PEN AND GREY INK)	
GF	FLEGEL, Georg	Gf. GF.		
GFG	GRIMALDI, Giovanni	GFG		
GG	GELDORP, Goltzius	AⁿN° 1599 ·GG·F·	ŒG	
GH	HAYTER, George	ⱢH1820	FAH	
	HOTHAM, George	GH <(initials from drawing)		
GJ	JONES, George	GJ <(FROM DRAWING OF BLUE, BROWN & GREY WASH, SOME WHITE & SCRATCHING OUT)		
GK	KNELLER, Godfrey	GK		
GL	LAMBERTS, Gerrit	GdL (1815) <(signature from drawing: pencil, pen & brown ink,watercolor, brown ink framing lines)		
GM	FRENCH SCHOOL	GM G M		
	MELDER, Gerard	G M		
	MOSTAERT, Gillis	Gᴨ		

GP	POMPE, Gerrit	*GP*
GR	GRAHL, August	
	REICHMANN, Georg	
	RENI, Guido	*G.R*
GS	MONOGRAMMIST GS	G·S· ·1·5·4·7· <(from pen & brown ink drawing)
	SCHALKEN, Gottfried	G·S·f. <(initials in red chalk) (red chalk drawing)
GSW	SCHADOW, Johann	*GS—W*
GT	TOBIN, George	GT 1813. < SIGNATURE FROM WATERCOLOR GT 1814 < SIGNATURE FROM WATERCOLOR
GV	VINCENT, George	G 1827
GVW	WITTEL, Gaspar	G:V:W:
H	AVERCAMP, Henrik	H
	HARDING, James	·H·

	HILLIARD, Nicholas	$\mathcal{H}.$
	HOGARTH, William	$\mathcal{H}.$
HA	AVERCAMP, Hendrik	
HAF	HIRSCHVOGEL, Augustin	MONOGRAM FROM ETCHING F IN MONOGRAM IS FOR FECIT
HB	BLOCKHAUWER, Harmen	
	BLOEMAERT, Hendrick	
	BOCK, Hans	
	BOGAERT, Hendrik	
	BOL, Hans	
	BROSMAER, Hans	
	HENSTERBURGH, Herman	
	HOEFEL, Blasius	
HC	COSTER, Hendrick	

HF	FRANCKEN, Hieronymus	*HF* <(initials in brown ink on gouache)
		HF:
HG	GOLTZIUS, Hendrick	*HGI* < (from engraving) *HG*
	GREVEDON, Henri	*"h=G*
HGB	BALDUNG GRIEN, Hans	*HGB* <(signature from drawing)
		1520
HH	HOFFMANN, Hans	*Hh* <(signature from watercolor on vellum)
		1578
	HONDIUS, Hendrick	*Hh.1642*
	HONE, Horace	*HH 1777* (INITIALS FROM MINIATURE PORTRAIT)
HHB	HENSTERBURGH, Herman	*(H:HB:fe =*
HHVW	WEYER, Hermann	*H.HV.W. ·1621·*
HK	HEEMSKERK, Egbert	*HK*
HL	LECOMTE, Hippolyte	*HL*

HLS	LAUTENSACK, Hans		MONOGRAM FROM ETCHING
		HSL 1553	
HM	MEYER, Hendrik de II	*H·M·1773*	< FROM DRAWING OF GREY WASH, HEIGHTENED WITH WHITE, ON BLUE PAPER.
HN	MASTER N H	*·H·N·*	INITIALS FROM WOODCUT
	NEERGAARD, Hermania	*HN 1866*	
HP	POT, Hendrick	*HP*	
HR	HEEMSKER(C)K, Egbert	*HR*	< LOOKS LIKE H R, REALLY IS H K
	RAMBERG, Johann	*HR*	
	RAVENSTEYN, Hubert	*HR*	
	ROBERT, Hubert	*H.R. :83* *HR* (1804)	
	ROTTENHAMMER, Hans	*HR.*	
HRBG	RAMBERG, Johann	*HR Bg*	
HS	SAFTLEVEN, Herman	*HS 1670*	<(black chalk, grey wash, ink framing lines)
		HS	<(MONOGRAM FROM DRAWING OF BLACK CHALK AND BROWN WASH)

HSB	BEHAM, Hans	I·SB [I·SB]	<(monograms from engravings, circa 1540)
HST	STURMER, Johann	[SH]	
HV	VERNET, Emile	H𝒱 Roma 1835 H𝒱	
HVR	RAVENSTEYN, Hubert	H·V·R	
HVS	STEENWYCK, Hendrik	H·V·S 1625	
	SWANEVELT, Herman	Hₛ₈	
HW	HEIMBACH, Wolfgang	H W 1642	
IA	AMMAN, Jost	I A 1556	<(signature & date in black ink)
		¬(pen & black ink on paper partly washed grey)	
		·IA· < MONOGRAMS FROM WOODCUTS >	[IA]
IAB	BEERSTRAATEN, Jan	IAB	
IB	BATTISTA, di Giovanni	I·B	< INITIALS FROM ENGRAVING
	BREDAEL, Joseph	I B	
	BRUEGHEL, Jan	I B	

IBF	FORNENBURGH, Jean	.B. F. <(From gouache on vellum)
ID	DASVELDT, Jan	ID <(initials from black chalk drawing)
IDG	GHEYN, Jacob	
IDP	PASSAVANT, Johann	
IH	HANTZSCH, Johann	I.H
	MONOGRAMMIST I H	iH. fecit
IKF	KOENIG, Johann	IK·F· 1618· THE F STANDS FOR Fecit
IL	LIEVENS, Jan	I·L·
IM	MOLENAER, Jan	I·M·
IMH	HAMBACH, Johann M.	
INS	SCHODLBERGER, Johann	
IP	PORCELLIS, Jan	IP <(initials from drawing of pen, brown ink & wash)
IPP	PANINI, Giovanni	J.P.P 1751

IR	ROTTENHAMMER, Hans	
IS	SCHNORR VON CAROLSFELD, Julius	
IVC	CAPPELLE, Jan	
IVDK	KERCKHOVE, Joseph	
IVE	ES, Jacob	
IVG	GOYEN, Jan	
IVH	HAENSBERGEN, Jan	
IZ	MONOGRAMMIST I Z	
	ZEEMAN, Joost	((from gouache)
JA	ASSELIJN, Jan	
JAB	BEERSTRAETEN, Jan	
JAK	KLEIN, Johann	
JAR	RAMBOUX, Johann	

JAS	SEDELMAYER, Joseph	
JAW	WINCK, Johann	\mathcal{IAW} $\mathcal{I.A.W.}$ 1801. $\mathcal{I.A.W.}$ < 1798
JB	BEERSTRAATEN, Jan	JB. < FROM DRAWING OF BLACK CHALK AND GREY WASH
	BERGLER, Joseph	B..
	BOUCHER, Jean	B <(monogram in red chalk from red chalk drawing) (1625)
	BRON(C)KHORST, Johannes	FROM WATERCOLOR AND GOUACHE > J.B. fe: J.B. < INITIALS FROM WATERCOLOR AND BODYCOLOR OVER BLACK CHALK FROM WATERCOLOR AND GOUACHE > .JB. fec:
	BUESEM, Jan	B
JBD	BEIJER, Jan	B B; ad viv: del: 1739. B)
JBH	HUET, Jean	J.BH (red chalk)
JCDS	DROOGSLOOT, Joost	J. B. 1646

JCF	FRISCH, Johann	
JCS	SEEKATZ, Johann	
JD	DOWNMAN, John	<(initials from drawing of pencil & black chalk)
	DUCK, Jacob	
	LEYSTER, Judith	
JDH	HARDING, James	
JDM	MOMPER, Joos	
JEHV	VERNET, Emile	<(INITIALS FROM WATERCOLOR)
JFH	HERRING, John	
JG	GRIFFIER, Jan	
JGW	WILLE, Johann	(black & white chalk drawing)
JH	HACKAERT, Jan	

	HOLLAND, James	HH <(initials from watercolor)	HH 1863
		4Hd 9H 1846	
	HORESMAN, Jan, Sr.	JH < FROM DRAWING OF BLACK CHALK, PEN AND BROWN INK	
JHB	HUCHTENBURGH, Jan	·JHB· JB	
JHR	RAMBERG, Johann	JR	
JJ	ISABEY, Jean	JJ	
JJB	BOISSIEU, Jean	A.1807 J:J:B:	
JJE	EECHKOUT, Jakob	JJE	
JL	LEEMANS, Johannes	JL	
	LIEVENS, Jan	J.L.	
	LINGELBACH, Johannes	JL	
JLA	AGASSE, Jacques	J.I.A.	
JLD	DAVID, Jacques		

JM	MANCADAN, Jacob	
	MATTENHEIMER, Theodor	
	MOLENAER, Jan	
	MORTIER, J.	< FROM DRAWING OF PEN, INK & WATERCOLOR ON PAPER WATER-MARKED 'WHATMAN 1822'.
JMD	DIONISY, Jan	
JMR	MOLENAER, Jan Miense	< JMR monogram. The R possibly could refer to the last letter in Molenaer.
JP	PASSINI, Johann	
	PEALE, James	
JR	ROTTENHAMMER, Hans	
JS	CARMICHAEL, James	
	SCHNORR VON CAROLSFELD, Julius	
	SEYMOUR, James	
	SMART I, John	

	STEEN, Jan	
	SUTTER, Joseph	
JSDEB	SARAZIN DE BELMONT, Loise	
JV	VANDERBANK, Johan	< FROM DRAWING OF PENCIL AND BROWN WASH.
	VERNET, Claude	
	VIEN, Joseph	
JVB	BREDAEL, Joseph	
JVC	CROOS, Jacob	(165?)
	KESSEL, Jan van III	
JVO	OOSTEN, Isaak	
	OSTADE, Isack	
JVOS	DUTCH SCHOOL	<(monogram from gouache)
JVR	RAVENSWAY, Jan	1831

	RUISDAEL, Jacob I.	
	RUYSDAEL, Jacob S.	
JVS	SON, Joris	
JVW	WALSCAPPELLE, Jacob	
JW	WARD, John	
	WINCK, Johann	
	WITHOOS, Johannes	
	WYNANTS, Jan	
JWA	ABBOTT, John	<(FROM PEN & INK DRAWING)
JWARD	WARD, James	
JWC	CARMICHAEL, John	
JWM	MEIL, Johann	
JWS	WARD, James	

JZ	ZOFFANY, Johann	
KDI	DUJARDIN, Karel	KDI.f.
KL	LUCKX, Christiaen	KL KL
KM	MANDER, Karl	KM 1596 <(MONOGRAM FROM DRAWING OF PEN, BROWN INK & WASH & BLACK CHALK) KM < FROM DRAWING OF PEN, BROWN INK, GREY WASH, HEIGHTENED WITH WHITE. KM 1594
L	LUCAS VAN LEYDEN	L L 1523 <(both monograms taken from engravings)
LA	ARLAUD-JURINE, Louis	<(initials from drawing of pen & ink & watercolor)
LB	BAKHUYZEN, Ludolfo	LB
	BOILLY, Louis	LB.
	BOULLONGNE, Louis	LB LB <(initials from drawing of black & white chalk on blue paper)
LC	CARLEVARIJS, Luca	L·C

	COCCORANTE, Leonardo	
	CRANACH, Lucas	
	CRUYL, Lieven	<(initials from drawing of black chalk, pen & black ink & brown wash on vellum)
LDV	VADDER, Lodewyk	L.D.V.
LF	FONTENAY, Louis	
LFDB	DUBOURG, Louis	LFDB
LG	GAUFFIER, Louis	
LH	LA HYRE, Laurent	LH. L.H.
LM	L'AINE, Louis	< BOTH INITIALS FROM DRAWING OF BODYCOLOR ON VELLUM.
	MOREAU, Louis	<(initials from gouache) < FROM WATERCOLOR AND GOUACHE
LP	LEPRINCE, Jean	

(from woodcut)

LC 1509

L.C.

LM 1784

L.M. 1796

LS	STRAUCH, Lorenz

AÑO: 1583.

LV	VOGEL, Georg

L.V.

LVL	LUCAS VAN LEYDEN

LVL

LVN	NOORT, Lambert

L·V·N
Inven:
·1555·

< INITIALS FROM DRAWING OF PEN, BROWN INK AND BLUE WASH

LVV	UDEN, Lucas

LVV

(L V U)

	VAL(C)KENBORCH, Lucas

L / V V 1592

1577.
L
VV

< TEMPERA ON PAPER MOUNTED ON PANEL

MA	RAIMONDI, Marcantonio

ΛA MONOGRAM FROM ENGRAVING

MAE	ELLENREIDER, Anna

MÆ

MAF	RAIMONDI, Marcantonio

ΛF MONOGRAM FROM ENGRAVING

F IN MONOGRAM IS FOR FECIT

MB	BLOEM, Matthys

MB:1663

MC	CATESBY, Mark

MC <(FROM FOLIO OF ETCHED PLATES OF WILD LIFE)

	BLOMMAERDT, Maximilian

M.B.

| MDV | VOS, Maerten | ·M·D·V· 1593 | <(INITIALS FROM DRAWING OF BLACK CHALK, PEN, BROWN INK, AND BROWN WASH) |

| ME | ELLENREIDER, Anna | ME. |

| MH | HEEMSKERCK, Maarten | A |

| MI | MITELLI, Guiseppe | MI TE FE. 1707 |

| ML | LAROON, Marcellus | M.L. Fe. | <(signature from drawing of pen & brown ink) |

| MO | MURILLO, Bartolome | MO | <(FROM DRAWING OF BLACK CHALK, PEN & BROWN INK, & BROWN WASH) |

| | OSTENDORFER, Michel | MO | <(ATTRIBUTED) (FROM DRAWING OF BLACK, WHITE & RED CHALK) |

| MP | PAGANI, Matteo | MP |

| | PEALE, Margaretta | M.P. |

| MR | MOLENAER, Jan | MR |

| | RYCKAERT, Marten | MR 1622 |

| MS | SCHNITZLER, J. | MS M |

| | SCHONGAUER, Martin | M✝S | <(from engraving, circa 1480-90) |

	SIMONS, Michiel	*M.S.*
	SORGH, Hendrik	MS 1642 <(initials from black chalk drawing)
MVV	VALKENBORCH, Martin	
N	NOLPE, Pieter	N
NB	BEATRIZET, Nicolaus	·NB· < MONOGRAM FROM ENGRAVING
	BERCHEM, Nicolas	NB
NC	CASISSA, Nicolo	
NCM	GERMAN SCHOOL	NCM 1733
NH	MASTER N H	·N·H· INITIALS FROM WOODCUT
NM	MELDEMANN, Nicolaus	NM INITIALS FROM WOODCUT
NOVB	BLOEMEN, Norbert	NO.V.B
NV	VLEUGHELS, Nicolas	N.V. 1722
OB	BEERT, Osias	B·

OCT	TASSAERT, Nicolas	<(INITIALS FROM DRAWING)
OM	OPPENHEIM, Moritz	
OPD	OPPENORD, Gilles	<(O P D SIGNATURE FROM DRAWING OF BLACK CHALK, PEN & BLACK INK, WITH GREY & PALE PURPLE WASH WITH WHITE)
PA	PAJOU, Augustin	<(from drawing of black & red chalk)
PAW	WILLE, Pierre A.	<(initials from watercolor heightened with gouache)
PB	BATONI, Pompeo	
	BINOIT, Peter	
PC	CLAESZ, Pieter	
	CODDE, Pieter	
	COOPSE, Pieter	
	CROOS, Pieter	

PCW	WONDER, Pieter	P.C.W.F
PDB	BLOOT, Pieter	PDB
PDG	GREBBER, Pieter	P. DG
PDH	HOOCH, Pieter	P·DH· 1653 P·D·H· 1658
PGW	WESTENBERG, Pieter	P.G.W.
PH	HESS, Peter	PH.
PHB	MONOGRAMMIST P H B	PB 1652
PHW	WOUWERMANS, Philips	PW
PK	KRAFFT, Johann	PK
PL	LASTMAN, Pieter	P
PM	MOLYN, Pieter	M
	MOREELSE, Paulus	M. 1636
PN	NASMYTH, Patrick	P.N.

	NAVARRA, Pietro	
	NEEFFS, Pieter	P. N.
	NOLPE, Pieter	PV AV
PP	PAOLINI, Pietro	P. P.
	PERRET, Pieter	P. P. f. 1643.
PPL	PAOLINI, Pietro	
PPP	PAOLINI, Pietro	
PQ	QUAST, Pieter	<(from drawing of black lead on vellum) 1646
PR	REVOIL, Pieere	·JR· <(MONOGRAM FROM DRAWING) P. R. 1826. <(MONOGRAM FROM DRAWING)
PS	SANDBY, Paul	PS <(initials from watercolor & pencil) PS
	SCHOTANUS, Petrus	P. S.
PSV	VIET, Philippe	

PVA	ASCH, Pieter	
PVB	BLOEMEN, Pieter	
	BOUCLE, Pierre	
	MONOGRAMMIST P. v. B.	
	VERBEECK, Pieter	
PVH	HAMILTON, Philip	
PVO	OVERSCHEE, Pieter	
PVV	VELDE, Pieter	
PW	WITHOOS, Pieter	< FROM DRAWING OF PEN, BROWN INK AND WATERCOLOR
	WOUWERMAN, Philips	
	WOUWERMAN, Pieter	
QB	BREKELENKAM, Quiryn	

QVB	BREKELENKAM, Quiryn	QvB 1652
R	REHBENITZ, Theodor	·R·
RE	EARLOM, Richard	RE
RF	ROBERT-FLEURY, Joseph	R.F.
RFY	ROBERT-FLEURY, Joseph	R.f.y.
RH	HATHAWAY, Rufus	RH
	HAVELL, Robert	R.H.
RL	REMBRANDT	RL RL RL.f.
RP	PEALE, Rembrandt	R.P. 1826
RS	SALMON, Robert	RS RS
RT	TROYEN, Rombout	RT feci— < INITIALS IN RED CHALK, DRAWING IN BLACK CHALK HEIGHTENED WITH WHITE, BUFF PAPER
RW	WESTALL, Richard	RW
	WILSON, Richard	R. W. F. RW R.W. (Roma 1754)

SA	SAINT AUBIN, Augustus	
SDV	VLIEGER, Simon	
SHPAB	RIBERA, Josef	<(both of these monograms were in the same engraving, spaced as shown, circa 1621)
SP	PEALE, Sarah	
	PROUT, Samuel	< FROM WATERCOLOR
SR	ROSA, Salvator	
ST	STIMMER, Tobias	<(FROM DRAWING OF PEN AND BLACK AND BROWN INK)
STO	STOOTER, Cornelis	
SV	VRANCX, Sebastiaen	
SVH	HOOGSTRAATEN, Samuel	
SVM	MEULEN, Sieuwert	

SVR	RUYSDAEL, Solomon	SvR
SW	SWEBACH(-DESFONTAINES), Jacques	Sw
TB	BUTTERSWORTH, Thomas	TBpint
	TIBORCH, Gillis	T.B. TB.
TDK	KEYSER, Thomas	TX 1637
TE	ENDER, Thomas	TE
TF	FRYE, Thomas	TF T.F.
TG	GAINSBOROUGH, Thomas	TG. <(initials from pencil drawing)
THM	HEEREMANS, Thomas	THn (1680)
TJ	JONES, Thomas	TJ1777 <(initials from watercolor over pencil)
TL	LAWRENCE, Thomas	TL. TL april 1819 ^(FROM DRAWING OF PENCIL, RED & BLACK CHALK)
TLR	ROWBOTHAM, Thomas	TL.R 1834 < FROM PENCIL AND WATERCOLOR, SCRATCHING OUT AND TOUCHES OF GUM ARABIC.
TM	MATTENHEIMER, Theodor	J.M.

	TRAUTMANN, Johann	TM	
TP	PATCH, Thomas	P. 1768	<(MONOGRAM FROM ETCHING)
	PEALE, Titian	TP	<(initials from pencil drawing)
TR	REALFONSO, Tommaso	T. R.	
TRP	PEALE, Titian	TRP	<(initials from watercolor)
TS	SPENCER, Thomas	TS. 1751—	
	SULLY, Thomas	TS 1837 TS	
TVC	GERMAN SCHOOL	TVC. fecit Roma 1807	
WT	WEBSTER, Thomas	18 WT 40 WT WT	
	WHITCOMBE, Thomas	T.W. 1785	
	WYCK, Thomas	Tw	
VB	VERBEECK, Pieter	VB	
VBL	RHINE SCHOOL	VB	<(FROM DRAWING OF BLACK CHALK, PEN AND BLACK INK AND GREY WASH)

VBVF	FORNENBURGH, Jan	
VD	VERDUSSEN, Jan	
VDL	VINNE, Vincent	(1684)
VG	GOYEN, Jan	
VGO	CARPI, Ugo	FROM WOODCUT (UGO)
VHDK	HEIDECK, Carl	
VR	REGEMORTER, Ignatius	
W	WECHLEN, Hans	

NOTE: BOTH MONOGRAMS WERE FROM THE SAME PAINTING. THE FIRST MONOGRAM WAS THE BOTTOM OF THE OTHER, WHICH HAS AN H V AT THE TOP. THIS H V & THE VERTICAL LINE IS EITHER PART OF THE MONOGRAM OR PART OF THE LINES OF THE BARK OF THE TREE WHERE THE MONOGRAM WAS PLACED.

	WOUWERMAN, Philips	
WA	ALEXANDER, William	<(initials from watercolor over pencil, heightened with body-color)
	ANDERSON, William	1802

WB	BROMLEY, William	*WB*
WC	CONSTABLE, William	*W.C.1807*
WD	DEVRIENT, Wilhelm	*WD*
	DUYSTER, Willem	*WD* *WD*
WDP	POORTER, Willem	*W.D.P. 1640*
WH	HENSEL, Wilhelm	*HwH* *W*
	HOGARTH, William	*W H*
	HOWITT, William	*HWH*
WK	KNYFF, Wouter	*WK* *WK 1641*
	KOOL, Willem	*WK*
WM	MULREADY, William	*W*
WMC	CONSTABLE, William	*W.M.C. 1806.* <(initials from drawing of pen & ink, grey wash & watercolor)
WP	PRINSEP, William	**WP** (Feb. 1858) INITIALS FROM PENCIL & WATERCOLOR

WR	ROMEYN, Willem	W. R.
WS	SARTORIUS, Willem	WS
	SCHADOW, Friedrich	W
WT	TURNER, Joseph	
	TWOPENNY, William	W.T.
WVV	VELDE, Willem	WVV 3W. 3. 3. J

(from drawing: black
lead & grey wash)

| XF | FABRE, Francois X. | X. F. |
| Z | HEIM, Francois | (looks like a Z, really is an H) |

SYMBOLS

ARLAUD-JURINE, Louis

< initials from drawing of
pen & ink & watercolor

BEYEREN, Abraham

< ATTRIBUTED SYMBOL/MONO

BLES, Henri

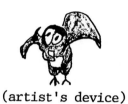

<(OWL)>

(artist's device) (artist's device)

BRIL, Paul

<(artist's device signature, a pair
of spectacles on a shop sign)

CRANACH, Lucas

1550

DURER, Albrecht

< THIS IS A SIMPLIFIED VERSION
OF A SCALLOP-SHELL SYMBOL USED
BY DURER; FROM PAINTING OF ST.
JAMES IN THE UFFIZI GALLERY.

FONTENAY, Louis

**GEYMULLER,
(Baron) H. von,
collector**

< THIS SYMBOL STAMPED ON OLD MASTER
WORKS IS FROM THE COLLECTION OF
BARON H. von GEYMÜLLER.

(THIS IS THE ONLY REFERENCE TO GEYMULLER IN
THIS BOOK)

HAARLEM, Cornelis

LANDSEER, Charles

1854

MARREL, Jacob

MEXICAN SCHOOL

MORLAND, Henry

<(MONOGRAM FROM PASTEL)

SCHNORR VON CAROLSFELD, Julius

<(FOX'S HEAD SIGNATURE FROM DRAWING
OF BROWN INK & PENCIL -- 1826)

SCHUZ, Christian

(device)> (fecit)

1748

VINCKBOONS, David

ALTERNATE NAME CROSS-REFERENCES

ALIGNY	see	CARUELLE d'ALIGNY
ANGELIS or ANGELLESI	see	ANGILLIS
ANTOLN	see	ANTOLINEZ
ARTVELT	see	EERTVELT
ASSELYN	see	ASSELIJN
BA	see	BACKHUYSEN
BAANE	see	BAEN
BACIGALUPO	see	BACCIGALUPPO
BACK, L	see	BAKHUYZEN, L.
BADENS	see	BAEDENS
BAGLIONVS, Ioannes	see	BAGLIONE, Giovanni
BAILLY	see	BALLY
BAK	see	BACKHUYZEN
BAKH	see	BACKHUYZEN
BANCK	see	VANDERBANK
BAPTISTE	see	MONNOYER
BARBIERI	see	GUERCINO
BATT[a].Yan..	see	FORNENBURGH, Jean
BAUR	see	BAUER
BEERSTRAT	see	BEERSTRAATEN
BEGA	see	BEGEYN
BEMEL, C. V.	see	BEMMEL, Johann C.
BEMEL, P. V.	see	BEMMEL, Pieter van
BERGHEM	see	BERCHEM
BETEL	see	PETEL
BEYER, De	see	BEIJER, Jan de
BIJLERT	see	BYLERT

BISCHOP	see	BIS(S)CHOP
BISOLUS	see	BISSOLO
BLOMMAERT	see	BLOEMAERT
BOGERT	see	BOGAERT
BOOM	see	VERBOOM
BOUCK	see	BOUCLE
BOULENGIER	see	BOLLONGIER
BRAKENBURG	see	BRACKENBURGH
BREDA	see	BREDAEL
BREENBORCH	see	BREENBERGH
BREUGHEL, A.	see	BRUEGHEL, A.
BRUGHEL	see	BRUEGHEL
BRUNAIS	see	BRUNIAS
BUSSCHOP	see	BISSCHOP
CAFISSA	see	CASISSA
CALIARI	see	VERONESE
CALRAET	see	KALRAET
CANINUS, Io Anglo	see	CANINI, Giovanni
CAPELLE	see	CAPPELLE
CARACIO	see	CARRACCI
CAROLIS	see	JACOPO DE CAROLIS
CASA	see	CASSA
CASSISSA	see	CASISSA
CHAMPMARTIN	see	CALLANDE
CHAUDET, E.	see	HUSSON, Jeanne
CHWATAL	see	QUADAL
CLAUDIO or CLAUDIUS	see	LORRAINE

COLYER	see	COLLIER
CORNELISZ	see	HAARLEM
COSTER	see	VALLEYER-COSTER
COUSYN	see	COSYNS
CRISPINOV	see	BROECK, Crispin
DAGOMMER	see	DAGOMER
DALENS	see	DELEN
D'ANVILLE	see	GRAVELOT
DEELEN	see	DELEN
DELLA CASA, N.	see	CASA, Niccolo
DENEYN	see	NEYN
DIEZSCH	see	DIETZSCH
DROOCHSLOOT	see	DROOGSLOOT
DUSAERT	see	DUSART
EPISCOPIUS	see	BIS(S)CHOP
Fdez	see	FERNANDEZ
F FRANCK, D	see	FRANCKEN, Frans III
FLAMAND	see	FLAMEN
FONTENAY	see	BLIN DE FONTENAY
FRAGO	see	FRAGONARD
FRANK	see	FRANCKEN, Frans II
GAAL, B.	see	GAEL, Barendt
GELLEE	see	LORRAINE
GEYN	see	GHEYN
GOIEN, I. V.	see	GOYEN, Jan van
GOLTIUS	see	GOLTZIUS
GOLTZ	see	GOLTZIUS

GRAVE	see	GRAAF
GRECO	see	THEOTOKOULOS
GRIMER, A.	see	GRIMMER, Abel
HAAS	see	HAS
HARD, P.	see	HARDIME
HASBROCK, G.	see	HAASBROEK, G.
HIEPES	see	YEPES
HILL(I)YARDE	see	HILLIARD
HIRE	see	LA HYRE
HOFEL	see	HOEFEL
HUEBNER	see	HUBNER
HUIJSUM, Jan van	see	HUYSUM, Jan van
IEGOROF	see	EGOROV
ISRAHEL, v M.	see	MECHENEM, I.
JARDIN, Karel du	see	DUJARDIN, Karel
JEGOROFF	see	EGOROV
JONGE	see	MARTSZEN
JONSON	see	CEULEN
JORAS	see	JEAURAT
JORDANUS	see	GIORDANO
KABEL	see	CABEL
KERCK, E. H.	see	HEEMSKERK, E.
KERKHOVE	see	KERCKHOVE
KINSOEN	see	KINSON
KONIG	see	KOENIG
KRUSSENS	see	CRUSSENS
LA HIRE	see	LA HYRE

LESCOT, H.	see	HAUDEBOURT, A. H.
LEYDEN	see	LUCAS VAN LEYDEN
LOON	see	LOO
LUNDE	see	LUNDENS
LUYKX	see	LUYCKX
MAES	see	MAAS
MAIR	see	LANDSHUTT
MALET	see	MALLET
MAN, H	see	HEEREMANS
MAN, I (or J) S	see	MANCADAN, J. S.
MANS, T or TH	see	HEEREMANS
MARCHONI	see	MARCONI
MARIA C.	see	COSWAY, Maria
MARI^is	see	MARESCALCHI
MARRELLUS	see	MARREL
MARTOZEN	see	MARTSZEN
MATTHAM	see	MATHAM
MAZOLII	see	MAZZOLINO, L.
MELENDEZ	see	MENENDEZ
MIN, Gio De	see	DEMIN, Giovanni
MOLIJN	see	MOLYN
MURER	see	MAURER
NEEDHAM	see	NEDHAM
NEFS	see	NEEFFS
NEGRETTI	see	PALMA, Jacopo
NICKELE	see	TROOST-NIKKELEN
NICOLETI or NICOLETTO	see	ROSEX

NIKKELEN	see	TROOST-NIKKELEN
NINO	see	GUEVARA
NYMEGEN	see	NIJMEGEN
NYTS	see	NEYTS
OOSTFRIES	see	OOSTVRIES
OPIZ	see	OPITZ
OPPNOR	see	OPPENORD
OUTS	see	OETS
PARIS, B.	see	BORDONE
PENNEE, Edw.	see	PENNY, Edward
PETLE	see	PETEL
PESARO	see	CANTARINI
PETRI	see	PIETRI
PLAZER	see	PLATZER
POELENBORCH	see	POELENBURGH
PRINCE	see	LEPRINCE
QUIERYN	see	BREKELE(N)KAM
RAMEDIUS	see	REGNIER
RENIERI	see	REGNIER
RIEDINGER	see	RIDINGER
RIETS	see	RIETSCHOOF
RIJCKHALS	see	RYCKHALS
RIJN	see	REMBRANDT
ROBUSTI	see	TINTORETTO
ROMBAOUTS	see	ROMBOUTS
ROP.	see	RUOPPOLO
ROSA	see	ROOS

ROSA or ROSSI	see	ROSEX
RUE	see	LA RUE
RYCKE or RYCKERE	see	RIJKERE
RYKAERT	see	RYCKAERT
SACHTLEVEN	see	SAFTLEVEN
SANCHEZ Y COTAN	see	COTAN
SCHALKEN	see	SCHALCKEN
SCHUTZ	see	SCHUZ
SEGNA	see	ROSEX
SLOOT	see	DROOGSLOOT
SCHMUTZER	see	SCHMUZER
SODOMA or SODON	see	BAZZI, Giovanni
SPRONCK	see	VERSPRONCK
STARRENBERG	see	STERENBERG
STEVAERTS	see	PALAMEDESZ.
STO	see	STOOTER, Cornelis
STRADA	see	STRAET
STRADANUS	see	STRAET
STUERMER	see	STURMER
TAIL. n.	see	TAILLASSON
TENCY, Johannes B. J.	see	TENCY, Jean Baptiste
TER HIMPEL	see	HIMPEL
THYRY, W.	see	THIERRY, Wilhelm
TOVAR	see	TOBAR
TROIJEN	see	TROYEN
TYNAGEL	see	TENGNAGEL
UGO	see	CARPI

VANDAEL	see	DAEL
VANDERHAMEN Y LEON	see	HAMEN Y LEON
VANLOO	see	LOO
VELLERT	see	FELAERT
VENEZIANO	see	MUS(S)I
VEREYK	see	VERRYCK
VERMEER VAN HAARLEM	see	MEER, Jan
VERONENS, Alexander	see	TURCHI, Alessandro
VERRIJK	see	VERRYCK
VERRYK	see	VERRYCK
VICUS	see	VICO
VIGHI	see	VICO
VLIET, J. T.	see	TOORENVLIET
WAAL	see	WAEL
WIJCK	see	WYCK
WITEL	see	WITTEL
WOROBIEFF	see	VOROB'EV
WTEWAEL	see	UYTEWAEL
WTRECHT	see	UTRECHT
WYKE	see	WYCK
YERRERA	see	HERRERA
ZEEMAN	see	NOOMS
ZUCHERI	see	ZUCCARO

SUPPLEMENTAL SECTION WITH ADDITIONAL INITIAL & MONOGRAM INFORMATION

All the alphabet information on the initials and monograms in this section has been gleaned from auction catalogues; the visual information for these signatures was not available to reproduce. Since such information, signature facsimiles or not, is an indispensable additional research source, prudence compels me to include this important information.

This section is arranged in alphabetical order according to the initials and monograms, and each entry is noted as to being initials or a monogram.....they are typed in upper and lower case as the information in the catalogues informed me. Initials with periods are obviously initials, and need not be noted as such.

A B monogram	BENSON, Ambrosius Flemish c.1494–1550
A. C.	CALRAET, Abraham van Dutch 1642–1722
A C monogram	KAUFFMAN, Angelica Swiss 1740–1807
A D initials	WILLAERTS, Adam Dutch 1577–1666
A G monogram	GEDDES, Andrew Scot/English 1783–1844
A K initials	KAUFFMAN, Angelica Swiss 1740–1807
A L initials	LEYDERDORP, Andries Dutch 1789–1854
A. S.	SCHELFHOUT, Andreas Dutch 1787–1870
A V monogram & initials	VACCARO, Andrea Italian 1598?–1670
A V initials	VERSTRALEN, Antoni Dutch c.1594–1641
A V D monogram	DIEST, Adriaen van Dutch 1655–1704
A V K monogram	KABEL or CABEL, Adriaen van der Dutch 1630–1705
A W monogram & initials	WOLFAERTS, Artus Flemish 1581–1641

B H monogram	BLANCKERHOFF, Jan Theunisz. Dutch 1628-1669
C A monogram	ALIGNY, Claude Felix T. French 1798-1871
C A initials	AMBERGER, Christoph German 1500-1562
C A D monogram	GABBIANI, Antonio Domenico Italian 1652-1726
C B initials	CRAESBEECK, Joos van Flemish c.1606-1654/61
C C W initials	WIERINGEN, Cornelis Claesz. van Dutch c.1580-1633
C E B initials	BISET, Charles Emmanuel Belgian 1633-after 1686
C F initials & monogram	FUES, Christian German 1772-1836
C. F. R.	LISZEWSKI, Christian F. R. German 1725-1794
C L S initials	SCOTT, (Lady) Carline L. English 1784-1857
C M initials	MOEYAERT, Claes Cornelisz. Dutch 1592-1655
C. N. Fe	NETSCHER, Caspar Dutch 1639-1684
C P linked	PEETERS, Clara Flemish c.1585-before 1657

C P M initials	MOOY, Cornelis Pietersz. Dutch c. 1656-1693
C R monogram	RIETSCHOOF, Jan Claes Dutch 1652-1719
C S monogram & initials	SCHUT, Cornelis Flemish 1597-1655
C. V. N.	NOORDE, Cornelis van Dutch 1731-1795
C W initials	WIERINGEN, Cornelis Claesz. van Dutch c. 1580-1633
D	DENIS, Simon Joseph Flemish 1755-1813
De La initials	LACROIX, Charles Francois French 1720-1782
D J monogram	DAULLE, Jean French 1703-1763
D K initials	KUYPERS, Dirk Dutch 1733-1796
D L initials	LOGGAN, David German/English 1635-1692
Do. P.	PIOLA, Domenico Italian 1628-1703
D V initials	VERHAERT, Dirk Dutch c. 1631-after 1664
D V B initials	VERBURGH, Dionijs Dutch 1655-1722

D V F initials	VERTANGEN, Daniel Dutch c.1598-after 1684
D V L monogram & initials	LISSE, Dirck van der Dutch c.1600-1669
E Q initials	QUELLINUS, Erasmus Dutch 1607-1678
E. Wms.	WILLIAMS, Edward English 1782-1855
F D M initials	MOMPER, Frans de Dutch 1603-1660
F F initials	FOSCHI, Francesco Italian c.1745-1805
F G initials	GIUNTOTARDO, Filippo Italian 1768-1831
F. M. E. F. T.	FABRITIUS DE TENGNAGEL, F. M. E. Danish 1781-1849
F O monogram	FIALETTI, Odoardo Italian 1573-1638
f. s.	SANTEFEDE, Fabrizio Italian c.1559-1623
F. S.	SCHOOTEN, Floris van Dutch c.1605-1655
Fs Hu initials	HUE, Jean Francois French 1751-1823
F Q monogram	QUESNEL, Francois French 1543-1619

F Z h l initials	ZEHELEIN, Friedrich Swiss? 1760-1802
G B C initials	CAMPION, George Bryant English 1796-1870
G C initials	CARPIONI, Guilio Italian 1612-1679
G. D E H initials	HONDECOETER, Gillis Claessz. de Dutch 1570-1638
G D H initials	HONDECOETER, Gysbert Gillesz. de Dutch 1604-1653
G D I initials	DIEST, Willem van Dutch 1610-1663
G. G. fi initials	GANDOLFI, Gaetano Italian 1734-1802
G K monogram	KNELLER, Sir Godfrey German/English 1646/49-1723
G N initials	NOGARI, Giuseppe Italian 1699-1763
G P initials	PEETERS, Gillis Flemish 1612-1653
G S p initials	SPAENDONCK, Gerard van French 1746-1822
g v d initials	DEYNUM, Guilliam van Dutch ac. mid 17c.
G Y initials	YATES, Gideon English ac. 1790-1840

H B linked & initials	BOLLONGIER, Hans Dutch c.1600–after 1642
H B monogram	BORCHT, Hendrik van der, Sr. Dutch 1583–1660
H D monogram	DUBORDIEU, Pieter Flemish 1609–1678
H E monogram	HEERE, Lucas Flemish 1634–1584
H h initials	HOFFMANN, Hans German 1545–1600
H: I: B: V D N:	NIEUWENHUYSEN, Henri Joseph B. Dutch 1756–1817
H K monogram	HEEMSKERCK, Sebastiaen Dutch ac.1691–died 1748
H M initials	MAURER, Hubert German 1738–1818
H S K monogram	SPRINGINKLEE, Hans German –1540
H T initials	TARAVAL, Hugues French 1729–1785
H T B initials	TERBRUGGHEN, Hendrick Dutch 1588–1629
H. V.	VLIET, Hendrick Cornelisz. van Dutch 1611/12–1675
I C initials	CAMPHUYSEN, Jochem Govertz. Dutch 1602–1659

I D H initials	HEEM, Jan Jansz. de Dutch 1650-1695
I G L initials	LOEFF, Jacob Gerritz Dutch 1607-1648
I H initials	HULSWIT, Jan Dutch 1766-1822
I L initials	LUYKEN, Jan Dutch 1649-1712
I. V G (V G in monogram)	MONOGRAMMIST JvC mid 17th century
I V H initials	HAANSBERGEN, Jacob van Dutch 1641-1705
I W B (W B in monogram)	BAUR, Johann Wilhelm German 1600-1640
I Z initials	ZAIS, Guiseppe Italian 1709-1784
J. B.	BERTAUX, Jacques French? ac. late 18c.
J B monogram	BEUCKELAER, Joachim Dutch c.1530-1573
J G initials	GREENWOOD, John American 1727-1792
J H P monogram	PRINS, Johannes Huibert Dutch 1757-1806
J M monogram & initials	MAJOR, Isaac German 1576-1630

J M monogram	MARREL, Jacob Dutch 1613/14-1681
J N initials	NAVEZ, Francois Joseph Belgian 1787-1869
J N initials	NIXON, John English c.1750-1818
J P initials	PETERSEN, Jacob Danish 1774-1854
J P initials	PILLEMENT, Jean French 1727-1808
J P initials	PORCELLIS, Julius Dutch c.1609-1645
J R A initials	RAVENSTEYN, Jan Anthonisz. van Dutch c.1570-1657
J R W initials	WALKER, John Rawson English 1796-1873
J T initials	TAYLOR, John (of Bath) English 1735-1806
Jv Do initials	DOES, Jacob van der Dutch 1623-1673
J V O initials	OOSTEN, Isaak van Dutch 1613-1661
J W initials	WYCK, Jan Dutch c.1640-1700
J Z monogram	ZAIS, Giuseppe German 1709-1784

K M initials	MOLENAER, Klaes Dutch c.1630-1676
L initial	LINGELBACH, Johannes German/Dutch 1622-1674
L. A.	ACHTSCHELLINCK, Lucas Flemish 1626-1699
L B initials	BACKHUYZEN, Ludolf Dutch 1631-1708
L B initials	BAUGIN, Lubin French c.1612-1633
L C monogram	CRUYL, Lieven Belgian 1640-1720
L. G.	GRAMICCIA, Lorenzo Italian 1702-1795
L O K initials	KRUG, Ludwig German 1489-1532
L V initials	VASLET, Lewis English 1742-1808
L V S initials	VERCHUIR, Lieve Dutch c.1630-1686
M D monogram	MONTEN, H. M. Dietrich German 1799-1843
M D H initials	MINDERHOUT, Hendrick van Dutch 1632-1696
M F monogram	FREMINET, Martin French 1567-1619

M M initials	MADDERSTEG, Michiel Dutch 1659-1709
M R initials	ROSSELLI, Matteo Italian 1578-1650
M S initials	SCHLIER, Michael German 1744-1807
M V monogram	UYTTENBROECK, Moses van Dutch c.1590-1648
N A initials	AB(B)ATE, Niccolo Italian 1509-1571
N E P initials	ELIAS, Nicolaes (PICKENOY) Dutch c.1590-c.1655
N P initials	POCOCK, Nicholas English 1740-1821
N V initials	VACCARO, Nicola Italian 1637-1717
O F monogram	FIALETTI, Odoardo Italian 1573-1638
O G R initials	REINAGLE Miss O. G. English ac.1824-1832
O M initials	MARINARI, Onorio Italian 1627-1715
P initial	POELENBURGH, Cornelis van Dutch 1586-1667
P A monogram	ASCH, Pieter Jansz van Dutch 1603-1678

P B monogram	BRIL, Paul Flemish 1554-1626
P C linked	CODDE, Pieter Dutch 1599-1678
P C V E compendium	EGMONT, Pieter Cornelisz. van Flemish 1615-1663
P F F initials	FONTAINE, Pierre Francois L. French 1762-1853
P H B monogram	BRINCKMANN, Philip H. German 1709-1761
P I monogram	JUVENEL, Paul German 1579-1643
P M monogram	MATTEIS, Paolo de Italian 1662-1728
P M initials	MEULENER, Pieter Dutch 1602-1654
P M monogram	MOLIJN, Pieter de Dutch 1595-1661
P M linked & initials	MULIER, Pieter I. Dutch 1615-1670
P M monogram	MULIER, Pieter (called TEMPESTA) Dutch c.1637-1701
P P initials	POU BUS, Pieter Flemish 1510-1584
P T initials	MULIER, Pieter (called TEMPESTA) Dutch c.1637-1701

P. V. D.	DAPELS, Philippe van Flemish ac. 1654–after 1659
P V O initials	NEOPOLITAN SCHOOL 17th century
P V R monogram	RUIJVEN, Pieter Jansz van Dutch 1651–1716
P V V initials	VELDE, Pieter van der Dutch 1634–c. 1687
R B initials	ROMBOUTS, Solomon Dutch ac. 1652–before 1702
R R initials	RUYSCH, Rachel Dutch 1664–1750
R V monogram & initials	RAPHAEL, Sanzio Italian 1483–1520
S A initials	ANGELL, Samuel French 1800–1866
S D initials	DAVIS, Samuel English 1757–1819
S HK (HK in monogram)	HEEMSKERCK, Sebastiaen Dutch ac. 1691–died 1748
S M initials	MOLET, Salvador Spanish 1773–1836
S R initials	RAVEN, Samuel English 1775–1847
S R initials	ROMBOUTS, Salomon Dutch ac1652–before 1702

T. G.	GELTON, Toussaint Danish? c. 1630-1680
T H initials	HICKEY, Thomas Irish 1741-1824
T. T.	TURPIN de CRISSE, Lancelot T. French 1782-1859
T V R (V R in monogram)	VERRYCK, Dirk Dutch 1734-1786
V T H monogram	VERHAECHT, Tobias Flemish 1561-1631
V V V initials	VINNE, Laurens Vincentz van der Dutch 1658-1729
W initial	WET, Jacob Willemsz. de Dutch c. 1610-1675
W B monogram	BAILLIE, William English 1723-1792
W H initials	HUBER, Wolfgang German 1490-1553
W. P.	PRINSEP, William English 1794-1874
W T initials	TURNER, William English 1789-1862
W V initials	VITRINGA, Wigerus Dutch 1657-1721
W W monogram	WITHERINGTON, William F. English 1785-1875

SUPPLEMENTAL SECTION WITH ADDITIONAL ALTERNATE SIGNATURE NAMES INFORMATION

All the alternate signature names information in this section has been gleaned from auction catalogues; the visual information for producing signature facsimiles was not available to me. Since such information, signature facsimiles or not, is an indispensable additional research source, prudence compels me to include this important information.

Considering the oddness of some of the signature spellings, I have tried my best to place them in alphabetical order. The signature information is typed in upper and lower case as the information in the catalogues informed me.

And Anc.	LILIO, Andrea called Andrea of Ancona Italian 1555-1610
Andres de Arragon	ARAGON, Andres de Spanish 18th century
P. Angellis	ANGILLIS, Pierre Dutch 1685-1734
Laz Bal	BALDI, Lazzaro Italian 1624-1703
Bacc Band	BANDINELLI, Bartolomeo called BOCCIO Italian 1493-1560
FRANC. / BASSis / .F.'	PONTE, Francesco da called Francesco BASSONO II Italian c.1549-1592
BEAUDIN	BAUDOUIN, Pierre Antoine French 1723-1769
CALAND	CALANDRUCCI, Giacinto Italian 1646-1707
De Beyer	BEIJER, Jan de Swiss 1703-1780
Ch. Bovmeester	BOUWMEESTER, Cornelis Dutch c.1670-1733
G. BOIS	DUBOIS, Guillam Dutch 1610-1680
CALAND	CALANDRUCCI, Giacinto Italian 1646-1707
G Ba cipri.	CIPRIANI, Giovanni Baptista Italian 1727-1785

DIAMA	DIAMANTINI, Giuseppe Italian 1621-1705
W V DRIELEN	DRI(E)L(L)ENBURG, Willem Dutch 1625/35-1677
Falange H. H.	FALANGE, Enrico Flemish/German 17c.
P. FARI	FARINATI, Paolo Italian 1524-1606
FRANCOIS	TROY, Francois de French 1645-1730
Joan Freylz.	FREYBERGER, Johann German 1571-1631
Henfius	HENSIUS, Johann Ernst German 1740-1812
E HKerk	HEEMSKERCK, Egbert van, Jr. Dutch 1645-1704
A. D. Hont	HONDIUS, Abraham Dutch 1625/30-1695
I. D. Honnt	HONDT, Lambert de Flemish 1620-1665
J H(linked)oogs	HOOGSAAT, Jan Dutch 1664-1730
Ioannes P	GLAUBER, Johannes called PIODORO or POLIDORO Dutch 1646-1726
Jonge, W. V. Velde	VELDE, William van de, Jr. English 1633-1707

JONSON or JONSON of Brussels	JANSSENS, Victor Honore Dutch 1658-1736
J. Jor.	JORDAENS, Jacob Flemish 1593-1678
Jacob Ligo	LIGOZZI, Jacopo Italian 1543-1627
H G lot	GRAVELOT, Hubert Francois French 1699-1773
MALBRANCHE	MALLEBRANCHE, Louis Claude French 1798-1871
TH mans (TH linked)	HEEREMANS, Thomas Dutch 1640-1697
MARIGNY, L	MARINI, Leonardo Italian c.1730-after 1797
Joanes Massiis	METSYS, Jan Flemish 1509-1575
Meulen J. V.	VERMEULEN, Johannes Dutch ac.1638-1674
PEDRINI	RICCI, Gian Pietro called GIAMPEDRINI Italian 1493-1540
D V PLACS	PLAES, David van der Dutch 1647-1704
ROSA	ROOS, Jacob Italian 1682-after 1761
Schenau	ZEISIG, Johann Eleazar (and/or see SCHENAU) German 1739-1806

C. Screta	SKRETA, Karel Sotnowski (and/or see SCRETA) Bohemian 1610-1674
v. STRAATEN	VERSTAATEN, Lambert H. Dutch 1631-1712
Thielens, Gaspard	THIELEN, Jan Philips van Flemish 1618-1667
J. vander SL	SLUIS, Jacobus van der Dutch c.1660-1732
Vigeel, Melle	VIGEE-LEBRUN, Marie Louise Elisabeth French 1755-1842
Watt	WATTEAU, Jean Antoine French 1684-1721
Wbroek, M. van	UYTTENBROEK, Moyses van Dutch c.1595-1648
v wilt	VERWILT, Francois Dutch 1620-1691
M. VAN. WTEN /broeck	UYTTENBROECK, Moyses van Dutch c.1595-1648

ABOUT THE AUTHOR

Photograph by Barbara Harris

John Castagno has been an art researcher for the past thirty years and is also a multimedia artist and sculptor. He received his art education at The Fleisher Memorial, The Philadelphia College of Art (University of The Arts), The Pennsylvania Academy of The Fine Arts, and The Barnes Foundation in Merion, Pennsylvania.

John Castagno's art is in more than forty museum and public collections in the United States, Israel, and Ireland, as well as in the private collections of Presidents Jimmy Carter and Gerald Ford. He has had twenty-five one-man exhibits, and has exhibited in twenty-four group exhibitions.

John Castagno also lectures on art and art as an investment. He is the author of Artists as Illustrators: An International Directory with Signatures and Monograms, 1800—Present (1989); American Artists: Signatures and Monograms, 1800—1889 (1990); European Artists: Signatures and Monograms, 1800—1990 (1990); and Artists' Monograms and Indiscernible Signatures: An International Directory, 1800—1991 (1991), all published by Scarecrow Press.

FINIS